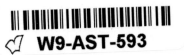

Leonardo da Vinci

Scientist Inventor Artist

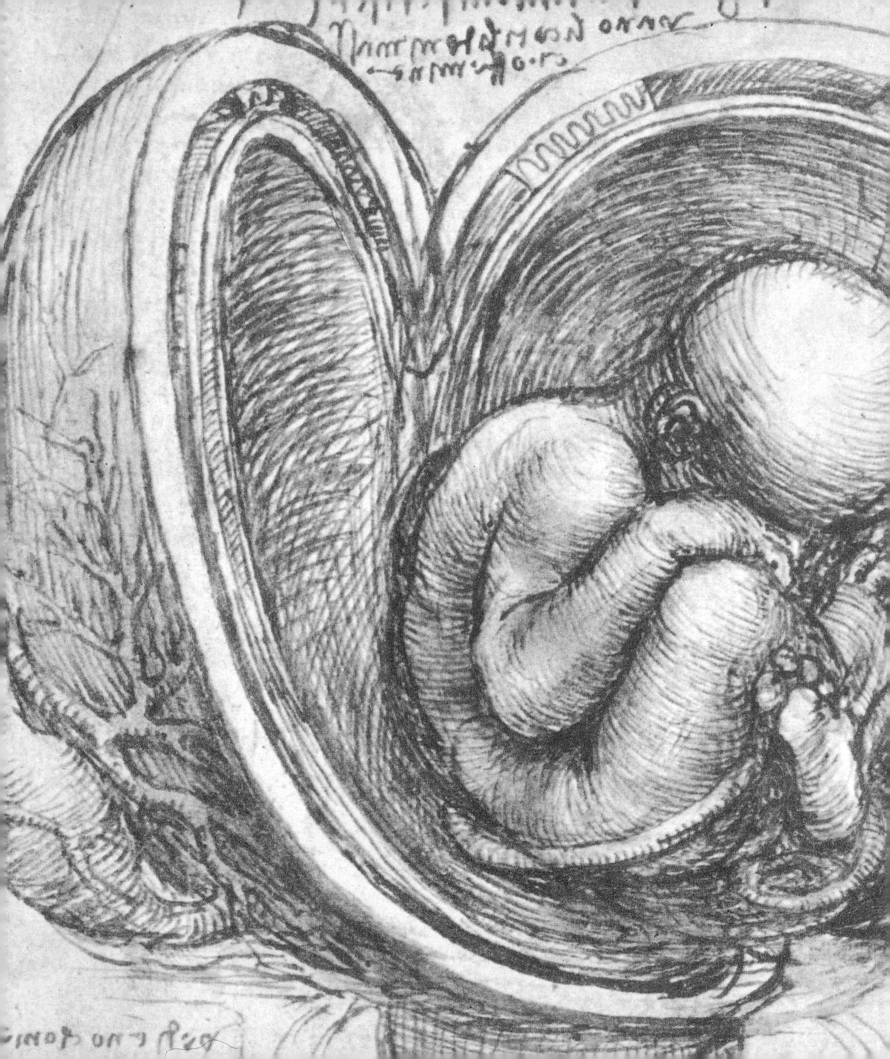

Leonardo da Vinci
Scientist Inventor Artist

Editors
Otto Letze and Thomas Buchsteiner

with contributions by
Nathalie Guttmann
Pietro C. Marani
Carlo Pedretti
Alessandro Vezzosi
and others

and excerpts from
Leonardo da Vinci's
"Treatise on Painting"

Verlag Gerd Hatje

Exhibition Committee

Dr. Otto Letze
Institut für Kulturaustausch Tübingen
Prof. Piero Palazzi
Head of Department of Culture, City of Malmö
Prof. Dr. Carlo Pedretti
The Armand Hammer Center for Leonardo Studies
University of California, Los Angeles

Sponsors
IWC International Watch Co. Schaffhausen
Mercedes Benz AG, Stuttgart

Where the legends refer to several illustrations,
the order of reference is from top to bottom
and from left to right.

Cover illustration:
Self-portrait
ca. 1516
Biblioteca Reale, Turin
(see page 8)

Back cover illustration:
Leonardo da Vinci and pupils
The Virgin of the Rocks
ca. 1495
Private collection, Switzerland
(see page 47)

Front flyleaf:
Anatomical studies of embryonic development
ca. 1510–1513
Royal Library, Windsor
(see page 97)

Back flyleaf:
Study of a deluge
ca. 1516
Royal Library, Windsor
(see page 155)

Exhibition

General management, realization and logistics
Dr. Otto Letze and Ira Imig
Institut für Kulturaustausch, Tübingen,
in cooperation with the presenting museums

Catalog

This book is published on the occasion of the exhibition
Leonardo da Vinci
Scientist Inventor . Artist

© 1997 Institut für Kulturaustausch
Reutlinger Str. 9/1
72072 Tübingen, Germany

Edited by Dr. Otto Letze and Dr. Thomas Buchsteiner

Descriptions of the paintings
Ira Imig
Roland Oberzig

Editorial staff:
Ira Imig
assisted by
Otto Danwerth
Roland Oberzig
Natalie Wilson

Translation
Institut für Kulturaustausch Tübingen

Design
Gerhard Brunner

Cover
Design-Büro Glas

Printed by
Dr. Cantz'sche Druckerei
Ostfildern bei Stuttgart

Published by
Verlag Gerd Hatje
Senefelderstr. 9
D-73760 Ostfildern-Ruit
T. 0711/4 49 93-0, F. 0711/4 41 45 79

ISBN 3-7757-0625-9

(German trade edition
ISBN 3-7757-0578-3)

Distribution in the US
D.A.P.
Distribution Art Publishers
155 Avenue of the Americas Second Floor
USA-New York, N.Y. 10013-1507
T. 212/6 27 19 99, F. 212/6 27 94 84

Printed in Germany

Contents

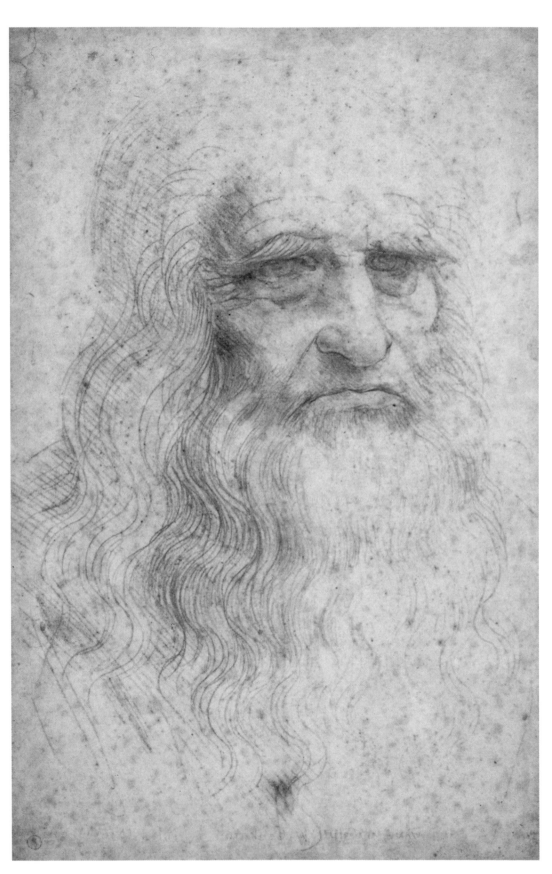

Self-portrait
ca. 1516
Red chalk
333x213 mm
Biblioteca Reale, Turin

On loan from

Museums and Libraries

The Armand Hammer Center for Leonardo
Studies
University of California
Los Angeles
Director Prof. Dr. Carlo Pedretti
The Elmer Belt Library of Vinciana
Arts Library
Los Angeles
Director Prof. Dr. Alfred Willis
Museo Ideale Leonardo da Vinci
Vinci
Director Prof. Alessandro Vezzosi
Österreichische Nationalbibliothek
Vienna
Director General Dr. Johann Marte

Thanks to

Bernd Barde, Dr. Cantz'sche Druckerei;
Gerhard Brunner, Dr. Cantz'sche Druckerei;
Bogdan Bunea, Interactive Design; Angela
Butterstein, Institut für Kulturaustausch;
Louise Ercolino; Margit Diefenthal, Kuhn
& Bülow; Dr. Meinrad Maria Grewenig,
Historisches Museum der Pfalz, Speyer;
Tina Keck, Institut für Kulturaustausch;
Peter Krecek, Dr. Cantz'sche Druckerei;
Michael Kuhn, Kuhn & Bülow; Hannes
A. Pantli, IWC Schaffhausen; Rosanna
Pedretti; Dr. Anna Plattner, Österreichische
Nationalbibliothek; Ilmar Reepalu, Mayor
of the City of Malmö; Wolfgang Rolli,
Mercedes Benz AG Stuttgart; Dr. Marta
Stamenov; Charles Steckel; Renato
Tomasini, IWC Schaffhausen; Sebastian
Zeidler, Verlag Gerd Hatje.

Galleries and Private Collections

The Alos Foundation
Liechtenstein
Joseph M.B. Guttmann Galleries
Los Angeles
Galerie Hans
Hamburg
Carlo Pedretti
Los Angeles
M. Steinberger Collection
Brussels
Private Collections
Germany
Private Collections
Switzerland
and further anonymous lenders

I would like to explain why IWC, a Swiss watch manufacturer, should support an exhibition on the Italian universal genius of the Renaissance. Da Vinci was, of course, one of the first theoreticians of the mechanical clock. IWC regards Leonardo da Vinci as a model for its innovative work. Furthermore, in 1985 in his honour as it were and as a memorial to the master, we named one of the most unusual watches after him: the "Da Vinci" by IWC, the chronograph with an endless calendar, permanently programmed up to the year 2499. An arc of one thousand years spans across this theme then. Is that not reason enough? I hope you are inspired by your time with Da Vinci.

Günter Blümlein
President of IWC Schaffhausen

Leonardo da Vinci — painter, sculptor, architect, inventor, scientist and engineer — was indisputably one of the greatest creative geniuses. Leonardo embodied the spirit and inspiration of the Italian Renaissance — an epoch so diverse and complex that it may in many respects be compared with our society today. Driven by the compulsion "to gain greater mastery over the problems of the time with technical innovations", Leonardo was a thinker ahead of his time.

In all his works as a machine designer, his efforts to use the energy sources available to man are apparent. His great dream was "to construct machines which will enable whole worlds to be moved". In his Codex Atlanticus (fol. 296v-a), Leonardo attempted to make mankind's eternal dream of mobility, in the form of a spring-driven automobile, come true. The attempt remained at the drawing board stage.

Nearly 400 years later, Gottlieb Daimler and Karl Benz turned Leonardo's dream of a "machine which generates its own energy" into reality and invented the car.

In the future, Mercedes Benz AG will continue to regard itself as committed to the central idea of this great machine designer "to gain greater mastery over the problems of the time with the help of technical innovations".

Dr. Dieter Zetsche
Member of the Board of Management
Daimler-Benz AG

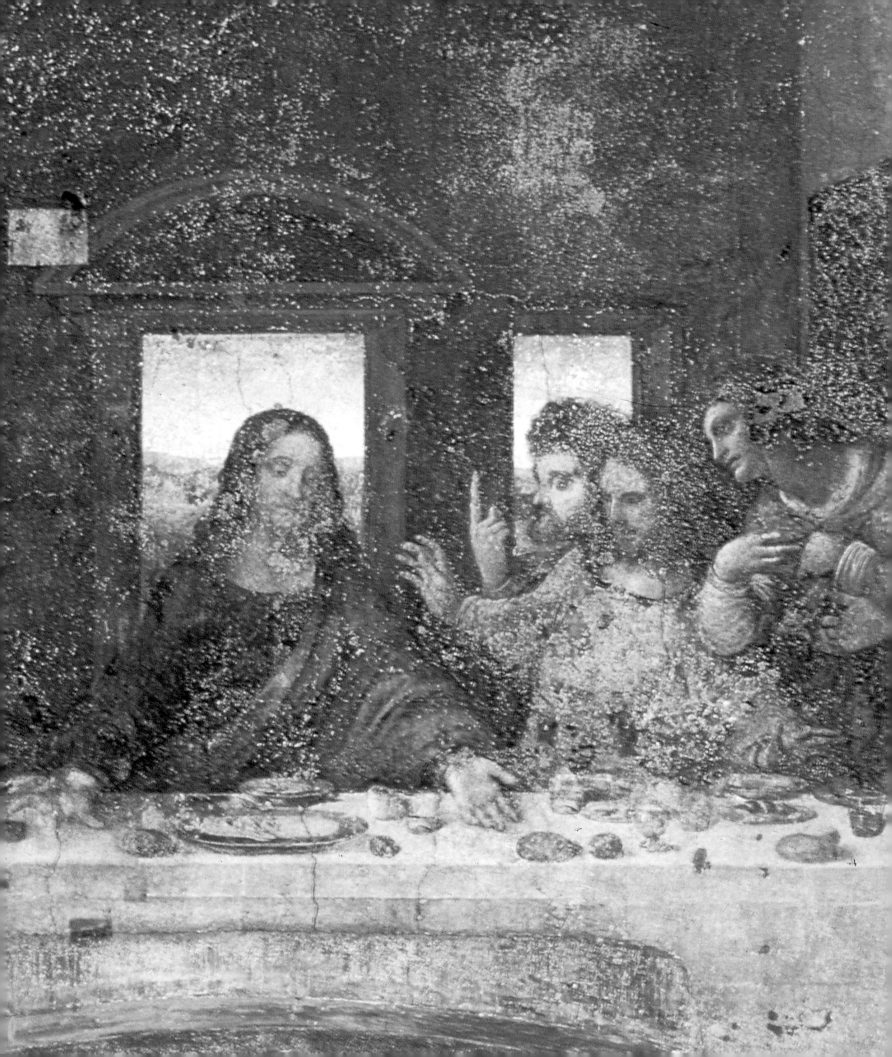

Leonardo da Vinci Scientist Inventor Artist

Leonardo da Vinci is one of the great figures of mankind. He is extremely well known at all levels of society and in all parts of the globe. He has been called a "universal genius", an attribute which has been granted to only a chosen few in the history of mankind. However, when you ask someone what exactly Leonardo da Vinci created, only the most famous works "The Last Supper" and "Mona Lisa" are associated with him. Nevertheless, his artistic, inventive and scientific work is unimaginably rich and diverse.

It is only when one considers the wide range of Leonardo's work, it becomes clear why his achievements are universal and ingenious and why they have become milestones in the development of mankind. The exhibition "Leonardo da Vinci – Scientist, Inventor, Artist" prompted this accompanying publication, which endeavors to illustrate the relationship between these three facets of his work.

"Lionardo", called "da Vinci", the illegitimate son of a notary, was born on 15 April, 1452 in the small mountain village of Vinci, 50 kilometers west of Florence. Little is known about the first years of his life. In documentation about Leonardo da Vinci, the legend around the child genius and autodidact, who attempted to draw the animals and plants at his parents' estate in full detail, has grown.

The most reliable source relating to Leonardo da Vinci is to be found in his complete works. Countless manuscripts, a wealth of drawings as well as less numerous paintings and sculptures, are the outcome of his productive life. He is familiar to us as painter, draftsman, sculptor and architect. Leonardo da Vinci's artistic works were invariably preceded and accompanied by scientific investigation and theoretical discourse. His art works were not only the attempt to reflect reality but also a search for the laws of nature, science and proportion to be handed down to posterity.

Leonardo the inventor is represented by countless pioneering innovations in the realms of technology and painting which may legitimately be understood as "visualized pictorial conceptions". This is where the exhibition "Leonardo da Vinci – Scientist, Inventor, Artist" begins: Leonardo as researcher and teacher, whose artistic creativity was a formative influence in his time and played a large part in shaping the Renaissance conception of the world. Most prominent, is the universal genius whose works anticipated the technical and scientific achievements of later centuries and whose modernity was only to be fully understood in our own industrial age.

The full range of Leonardo's works have never been exhibited to the public in this form until now. This exhibition is the first step in highlighting the fascinating correlation between science, invention and art. It also demonstrates the bridge between the beginning of the modern era and the present time, shortly before the end of the millennium.

Our aim is to convey the significance of Leonardo's unique work to the modern world. The exhibition forges a link between the Renaissance and the present whilst remaining fully aware that, although the current state of science and technology allows us to realize Leonardo's theoretical schemes with perfection and precision, the intentions of the all-round thinker have been lost in the process.

If today we associate the name of Leonardo primarily with the "Mona Lisa", we in no way do justice to the universal genius. Our concept is, consequently, first and foremost didactic.

The Last Supper
1495–97
Detail
Oil-tempera mix, fresco
Refectory, S. Maria delle Grazie, Milan

The visitor should be given the opportunity of grasping Leonardo's thought, to pose questions and to find answers. To this end — and in the spirit of the forward-looking Leonardo — the 230 exhibits are supplemented by modern, interactive multimedia units which, with over 8,000 pictures and a wealth of information, can be used by visitors to call up explanations of the ideas of the "Renaissance Man", his school and times as well as to provide a profound insight into the period of the Renaissance. Furthermore, wooden models, which can be touched and moved, help to make history comprehensible. The exhibition seeks to bring about a dialog between Leonardo's creations and the visitors, who should not only contemplate the works but also grasp the ideas behind them. We hope that the process of learning will be an enjoyable experience.

In view of the extremely difficult discussion centering around the works attributed to Leonardo, it is almost impossible to organize a pure "art exhibition " of Leonardo's works. Five hundred years ago, it was not common practice to sign every painting and every sketch with a name or a date. So the question of attributions to Leonardo seems to be a scientific battle field, and there is no solution in sight. We restrict ourselves to the feasible in order to do justice to Leonardo, his students and his times; we should regard Leonardo in terms of his significance in the history of culture.

Accordingly, our idea was not that the accompanying publication should offer the visitor an exhibition catalog in the usual sense, but rather that it should offer a comprehensive foundation with numerous illustrations of Leonardo's complete works. The interested reader then has the opportunity, for example, of comparing Leonardo's paintings with works from his artistic milieu and of following the development of the painting of the time.

The exhibition is divided into three sections: the scientist, the inventor, the artist. The scientist and inventor is presented in over 150 drawings and studies by Leonardo prepared in the form of authorized, hand-colored facsimiles made available especially for this exhibition. An exhibition of this size would never have been possible with the original drawings.

The display of the inventions is supplemented by 25 wooden models after Leonardo's drawings which are articulated to permit the visitor to really "see" the working invention.

The section on the artist encompasses about 20 typical and exemplary original works by Leonardo da Vinci, his school and other significant artists of the period. We would have liked to have been able to exhibit the originals of Leonardo's principal works, the "Mona Lisa" or "Madonna, Infant Christ, and St Anne", however these works are no longer permitted to "travel". In an age of total mobility the expectation is that the interested visitor will go to see the paintings at their respective museums.

It is, for this reason, all the more important to call to mind the effect of Leonardo's work on his immediate environment and on his successors, using the outstanding paintings which have generously been made available. They reflect Leonardo's achievements and clearly show the fruitful dialog in which the great artists of his time participated.

Leonardo da Vinci was the first artist who, by demanding a synthesis of nature and intellect, established a fundamentally new creative principle. The perfect balance of art and science

underlines Leonardo's importance to the cultural history of the western world and brings forward our current conception of both areas for discussion.

We are delighted to be able to present this exhibition to the international public, and would like to thank our sponsors, Mercedes-Benz and International Watch Company (IWC), without whose material and financial support this exhibition would not have been possible.

The City of Malmö and the Head of its Department of Culture, Prof. Piero Palazzi, deserve thanks. They compiled the basic elements of the exhibition. We are particularly thankful to Prof. Dr. Carlo Pedretti, Director of the Armand Hammer Center for Leonardo Studies, University of California, Los Angeles, who offered suggestions and organized loans for this exhibition. We would also like to thank the Director of the Museo Ideale Leonardo da Vinci in Vinci, Italy, Prof. Alessandro Vezzosi, who, through the loan of models, substantially enriched the exhibition. Last but not least, we are extremely thankful to all the museums, galleries and lenders: their commitment is, in every way, the basic requirement of exhibition work.

Otto Letze
Thomas Buchsteiner
Institut für Kulturaustausch

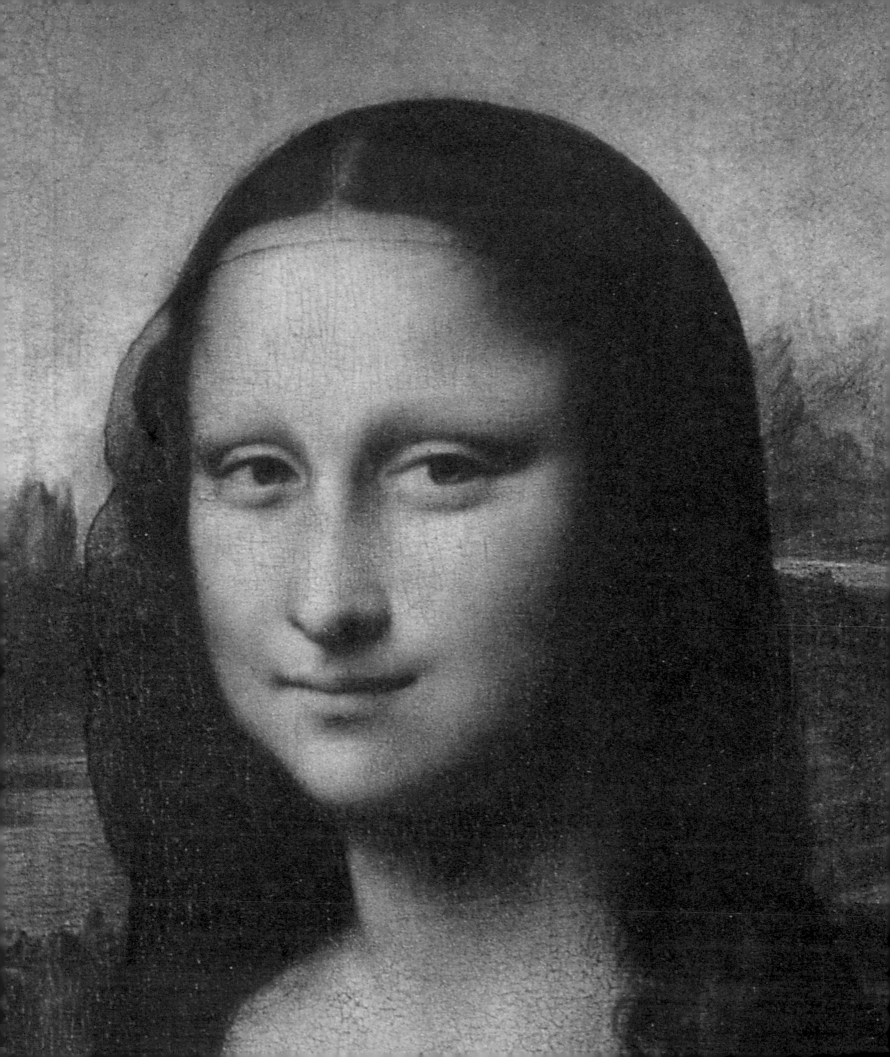

Leonardo da Vinci

by Carlo Pedretti

From the very beginning Leonardo da Vinci (1452–1519) dedicated his artistic career to the celebration of painting as a profession and as a form of knowledge of the first order. In a period in which visual culture was not yet dominated by photography or the cinema, Leonardo da Vinci insisted on the ideal of painting as a universal language, which in form, color and atmosphere would produce precise visual images of objective reality, and even of the idea of movement within that reality: according to Leonardo an indispensable prerequisite for the expression of the "movements of the mind" – and this too with the objectivity and uncompromising stringency of a camera.

It may be said that it was precisely this, the stringent discipline to which his work was subjected, a discipline embracing both theory and practice, and his endeavor not to subordinate the experience of the world of things to the expression of his own subjectivity, which made Leonardo so unique and inimitable. If he spoke of himself as a painter, it was almost always to point out failings to be avoided, such that the rules he formulated sound more like self-directed exhortations than precepts for others. It was this which, while painting portraits at the court of the Sforza, and based on his observation that the pupils enlarge or constrict in response to the intensity of light, enabled him to admit: "this deceived me even while depicting an eye; and thus I acquired this knowledge". To some extent this was also the source of Leonardo's misfortune: the continual dissatisfaction, the insatiable yearning for perfection, the restlessness, which beyond the Furor poeticus (or, with Sinisgalli, the Furor mathematicus) showed itself in his blood pressure values. Those who were close to him were able to impart quite a different picture of Leonardo, less entrancing than those of the anecdotes and legends, aptly conveyed in Lomazzo's reminiscence of 1590: "Leonardo appeared to tremble constantly while painting, so that he never finished that which he started; he saw defects where others only perceived wonders". The portrayal of the "divine Leonardo", which we owe to the rhetoric of Vasari's "Lives" (1550 and 1568), is matched by a more reliable and fascinating picture originating from more credible sources – Leonardo's own documents and manuscripts. The short biography of Leonardo by Paolo Giovio, written in Latin around 1520 but first published in 1796, must be counted as one of the most important yet least accessible sources. Giovio writes as an eye-witness. During the period 1508–10, while taking his exams in medicine in Pavia, his teacher was the same Marcantonio della Torre who, during this period, was engaged in dissecting corpses with Leonardo. His report on Leonardo's programmatic principles agrees exactly with those coming to us from Leonardo himself, for whom finally all scientific or technical research was always more or less directly connected with his profession as a painter.

"Born in Vinci, a modest village in Tuscany, Leonardo brought the art of painting to full flower through his insistence that nobody could execute it genuinely without first mastering those liberal arts which are the handmaidens of painting". Giovio begins his text in this way, and it is well known that Leonardo strove to create a place for painting alongside the other liberal arts, if not above the other sciences, including geometry and arithmetic, as according to Leonardo "these two sciences are concerned only with continuous and discontinuous quantity, not however with the quality which is the beauty of works of nature and the

Mona Lisa
1503–07
Detail (see p. 61)
Oil on panel
Louvre, Paris

adornment of the world". Giovio also shows himself to be well-informed when he adds that Leonardo "gave precedence to sculpture over the brush as a model of plastic representation of surface": as the problem of plastic representation in painting had always been Leonardo's primary concern. He approached the problem by studying not only living models but also models made from clay or wax in the most precise detail – following a method which, according to Cellini, was introduced by Masaccio and taken up by "Leonardo da Vinci, the painter of several beautiful things in Milan and Florence". This comment obviously refers to the "Last Supper" (see p. 55) and the "Battle of Anghiari" (see p. 59) and probably also relates to a remark by Leonardo about a wax model for one of the battle figures. The optical problems of light and shade are also linked to the problem of plasticity in painting. Giovio reports further that Leonardo "considered nothing so important as the optical rules of which he made use in order to establish precisely the laws of light and shade". This appears to be a reference to the texts on the eye and the faculty of vision written by Leonardo after 1505 when he increasingly devoted his energies to anatomical research about which Giovio narrates in the same connection: "In the medical faculties and under inhuman and appalling conditions, he had also learnt to dissect the corpses of criminals so that he could faithfully reproduce the various flexions and extensions of the limbs, which are influenced by the nerves and joints. And for this reason he took admirable care to make drawings of the form of each of the smallest organs right up to the finest veins and most secret parts of the skeleton, so that, as the fruit of these years of effort, unlimited copies of copper engravings could be produced for the benefit of the arts".

This unusual report of the plan to publish the results of the anatomical studies is confirmed by Leonardo himself. On one of the folios of bone studies in Windsor from 1510, Leonardo describes his intention of representing the cervical vertebra from various perspectives – joined and detached, from above and below – and closes with the following words: "And so you will faithfully reveal its form. The ancient authors and those of the present time have only achieved this in tortuously ponderous, long-winded and confused written reports. With this terse form of description on the other hand, they will be exhaustively presented from various viewpoints; and that this, my gift to mankind, is not lost, I shall teach the method of reproducing the same in print; and you, O my successors, I beseech thee, do not be led by miserliness to make wood engravings of them!"

This explains the metallic quality of many of Leonardo's anatomical drawings in the Royal Library at Windsor, particularly the series of bone studies from 1510. Giovio may have seen them when Leonardo was working on them assiduously until della Torre fell victim to an epidemic in 1511. It is true that Leonardo continued his anatomical studies several years afterwards without della Torre, but obviously no longer entertained the intention of publishing them in print; at the same time Leonardo's characteristic process of interdiscipli-nary thought had resulted in new prevailing interests – a process which may well have appeared to his contemporaries, including Giovio, as a sign of his inconsistency. "But while devising new means and methods for the perfection of art with the utmost meticulousness, he finished only a very few works: due to his changeable character or to inherent impatience he always presented only his first ideas. Despite that, his wall-painting in Milan [in the

Allegory of river navigation
ca. 1515
Red chalk on brown-gray paper
Pedretti 54r
172 x 285 mm
Royal Library, Windsor (RL 12496)

Refectory of S. Maria delle Grazie] showing Christ with his disciples at the Last Supper [see p. 55] is greatly admired; a work which it is said King Louis [XII] coveted so much that he cravenly asked the beholders standing about the painting with him whether it would be possible to remove it from the wall and take it back to France, even if it were to involve destroying the refectory."

Giovio only mentions two other paintings by Leonardo: the painting of "St Anne" (see p. 63), which is said to have been acquired by Francis I for his chapel (other witnesses have also linked the picture to him), and the "Battle of Anghiari" (see p. 59), the painted fragment of which was still to be seen in the Palazzo Vecchio in his lifetime: "Further, there exists a picture by Leonardo of the Infant Christ playing with his mother and St Anne which was bought by Francis, King of France and exhibited in his chapel; and, in the council chambers of the Signoria of Florence, a battle and victory over the Pisans, a magnificent work which, unfortunately owing to a defect in the plaster which persistently repels the colors dissolved in nut oil, remains unfinished." It would appear as if Giovio had conjectured the real reasons for the failure of Leonardo's technique – intimated by Anonimo Gaddiano when he speaks of linseed oil "which was blended for him" – only then to add: "but still it seems that the grief about the unexpected damage increased the fascination with the unfinished work extra-ordinarily".

Giovio then recounts the gigantic sculpture of a horse for Francesco Sforza and comments that "in the impetuous life-like action of the animal we are made aware of the perfection of both the art of sculpture and of nature itself". Giovio concludes with a sketch of Leonardo the man and his character: "the magic of Leonardo's being, his brilliant aptitude, the generous goodness of his nature were not inferior to his physical magnificence; and just as great was his inventive genius, his arrangement of theatrical productions and pageantry; he was considered the principal judge in all questions of elegance and beauty; he also sang

excellently to the delight of the whole court whilst accompanying himself on the lute. He died in France, sixty-seven years of age, to the sorrow of his friends which was all the greater as, amongst all the students who belonged to Leonardo's flourishing workshop, not a single one was destined for eminence."

This was just one more of Leonardo's "failures". The greatest of the masters did not manage to train a single student worthy of himself who could have taken up the challenge of his maxim: "dispirited is the pupil who does not surpass his master." In the 16th century his Milanese emulators merely produced forced copies of his compositions and models lacking any inner impulse of their own: a waxworks of ossified figures in which even the landscapes are preserved with Flemish accuracy and all the fire of life is extinguished. All that remains is the darkness into which these ghosts, whose pale colorlessness is hardly illuminated by even the dullest flash, withdraw deeper and deeper. All the same, the darkness and flashes were at least capable of stirring the spirit and imagination of Caravaggio at a later date.

The manuscripts and drawings left by Leonardo to his student Francesco Melzi and administered by him until about 1570, nonetheless aided the slow dissemination of Leonardo's teachings. Melzi made himself the agent of these teachings by compiling the "Treatise on Painting" in a codex which obviously reached the printer's, but then inexplicably found its way to a proof-reader's desk only then, still unpublished — and again inexplicably — to end up in the library of the Duke of Urbino. Even in Melzi's lifetime work was begun on making copies of an abridged version of the "Treatise" of which, alone in Florence, more than twenty copies dating from the 16th century still exist. One of these copies belonged to Viviani and before him it is presumed to Galileo who, in the first of his dialogs gives Salviati the following words: "others are familiar with all da Vinci's rules, but are still incapable of drawing even a stool".

There are copies of the "Treatise on Painting" which are known to have been the property of artists, Lanino for instance, Procaccini or even Guido Reni; if it were possible to prove that Barocci knew the "Treatise" too — which is highly probable (possibly even from the original in Urbino) — it would surely be possible to assert that the true successors of Leonardo first appeared about one hundred years after his death. Annibale Carracci used to say that he would have saved twenty years of work had he known Leonardo's "Treatise" earlier. It is actually possible to find traces of Leonardo's didactic method in the "Treatise", a method which paved the way for all the advantages and disadvantages of the academicism of a later generation. One might also maintain that the reason for Leonardo's failure as a teacher lay in a misconception: he upheld a didactic method of the Quattrocento, but was himself still capable of adapting to new currents. He was also a "bad teacher" in the sense that he did not allow his students to go beyond the point he himself had reached, but forced them rather to take the same path that he had already arduously trodden. If we understand painting in terms of a craft, he was of course absolutely right; but art could not remain fettered to the Quattrocento principles which on the one hand he valiantly upheld, and on the other contradicted, particularly in the works of his mature period — those so closely related to the Venetian world of Giorgione and the late Bellini — and which were not even allowed as objects of study. An unusual document relating to this conflict and which is jointly

Leonardo da Vinci (attribution)
The Budapest Horse
Early 16th century
Bronze
Height 22 cm
Szépmüvészeti Múzeum, Budapest

responsible for Leonardo's tragedy in this respect has been handed down to us by Giovio. In a report which, strangely enough, still receives little attention even today, it is said of Leonardo's didactic method: "The eager to learn and the avidly talented must not be allowed to succumb to the temptation to fly prematurely like little birds without feathers and strong wings." With examples like this and similar, Leonardo da Vinci made it clear to his favorite students that he had only managed to win such honors for the art of painting in our time by unravelling the secrets of the ancients with his sharp and active mind. Until the age of twenty Leonardo strictly forbade his students to paint with brush and paints and only allowed them to practice with a pencil; he exhorted them to select and copy the most notable works of antiquity with the greatest care in order, with a few strokes, to trace the powers of nature and contours of the body presenting themselves to our eyes in the most various of movements. He also required them to dissect human corpses in order to study with attention the articulation and joints of muscles and bones and the functions of the ligaments; and on top of that he himself had written a detailed book and illustrated it with depictions of each of the arts. It was his aim to prevent anything being painted in his studio which was not true to life: "that is, that the impetuous talent of the youths not be attracted to the brush and the magic of paint until by profitable practice they had learnt to reproduce the appearance of things in their exact proportions and without the help of models."

Giovio, with Leonardo's example before his eyes, then turns to those striving towards a literary career: "Whoever then is seized by the true passion will have to continue on this path of truly laborious writing, however arduous the way may seem (although at its end satisfaction awaits) with the aim of never needing to regret having started to write too soon simply because he neglected to consult the illustrious antique authors."

At this point, at which Giovio repeats the necessity of daily practice, he returns to the theme of art and refers to another teaching example: Donatello in Padua. Giovio presents us with information not recorded in any other source and which he had probably received from Leonardo himself who had "resumed" work on the horse for the Sforza Monument in 1490, in a way comparable to Donatello's: "On the other hand daily practice in the art of composition is unreservedly accepted as the best means of mastering style, as clearly shown to us in the other arts. In response to the question, which is the best method of learning the art, Donatello, the creator of the bronze equestrian statue of the Gattamelata on the piazza in Padua, a glorious witness to the marvellous powers of art, replied: 'in the arts, to do and do again is to make progress.'"

Giovio's notes are merely the draft of a dialog which was intended to serve as the introduction to biographies of Leonardo, Michelangelo and Raphael – a project that during the Sack of Rome remained unfinished, but which, nonetheless, induced the author to invite Vasari to write the far more expansive biographies of the artists. Giovio had a clear notion of the direction Italian art would take at the beginning of the 16th century thus enabling him to explain the downfall of Perugino, who was still living as Giovio was writing: "Who in recent years has practiced the craft of painting with greater success and acclaim than Perugino, who still as an eighty-year-old paints with a fairly steady hand – but without reaping more glory?" The same Perugino who, once esteemed as the greatest master, was only to have his

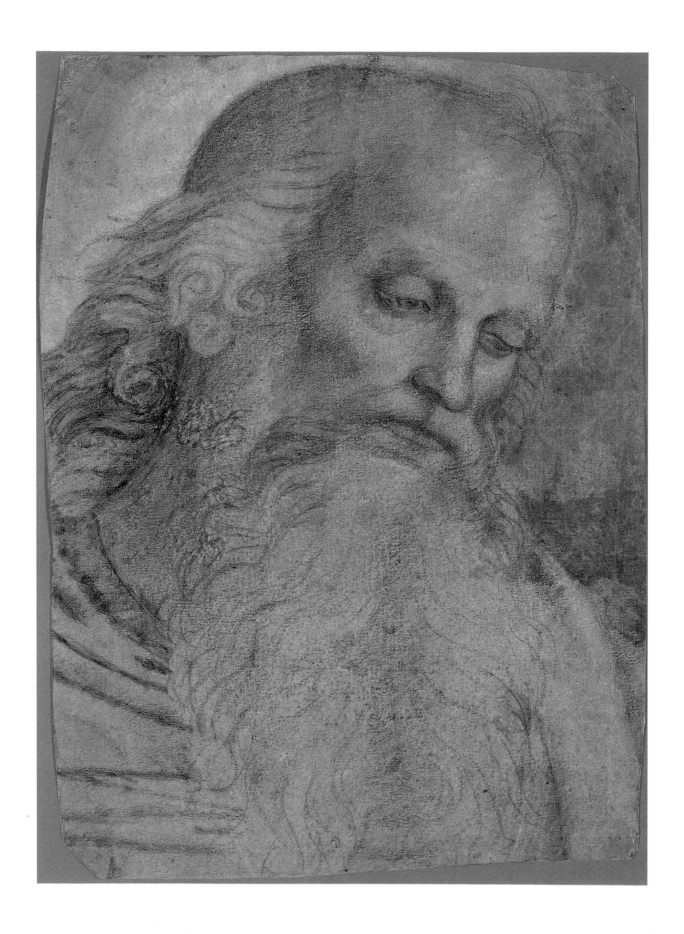

fame overshadowed by the appearance of the "stars of a perfect art": Leonardo, Raphael and Michelangelo. The peculiarity of the art of the Cinquecento, from which Perugino was to remain excluded, is summarized by Giovio as follows: "By emulating and imitating better works, Perugino strove in vain to maintain the position he had won, as his failing imagination forced him again and again to resort once more to those embellished faces upon which he had already concentrated in his youth, to such an extent that his spirit was hardly able to hide the shame; whereby the others — Leonardo, Michelangelo and Raphael — whatever the theme, represented the nude limbs of majestic figures and the urgent forces of nature in astonishing variety."

Pietro Perugino (1446—1523)
Head of an old, bearded man
ca. 1500
Black, white, and brown pastel on blue-green paper
333x246 mm
Galerie Hans, Hamburg
Original cartoon for the figure of St Jerome for the painting "Madonna and Saints" (1494) in the church of San Giacomo in Breda ed Agostino, Cremona.

Provenance:
de Mestral de Saint Saphorin, Benno Geiger, Randall, Wolf Bürgi
Bibliography:
Benno Geiger, Handzeichnungen alter Meister, Zürich, 1948, cat. no. 5, Ill. p. 35;
Scarpellini, 1984, cat. no. 61, Ill. p. 91

Leonardo da Vinci (attribution)
Bust of Christ as a Youth

ca. 1495
Terracotta
Height: 33 cm, base: 20x21 cm
Luigi Gallandt Estate, Rome

Acquired by the Italian sculptor and collector Luigi Gallandt from the friars of a convent in Ascoli Piceno in the Southern Marches in Italy in 1924, and then taken to London, this terracotta bust of "Christ as a Youth" is now kept in Rome, Italy, as part of the Gallandt Estate. It was first attributed to Leonardo by A. Bianchi in the "Illustrazione Vaticana" of 1931. On April 13, 1938, Adolfo Venturi signed a certificate to the effect that it was by Andrea Verrocchio "at the time when young Leonardo was working at his side, and probably with the help of his great pupil". It was first exhibited in the Leonardo quincentenary exhibition in 1952 at the Biblioteca dell'Archiginnasio, Bologna, organized by Carlo Pedretti, who published it in his "Studi Vinciani" of 1957 and in "L'Arte" of the same year, reporting Planiscig's unpublished attribution to Verrocchio and suggesting Leonardo's authorship, a view immediately taken up and applauded by Giorgio Nicodemi in the monumental "Storia di Milano". As such it appears in later publications. (See bibliography under Kemp and Vezzosi). In 1989 it was again discussed by Pedretti, with a firm attribution to Leonardo, an attribution fully endorsed by Martin Kemp with a seminal paper in the same journal. Kemp's conclusion as to a date of about 1495–1500 is consistent with the thermoluminescent test conducted at the Research Laboratory of Archaeology and the History of Art at Oxford in 1986 (report of 21 January, sample 381 t 41) which estimates the firing of the clay as having occurred between ca. 1350 and ca. 1550.

It is well-known that Leonardo was just as proficient in sculpture as he was in painting, and this by his own admission: "Adoperandomi io non meno in scultura che in pittura, et esercitando l'una e l'altra in un medesimo grado ..." (Treatise on Painting, no. 47, fol. 23, p. 32), though nothing is left of his early production as a sculptor trained in Verrocchio's workshop in Florence in the 1470s. Nor is there any record of sculptures produced later, except for the ill-fated projects of equestrian monuments to Francesco Sforza and Marshal Gian Giacomo Trivulzio before and after 1500. And yet there is plenty of circumstancial and even documentary evidence of his sustained interest in sculpture and the theoretical aspects of it as still recorded by Cellini in 1564. In 1550 first, and again in 1568, Vasari reports about his early works in clay characterized by lively portrait busts of girls and children, additional information being provided by Gian Paolo Lomazzo in 1584, who describes a terracotta head of "Christ as a Youth" in his possession in a way that matches exactly the Gallandt terracotta bust:

'A clay head on reduced scale "una testicciola di terra" of a Christ, while he was a youth, from the hand of Leonardo himself, in which the simplicity and innocence of youth are accompanied by a certain quality indicative of wisdom, intelligence and majesty, and an air which, although it is of a tender youth, appears to show the wisdom of an old person, something which is truly excellent' (Trattato, II. 9).

As Martin Kemp points out, the bust succeeds remarkably well in evoking the transitory and composite expressions which are reflective of the "motions of the mind" in all their full complexity. The effect is hard to describe. "There is an element of surprise", adds Kemp, "even alarm, but this is seemingly modulated by an instantaneous inner awareness, tempering the expression and permitting feelings of tenderness and sweetness to persist". This composite effect corresponds very closely to Lomazzo's reading of the bust in his

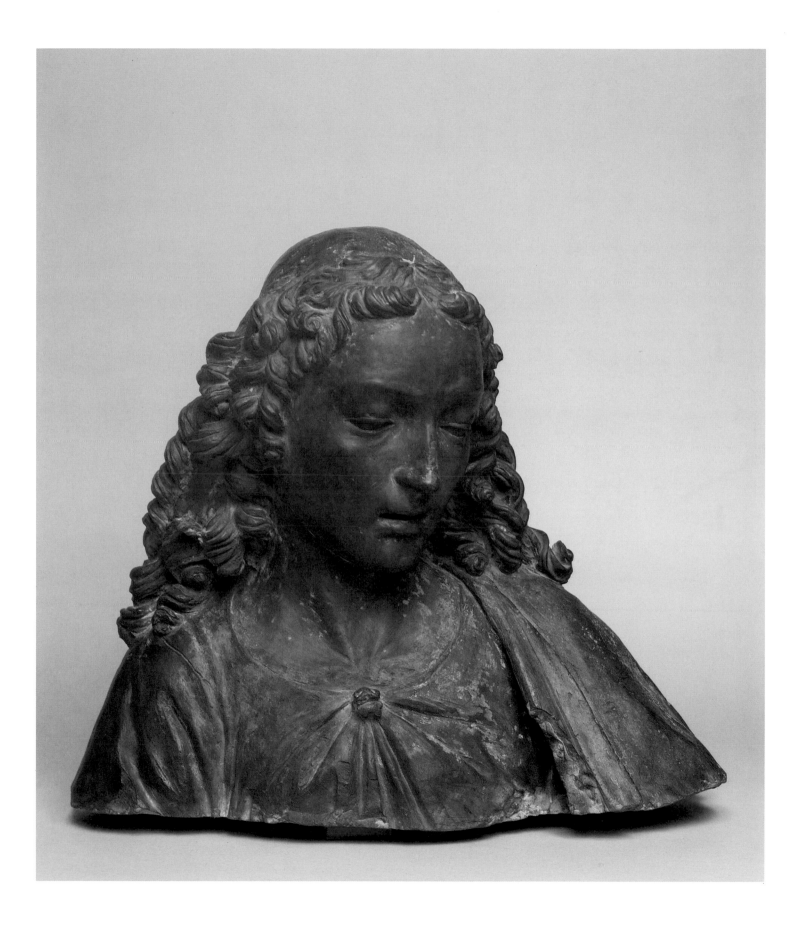

possession. The bust, in turn, finds unmistakable reflections in the work of Leonardo's Lombard followers, notably in Correggio's small paintings of the Young Christ as a "Salvator Mundi".

In his masterly analysis of the formal and emotional qualities of the bust, Martin Kemp recognizes features of Leonardo's established oeuvre. The most precise similarities can be made with the Windsor studies for the heads of St James the Greater and St Philip in the "Last Supper". St James closely shares the motion of the "swan's neck" recoil, with its air of decorous surprise, albeit with the element of alarm more naturally prominent. St Philip possesses more of the bust's quieter tenderness, and the shape of the saint's mouth, with a small pendulous tip at the middle of the upper lip, is virtually identical. We might also look to the entourage of youths who crowd around the Virgin in the Uffizi "Adoration of the Magi" for features and motions of comparable kinds. The profile of the youthful Christ, for all its Verrocchiesque qualities, is entirely consistent with one of Leonardo's own stock types which appears in the early Florentine period and reappears throughout his career in close variants. There is no problem in finding clear analogies for the vortex hair style, which became an almost self-parodying feature in Leonardo's profiles of epicene youths and leonine men. The density, variety and three-dimensional complexity of the hair vortices stand as worthy counterparts to his water studies, the patterns of which Leonardo himself regarded as deeply analogous to the motion of the hair.

Kemp's views, before and after publication, were fully endorsed by Charles Avery, former keeper of Italian sculpture at the Victoria and Albert Museum in London. In 1989, another authority of Italian sculpture, Professor Alessandro Parronchi of the University of Florence, gave a new, fresh account of Leonardo's career as a sculptor (ALV Journal, II, pp. 40–67), which ends up with a cogent and compelling assessment of the Gallandt bust: "A further deepening of the expressions raised in an idealized climate with subtle implications will be reached by the "Christ as a Youth" in a Roman collection – first recognized as Leonardo's work by Carlo Pedretti – where a divine pensive look is ineffably characterizing the youthful countenance."

Nathalie Guttmann

Bibliography:
M. Kemp, Lettura Vinciana, Florence 1988. Id., Christo Fanciullo, ALV Journal, IV, 1991, pp. 171–176.
Giorgio Nicodemi, Storia di Milano, Milan 1957, vol. X, pp. 787–788. A. Vezzosi (ed.), Leonardo e il leonardismo a Napoli e Roma, Naples (exhibition cat.), Florence 1983, no. 442.
C. Pedretti, ALV Journal, II, 1989, pp. 40–67.

Leonardo da Vinci The Artist

by Otto Letze

Many art historians regard Leonardo da Vinci as the quintessential Renaissance figure. Yet even a definition as broad as that evidently imposes too narrow confines on Leonardo when we consider the sheer opulence and enduring worth of his output. He does not lend himself to association with any given era, he defies categorization, and the more we find out about him, the more enigmatic he becomes. Which raises the question of his identity as an artist. Leonardo himself ridiculed the "trumpeters and declaimers", the "sycophants" in the Vatican and the "smug intelligentsia" at the courts. He despised their meager gifts and derided them for "merely citing precedents and relying on their memories in the absence of an independent mind". Leonardo's fellow artists in turn decried him as no more than a "contriver", too untutored to understand anything of scholarship.

The fact is that Leonardo did not — in modern parlance — have a secondary education, let alone a university degree. He picked up his knowledge piecemeal, by observation, by reading and by asking pertinent questions.

Leonardo was at loggerheads with the art market and wealthy merchant-class patrons of his day. When his wilfulness finally exasperated the Medicis, he moved to the Milanese court but during his sixteen years in Milan his commissions (apart from a few minor portraits) numbered no more than two large-scale projects: "The Last Supper" (see page 54) and the equestrian statue for Francesco Sforza. He painted "The Virgin of the Rocks" as a subcontractor of the de Predis brothers. Then he spent four years in Rome without picking up a single commission, which earned him the derision of Giuliano de Medici. This, then, was the much-vaunted Italian High Renaissance as Leonardo experienced it. A man who ranks as one of Italy's greatest painters, bequeathed to posterity the quantitatively smallest output quite simply because commissions failed to materialize. Unlike today, it was not customary in Leonardo's time for an artist to paint a picture on his own initiative.

"The painter enters into a dialog and rivalry with Nature," Leonardo once wrote. An untiring explorer of the world around him, he came to view painting as a science whose scope extended far beyond mere reproduction. He saw in his paintings and drawings an approach to rolling back the frontiers of human knowledge and paving the way for an overall perception of the world.

Leonardo sought the answers to his questions in his drawing, which eventually grew into a scientific method. His objective was to progress from experiment to insight and thus to perceive the "world" as a universe. As soon as Leonardo had hit upon the answer to one question, his questing spirit impelled him to tackle a new problem. This explains why he left so many of his paintings unfinished or completed them only at the insistence of his patrons. The present exhibition focuses on Leonardo's abilities as a scientist and inventor, but he drew substantially on these in his painting. This publication therefore provides a brief survey (beginning on page 28) of his important works of art not included in the exhibition. They will supplement the visitor's understanding of Leonardo and serve as a basis for relating his output to that of his successors and students. The present publication, then, is a compendium of the life and work of a great man.

Leonardo da Vinci and Andrea del Verrocchio
The Baptism of Christ

ca. 1472–73
Oil and tempera on panel
176.9x151.2 cm
Uffizi Galleries, Florence

In terms of its conception and much of its execution, this painting has been established as Verrocchio's work. Leonardo, who was still apprenticed to Verrocchio around 1472, later added the left-hand angel and overpainted part of the background. There are evident technical distinctions between the work of the teacher and that of the student. Verrocchio painted in conventional tempera while Leonardo employed oils, which were not yet in widespread use.

The foreground shows John the Baptist baptizing Christ in the River Jordan. Two angels are watching the baptism. The dove – representing the Holy Ghost – above Christ's head is flanked by the hands of God. The middle ground is occupied by a rugged landscape of rocks, trees and a palm. The course of the River Jordan guides the eye towards the back of the picture and the horizon of hills, cliffs and woods, which despite their distance are picked out in considerable detail.

The composition of Verrocchio's painting is built up around three vertical axes: Jesus in the center, John the Baptist on the right, and the palm tree on the left. The river bank in the foreground and the various pictorial elements in the middle ground – the rocks, the trees, the divine symbols in the middle axis, and the bird flying off to the right – complete the scene without relating immediately to the group of figures.

Disrupting Verrocchio's compositional scheme of pictorial elements arranged laterally or one in front of the other, Leonardo shows his angel in a three-quarters view from the back. The angle of the body of the kneeling figure on the left, in conjunction with the bent leg, forms a diagonal pointing to the bottom left corner of the picture. This effect is enhanced by the folds of the fabric. The diagonal relieves the stiffness of the arrangement of the other motifs and creates a greater sense of depth.

The background landscape which Leonardo overpainted contrasts starkly with the rugged outlines of the middle ground. In his representation of nature, Leonardo takes account of the effects of light and aerial perspective. He is more successful than his teacher in revealing a whole new world of visual experience. By abandoning the schematic conventions of landscape portrayal, he is able to achieve a more naturalistic depiction. His drawing of the Arno landscape (see page 67), dating from the same year, provides particularly clear evidence of this process.

In the juxtaposition of Leonardo's and Verrocchio's work we witness not only the clash of two contrasting stylistic approaches to pictorial representation – a contrast which heralds the advent of the High Renaissance – but also two different techniques of painting. A goldsmith by craft who later concentrated principally on sculpting in bronze, Verrocchio perceives pictorial objects as if their outlines had been fashioned with a knife, investing their contours with a hard, sharply-defined quality associated with drawing. The palm tree on the left of the picture is a case in point. Verrocchio's manner of pictorial representation is reminiscent of the techniques of engraving or chasing: the style of bringing out the plastic contours of objects as dictated by the use of chisel and cutter.

Leonardo, by contrast, uses fluid shading and the play of light and shadow to convey a sense of figural fullness. He deliberately softens sharp contours, employing a technique specific to painting as Wölfflin understood the term.

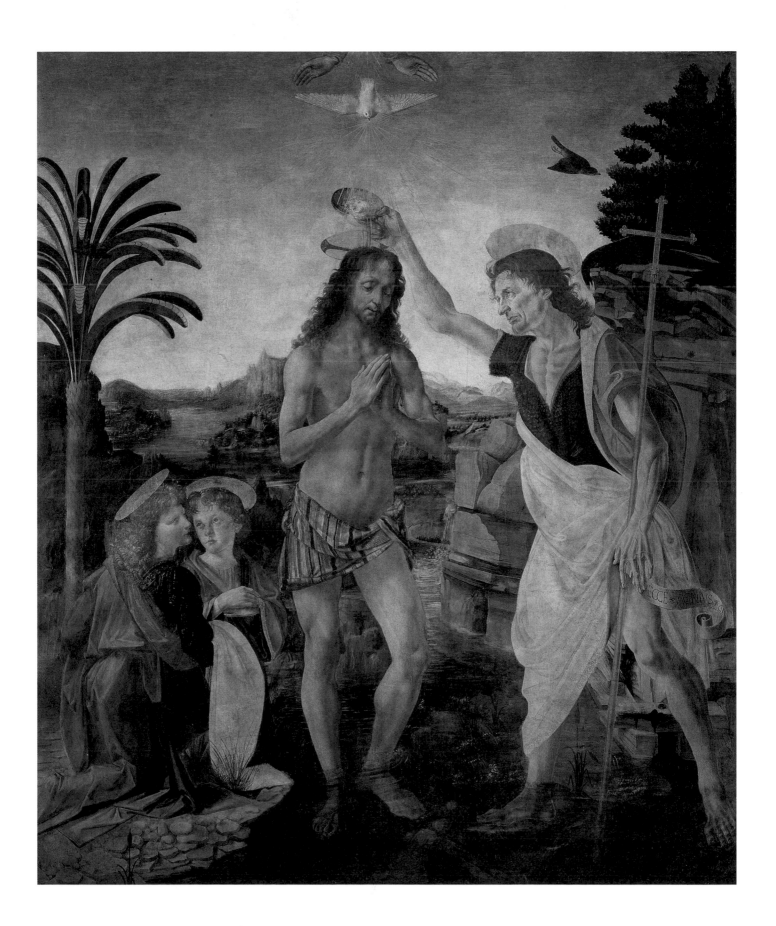

Leonardo da Vinci (attribution)
The Annunciation

ca. 1475
Oil and tempera on panel
98.4×217.2 cm
Uffizi Galleries, Florence

The Uffizi acquired this painting in 1867. There is no hard and fast evidence to support its exclusive attribution to Leonardo, and it may rather be regarded as testifying to the practice common in the Renaissance by which several artists collaborated on a single picture. The question of attribution is relativized by the juxtaposition of varying stylistic elements in late fifteenth-century Florentine painting within this one picture.

The subject of the painting is the Annunciation to the Virgin Mary by the Archangel Gabriel. The encounter takes place in a garden surrounded by a wall. This "hortus conclusus" symbolizes the enclosed garden of the "Song of Songs" and represents the Immaculate Conception of the Virgin. Between Mary and the angel stands a lectern with an open book which she had been reading when Gabriel appeared. In iconographic terms, the book denotes the wisdom of Mary. The kneeling angel has raised his right hand in benediction. In his left hand he is holding a white lily, a symbol of virgin purity. Mary is staring at the angel, and her whole bodily posture — the slight movement of starting back emphasized by the hesitant lifting of her left hand — shows her to be astonished and anxious.

The foreground figures belong to two distinct areas, and this duality appears to be reflected in the landscape behind them. The wooded background seen behind the angel contrasts with the solid architectural construction on Mary's half of the picture. The garden wall with its opening to the woods beyond links the two contrasting pictorial elements. The perspective tapers to a mountainous riverside landscape in the distance.

If we follow the straight lines to their vanishing point, they converge in the upper third of the picture precisely on the vertical central axis. Mary and the angel are equidistant from this central axis. In terms of the central perspective, the picture's spatial composition is correct — indeed pedantically so — throughout. The painting is divided into two virtually unrelated halves not only by the group of two figures but by the composition as a whole.

As is the case with the "Baptism" (see page 29), the most convincing part of this painting is its background landscape, which is unanimously attributed to Leonardo. The treatment of the vanishing point also suggests Leonardo's early mastery of the reproduction of pictorial space. He lets the lines of perspective converge virtually in nothingness, and in the radiant mountain backdrop there is no hint of a "horror vacui", the artist's fear of infinite pictorial depth. Even in this narrow strip of landscape, Leonardo manages to evoke a naturalistic atmosphere.

The "Annunciation" acquired by the Louvre in 1861 probably dates from only slightly later. Its format suggests that it was originally a predella painting. The motifs bear a close similarity to those in the Florentine "Annunciation", but in the Louvre painting the problems posed by the spatial composition and by the individual pictorial elements are solved more satisfactorily. The later painting is not devided into two halves. It focuses effectively on the moment of the annunciation as such, while all the other motifs are less dominant.

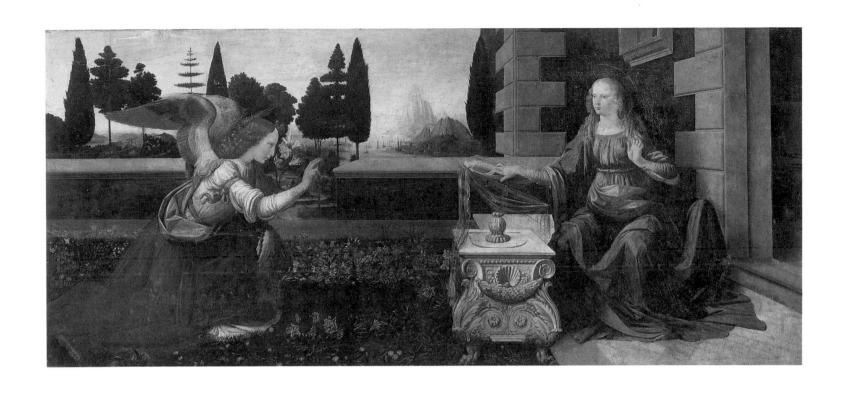

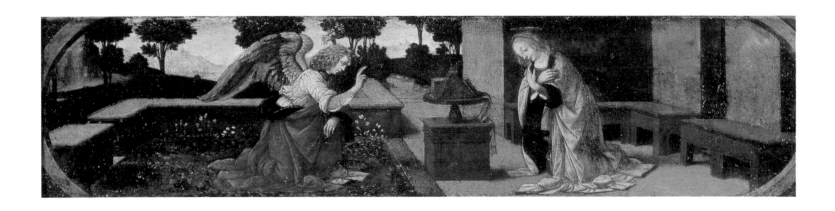

Leonardo da Vinci and students of Verrocchio (attribution)

The Madonna with the Carnation (The Madonna with the Vase)

ca. 1475–77
Oil on panel
62.9x47 cm
Bayerische Staatsgemäldesammlungen
Alte Pinakothek, Munich

While the middle ground consists of a Renaissance structure with round-arch windows opening on to a rugged mountain backdrop, the figures are placed at the front of the picture. The composition of the figures is pyramidal. The seated Madonna, who is turning her head to the left to look at the Child on her lap, is holding out a red carnation, a symbol of pure maternal love. The Child is reaching awkwardly for the flower. A vase on the right of the picture balances the composition by acting as a counterweight to the figure of the Madonna, which is slightly out of line with the central axis.

There is evidence of Leonardo's involvement in the following two aspects of the painting: Mary's blue cloak is folded over on her lap, its yellowish-golden lining catching the light in a way reminiscent of the Florentine "Annunciation" (see page 31); and the perspective of the Child's left arm, extended towards the spectator, is radically foreshortened, a mirror inversion of a motif that recurs in the "Madonna Benois" (see page 37). However, the various pictorial elements (Madonna, vase, architecture, landscape), although homogeneous in themselves, appear somewhat arbitrarily juxtaposed and fail to convey a sense of natural contiguity. A comparison with the "Madonna Benois" makes this clear.

On the basis of the above evidence, the painting is widely believed to have been begun by Leonardo and subsequently continued by other students of Verrocchio. The difficulties of corroborating an attribution to Leonardo are aggravated by the fact that his early output is barely documented by drawings or written records.

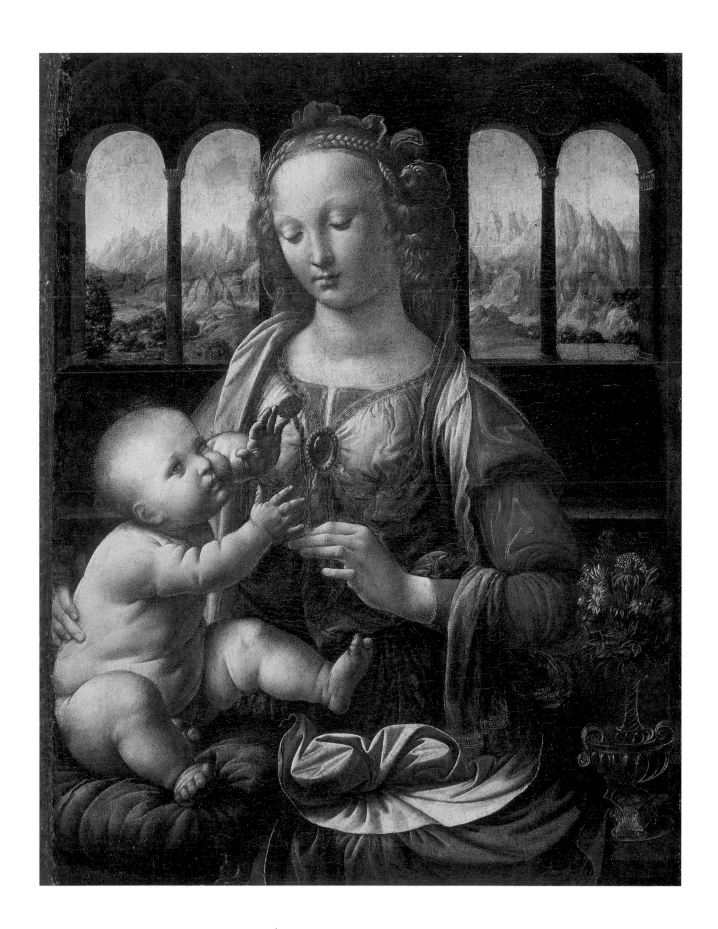

Leonardo da Vinci (attribution)
Ginevra de' Benci

1475–80
Oil and tempera on poplar
38.8 x 36.7 cm
National Gallery of Art, Ailsa Mellon Bruce Fund,
Washington, D.C.

This picture has been described as the first psychological portrait. Although it is an early painting, Leonardo succeeds not only in creating a lifelike reproduction of the young woman's features but, over and above this, also initiates a wordless question-and-answer game between the subject and the spectator: the picture and its observer enter into a reciprocal dialog.

Probably Leonardo's first portrait commission, it is one of his best-preserved paintings, although it has been trimmed along the bottom edge. The landscape in the far distance clearly betrays correlations with Flemish painting. The face of Ginevra de'Benci stands out starkly against the juniper bush, which occupies the greater part of the picture's surface. The bush is also an allusion to the subject's name, juniper being "ginepro" in Italian. The daughter of the banker Amerigo de' Benci, she married Luigi di Bernardo Niccolini in 1474. Numerous sonnets eulogize her beauty (she was herself a noted poetess). Lorenzo de Medici, who was much taken by her, dedicated two poems to her in which he sang the praises of her beauty and virtue. In the latter years of the Quattrocento it was customary to epitomize virtue in female portraits, and a whole symbology of female virtues had emerged. In his portrait of Ginevra de' Benci Leonardo continues this tradition, taking it one step further than his contemporaries.

The picture on the reverse is painted on an illusionistic background of porphyry marble, a symbol of the constancy of Ginevra's virtue. A ribbon with the inscription "virtutem forma decorat" (beauty is the embellishment of virtue) is entwined around sprigs of laurel (an allusion to her poetic aspirations) and juniper (a further reference to her name) and a palm frond (a traditional symbol of virtue). Leonardo's portrayal of virtue, then, has two distinct levels: the less ambitious reverse with the afore-mentioned attributes and inscription; and the aesthetically more ambitious portrait itself, in which painted beauty articulates virtue. Leonardo set out to dispense with any kind of conventional attributes or symbols in painting by seeking to capture traits like virtue, beauty and constancy in the individual expression of his portraits. The starting-point for this quest was his knowledge of physiognomy and anatomy. The most striking case in point is the "Mona Lisa".

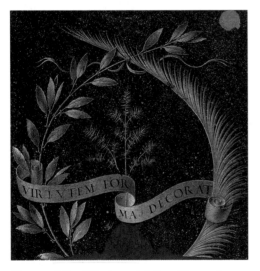

Verso of the "Ginevra de' Benci" panel
ca. 1475–80
Oil and tempera on poplar
38.8 x 36.7 cm
National Gallery of Art, Ailsa Mellon Bruce Fund,
Washington, D.C.

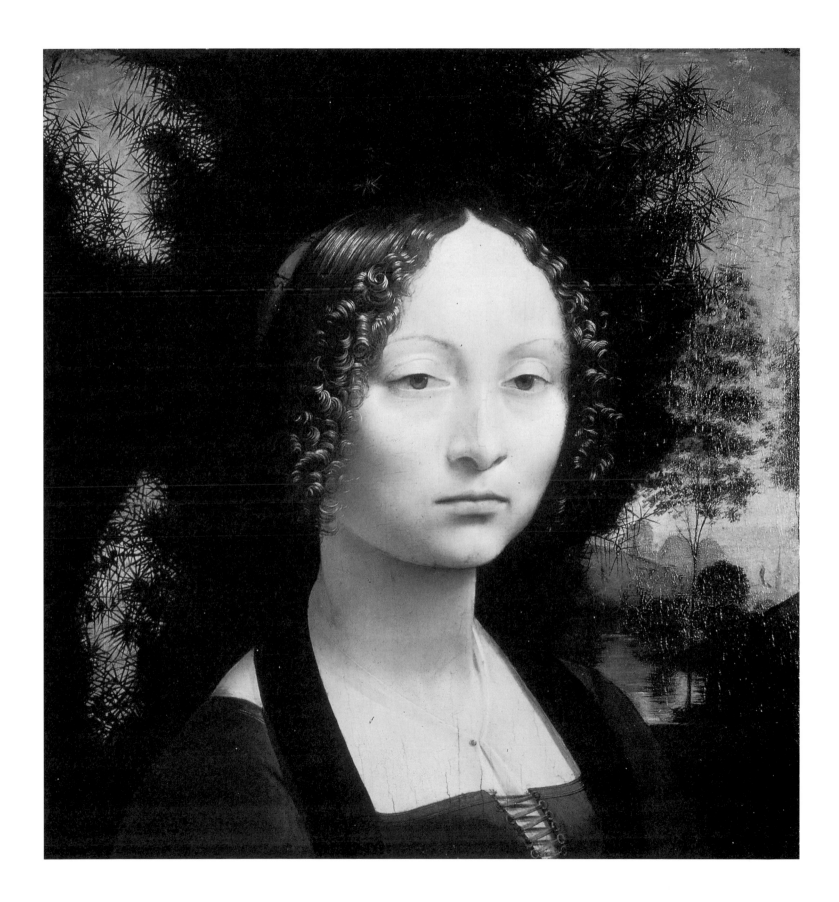

Madonna Benois

Begun ca. 1478
Oil on canvas (originally panel)
49.6 x 31.5 cm
Hermitage, St Petersburg

Preparatory drawings corroborate the attribution of this picture to Leonardo. It sustained minor damage when it was removed from its original wood mounting and transferred to canvas. The damaged areas were painted over.

The Madonna and Child are seated on a bench which marks the bottom edge of the picture. The round arch closing off the top focuses attention on the two figures, who occupy most of the picture. The central vertical axis runs precisely between the two figures. Mary, slightly to the left of center, is holding the naked Infant Jesus on her lap, supporting him with her left hand and holding a flower in her right. Jesus is reaching for the blossom with his right hand and is stretching out his other hand to hold on to his mother. This game with the flower constitutes the picture's key motif. The three hands and their gentle interplay make up the center-point of the composition.

Mary is clad in a flowing, elaborately draped blue robe with a red skirt and sleeves. She wears a brooch at her neck, and her loosely curled hair is carefully plaited. Many of the pictorial and compositional features are reminiscent of the "Madonna with the Carnation" (see page 33). The deeply-felt affection which Mary's facial expression articulates looks ahead to the depiction of the Virgin in the Florentine "Adoration" (see page 41). However, the mother-with-child group in the present picture possesses greater intimacy and homogeneity. Nothing distracts the spectator's attention from the two figures, whose glances and gestures all remain within the confines of the picture's inner reference.

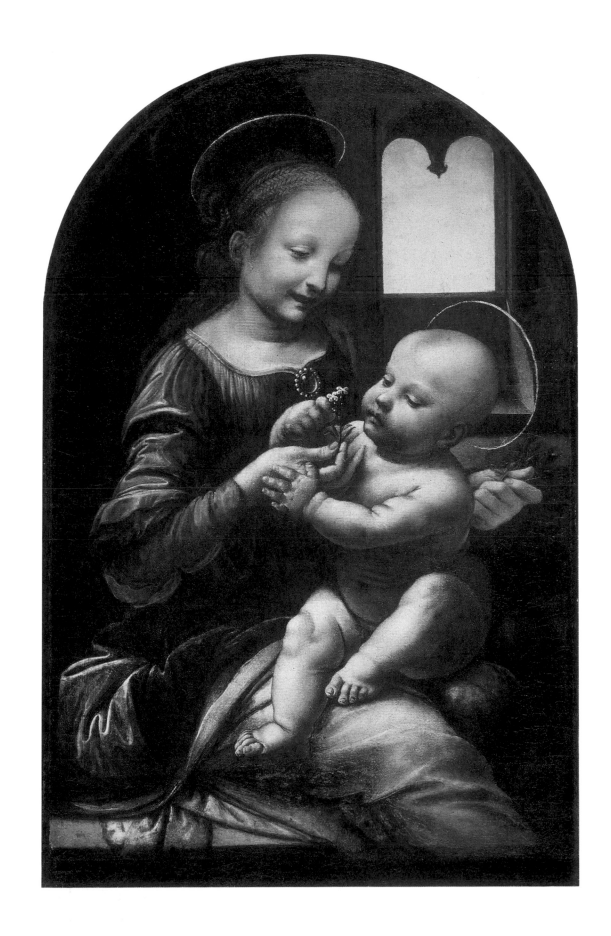

St Jerome

ca. 1481
Oil on panel
103.2 x 75 cm
Vatican Museums, Rome

St Jerome was one of the Fathers of the Roman Church and is credited with having translated the Bible into Latin. In iconographic terms St Jerome, who lived the life of a hermit and founded a monastery and a school in Bethlehem, conventionally represents the combination of scholarship and stringent asceticism. Legend has it that he once extracted a thorn from a lion's paw, after which the lion became his loyal companion. Many pictures of St Jerome include the lion.

Early documents and copies underpin the attribution of this painting to Leonardo, and its authenticity has never been questioned. The picture, which is unfinished, dates from his first period. At some stage it was sawn into pieces – traces of the joints are still visible – but all the constituent pieces have fortunately been preserved.

St Jerome occupies the exact center of the picture. He is kneeling in a crouched position on the bare ground. His emaciated body is clad only in a cloth. The lion on the right of the foreground is turned towards him. A mountainous background is hinted at, and on the right an opening in the rocks reveals a sketched architectural structure.

The treatment of perspective evinces great skill throughout. Leonardo forgoes the conventional technique of employing an architectural setting and vanishing lines to establish the central linear perspective. Jerome and the lion are located on a diagonal crossing the picture towards the top left corner. It is exclusively the effect of movement and counter-movement within the individual bodies and in their interaction that creates the sense of depth. The lion is lying stretched out on the ground. Its head, which is turned towards Jerome, and its tail, which forms a semicircle curling smoothly towards the bottom left corner of the picture, form a gentle S-shaped curve. Jerome's legs, the upper part of his body and his left arm are turned almost frontally to the spectator and are thus substantially foreshortened for reasons of perspective. This foreshortening contrasts vividly with the figure's outstretched right shoulder, which is prolonged to the clenched fist on the left edge of the picture. The extended arm emphasizes the body's forward movement and at the same time forms a contrary diagonal pointing to the top right corner. This latter diagonal is reinforced by the angle of the lion's body, which runs parallel to it.

The focal point of the picture is Jerome's head. The execution of his facial features bears witness to Leonardo's interest in skeletal and muscular anatomy and the individuality of – frequently ecstatic – facial expression.

Leonardo largely completed the posture of the head and the facial expression, whereas other parts of the picture must rank as no more than preliminary sketches. The look on Jerome's face and the gesture of his body, his contorted expression, his outstretched arm and his fist – clasping a stone which he will hammer against his chest in self-castigation – articulate the saint's suffering in terms of dynamic action. We do not witness him lost to the world in his ascetic isolation, but rather we are challenged to share his passion by the frontal immediacy of the portrayal.

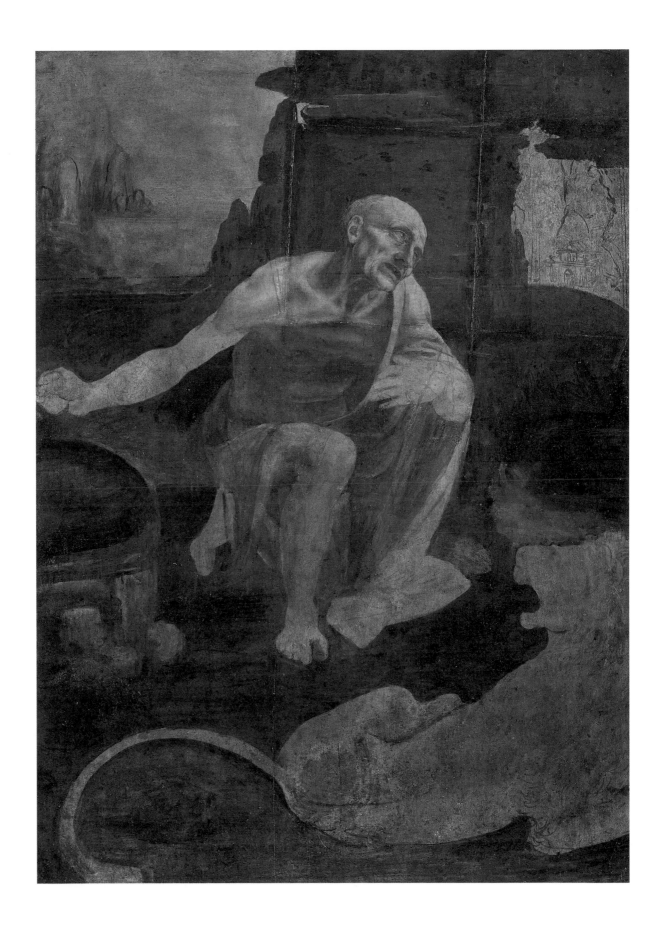

The Adoration of the Magi

1481
Oil on panel
246.7 x 243.5 cm
Uffizi Galleries, Florence

In 1481 the monastery of San Donato a Scopeto near Florence commissioned from Leonardo a painting for the high altar of their church. Leonardo's father, who was in close touch with the monks of San Donato, acted as intermediary. The contract which Leonardo signed contained some extremely curious terms. Basically, the monks wanted something for nothing, and they inserted in the contract a number of elaborate clauses which stipulated that Leonardo would be paid by a merchant closely associated with the monastery but that, once he had received his money, Leonardo would be obliged to contribute to the dowry of the merchant's daughter. Leonardo was further required to pay for the paint and gold leaf out of his own pocket. These adverse terms do not, however, appear to have deterred Leonardo. The painting did not progress beyond the brownish lay-in, although numerous preliminary studies testify to Leonardo's keen interest in the subject. Having admonished him several times to complete the picture, the monks finally terminated their payments. Fourteen years later the monastery engaged the services of Filippino Lippi, who supplied an altar picture of the same proportions in the following year. When Leonardo set off for Milan, he left the panel unfinished. Today both it and Filippino Lippi's painting are in the Uffizi in Florence.

Mary and the Infant Jesus occupy the center of Leonardo's picture. She is surrounded by several groups of figures lending the scene a quasi-theatrical vitality. The ruined architectural structure on the left is a traditional component of the subject, but Leonardo enriches it with a number of new motifs. The battle scene on the right is attested by sketches and appears to anticipate the dynamism of the "Battle of Anghiari". The depiction of a battle may seem incongruous on a picture of the Adoration, but there are historical precedents: a small panel portraying the Adoration in the Florence Barghello, for instance, has a fight between two rearing horses as part of its background. Unlike paintings on the same theme by Gentile Fabriano or Benozzo Gozzoli — which Leonardo must have known — the figure of the Virgin Mary is here once more placed at the center of the scene. Her head, inclined slightly to one side, is located in the very middle of the picture. The corner diagonals point precisely to her right temple. The diagonals set up a triangle resting on the bottom edge, its apex in the center of the composition.

The Virgin Mary and the Infant Jesus have no halos, the kings no crowns. It is their emanations that define them. On closer scrutiny we can distinguish twelve separate groups which — in Leonardo's terms — are identifiable by their intrinsic values and not by external characteristics such as background, vocation or social standing. Taken together, they bear witness to Leonardo's views on human existence in all its diversity.

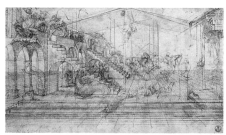

Architectural study with figures for
"The Adoration of the Magi"
ca. 1480
Pen and ink, bistre, heightened with silverpoint
and white
163x290 mm
Uffizi Galleries, Gabinetto dei Disegni
e delle Stampe (436 Er), Florence

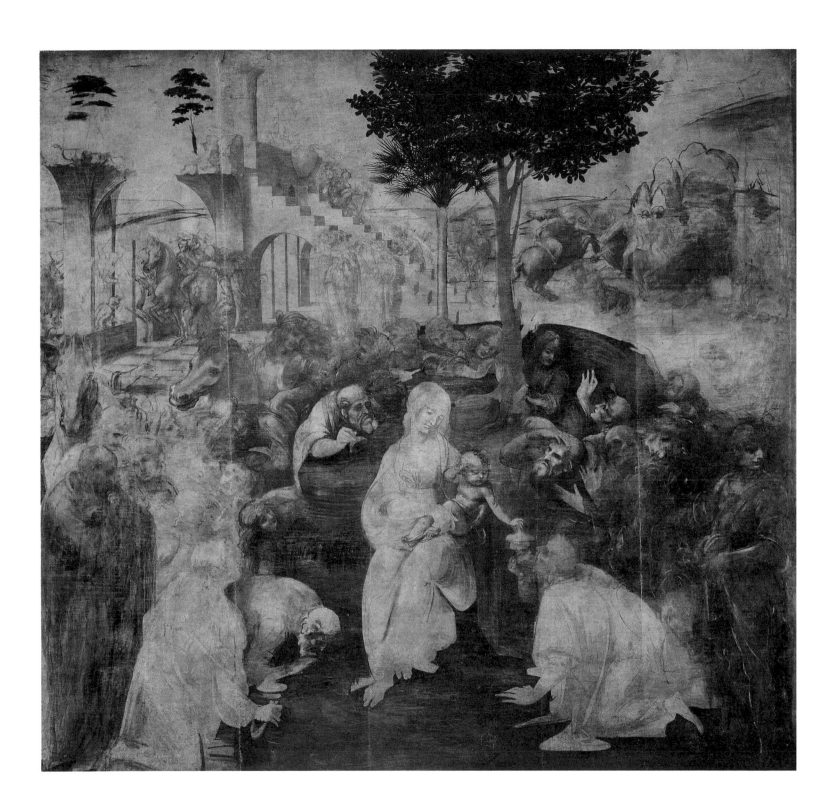

The Virgin of the Rocks

1483—85
Oil on canvas (originally panel)
198.1x123.2 cm
Louvre, Paris

Leonardo acquired his first major commission in Milan indirectly, through the workshop of the de' Predis brothers who were better businessmen than artists. The contract, issued by the Confratelli della Concezione and dated April 25, 1483, provides for the painting of an altar picture for the order's chapel in San Francesco il Grande. The Parisian version of the Virgin of the Rocks bears strong traces of the Florentine style, and one is tempted to speculate that Leonardo might have painted it while still in Florence and used it for the Concezione altar. However, given that Leonardo worked extremely slowly and sometimes failed to finish pictures even when he was bound by contractual obligations, it seems unlikely that he would have painted a picture without a specific commission to do so.

Despite the obvious Florentine elements in the painting, it introduces a number of new approaches. The subject is associated with the theme of the Immaculate Conception, which was highly revered in Milan at the time. Moreover, we often forget that this painting is just a small part of the whole project, so accustomed are we to seeing it hanging on a gallery wall. But the original setting in the Concezione church was a monumental altar in carved wood of the kind then customary in Lombardy. The "Virgin of the Rocks" was designed to be inserted in a blank area framed by wood carvings and flanked by four angels singing and playing instruments. Incidentally, the contract stipulated that Leonardo and the de' Predis brothers were to paint the wood carvings. That Leonardo would have deigned to work as an artisan, gilding and painting picture frames, pillars and reliefs, seems irreconcilable with our modern-day view of him. The present picture, set amongst resplendent frames and reliefs, must have appeared like a challenge issued by a man determined to assert his artistic independence.

The perspective of the present painting is designed to achieve a sense of depth. The figures are recessed slightly from the foreground. Mary's arms, spread out in pyramidal form, and the angel's finger pointing at the Infant John, seem to divide the space in various directions. The picture is pervaded by shadow and the delicately fashioned play of light. Leonardo may possibly have been alluding to a passage in the Protoevangelium of James which reads: "A cave was miraculously transformed into a mountain to afford refuge to the infant John and his mother Elizabeth." In Florence this motif was taken up by the organizers of nativity plays — with whom Leonardo was in contact — and soon became fashionable in portrayals of the infant John with Jesus.

The later London version of the same subject is a development of the theme. The figure of Mary has greater bodily presence and volume. The Infant Jesus is nestling against her. The landscape on the left of the picture makes wider use of "sfumato" technique, Leonardo having progressed further in his studies of the blurring effect of light and distance on the outlines of objects. His revised view of the subject inspired many other artists to attempt imitations and developments.

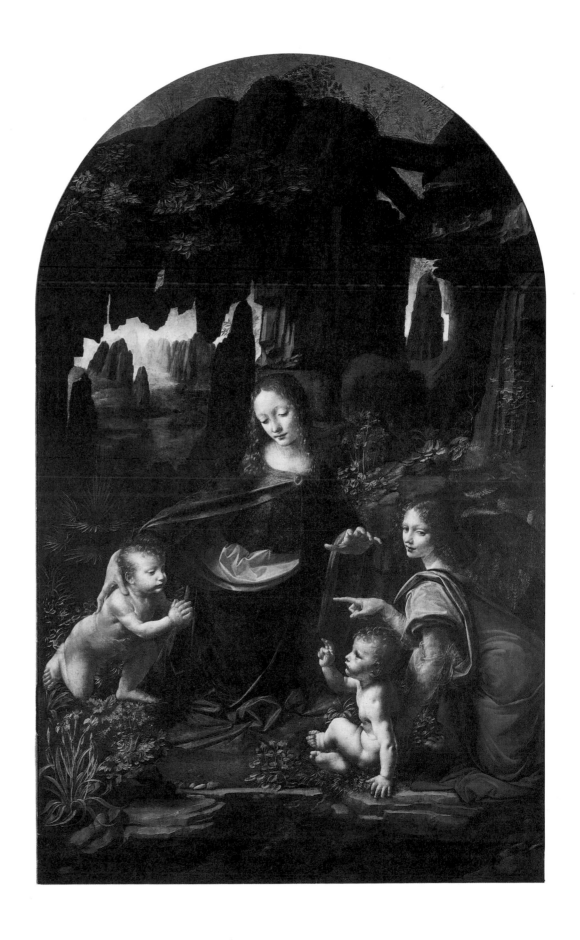

Leonardo da Vinci and pupils
The Virgin of the Rocks

ca. 1486–90, 1506–08
Oil on panel
198.5x120 cm
National Gallery, London

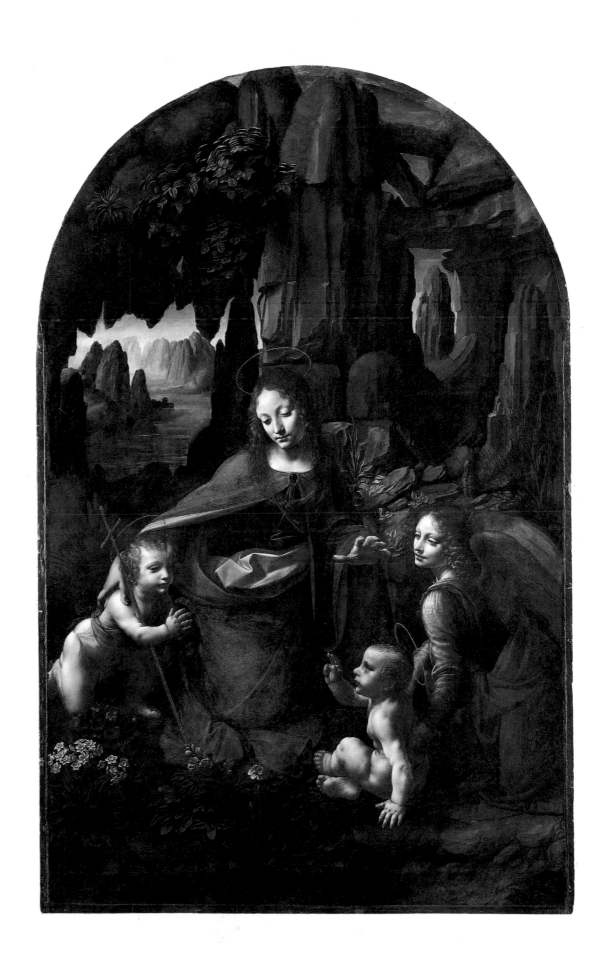

The Virgin of the Rocks

Leonardo da Vinci and pupils

ca. 1495
Oil on canvas
168x140 cm
Private collection, Switzerland

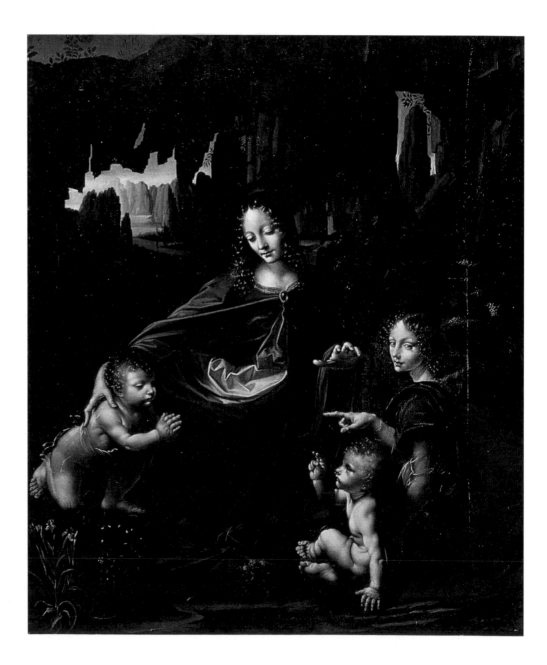

Anonymous North European Artist

ca. 1495
Oil on canvas
119.5x144.5 cm
National Museum of Art, Copenhagen

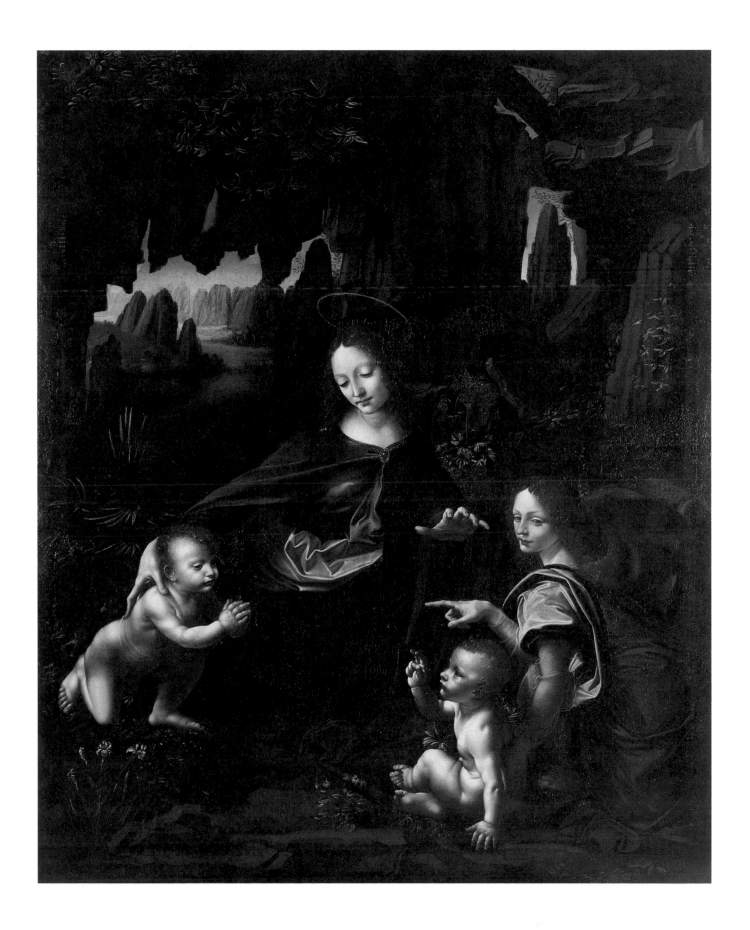

The Lady with the Ermine (Cecilia Gallerani?)

1483–90
Oil on panel
56.2 x 40.3 cm
Czartoryski Muzeum, Cracow

Art historians are now unanimous in both the dating of this portrait and its attribution to Leonardo. The subject has been identified as Cecilia Gallerani (born in 1464), the mistress of the Duke of Milan, Lodovico il Moro, to whose son she gave birth in 1484.

In a sonnet by the court poet Bernardo Bellincioni, Leonardo is named as the painter of the portrait. The same sonnet describes the young lady depicted as appearing to listen rather than to speak. In 1498 Cecilia Gallerani wrote in a letter to Isabella d'Este that the portrait no longer resembled her.

The almost mannerist fashion in which the figure's head is turned shows Leonardo introducing a new concept of portrait painting. He was later to pursue this motif with greater sophistication in his "Madonna of the Yarnwinder". Cecilia Gallerani is here seen holding a stoat, the Duke's heraldic animal and a symbol of virginity, cradled in her arm. The fashioning of the right hand and of the stoat are indicative of Leonardo's detailed knowledge of anatomy. The animal's fur is also executed with enormous care. Leonardo succeeds in conveying the stoat's untamed and nimble-footed nature and yet in investing the animal with a certain heraldic dignity. The almost serpentine twist of the stoat's body matches the afore-mentioned turning of Cecilia Gallerani's head. This feature distinguishes the present painting from other portraits of the time.

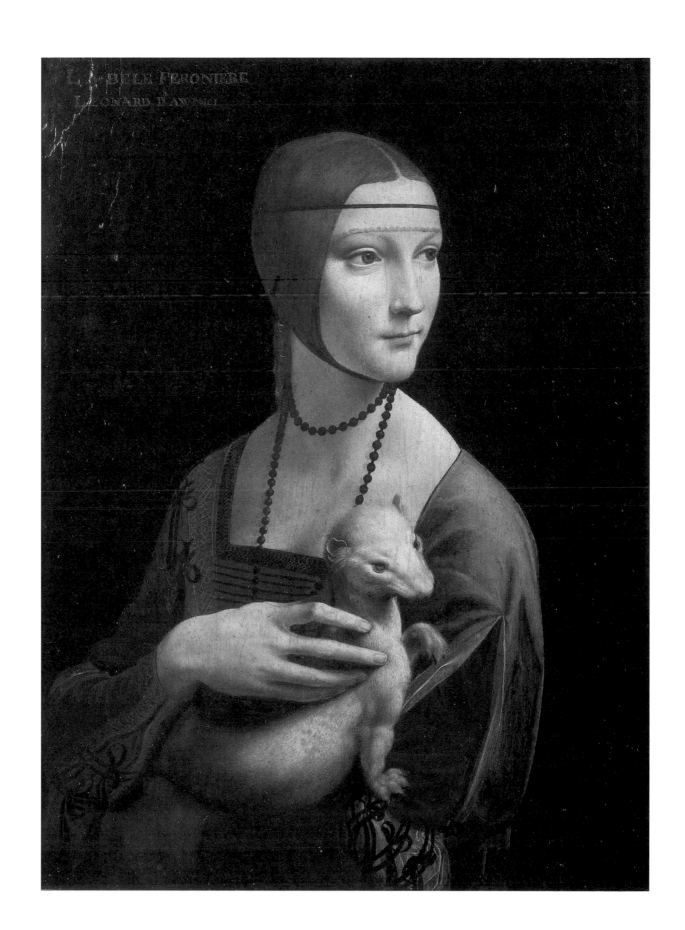

Leonardo da Vinci (attribution)
Madonna Litta

ca. 1490
Tempera on canvas (originally panel)
41.9 x 33 cm
Hermitage, St Petersburg

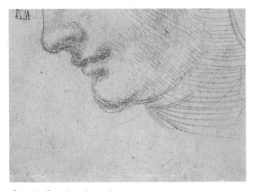

Study for the head
Metalpoint
64 x 89 mm
Städelsches Kunstinstitut, Frankfurt
Graphische Sammlung (6954v)

No other picture in the canon of Leonardo scholarship has given rise to such irreconcilably conflicting views as the "Madonna Litta". The expert assessments advanced range from certain attribution to the outright negation of any involvement on Leonardo's part. The sheer disparity of such scholarly estimations offers further evidence of the — perhaps insurmountable — difficulties with which the whole issue of Leonardo attributions is fraught. A study of a chin by Leonardo in the Frankfurt Städel (left) may have served as a preliminary sketch for the profile of the Madonna on the present painting. In this case Leonardo may have been responsible for the original conception of at least parts of the picture. The overpainting of several areas at various times further aggravates the problems of identification.

The overall composition with the Mother and Child in the foreground, round arches in the middle ground, and a mountain landscape in the background is reminiscent of the "Madonna with the Carnation" and the "Madonna Benois" (see pages 33 and 37).

The motif of the Virgin Mary in the guise of "Maria lactans" breast-feeding her child was widespread, notably in the Late Middle Ages. Here the Madonna is holding the naked Child in front of her with both hands, her left breast bared. The child's upper body is nestling against his mother's body. His eyes are gazing out of the picture. The Madonna's head is seen in three-quarter profile, which distinguishes her from previous Leonardo Madonnas.

In his left hand Jesus is holding a tiny goldfinch. Barely visible in the shadows cast by the two human figures, it points forward to the destiny that awaits the Child later in life. Birds are a common biblical symbol of people in distress, suggesting as they do the anguish of the hunted prey. Moreover, the goldfinch feeds on thistles, an additional pointer to the Passion. In Christian iconography, thistles rank among the plants associated with the crucifixion.

The bird is placed exactly on the picture's central vertical axis. Although concealed, it occupies a highly exposed position. Its symbolic significance invests the human figures with an additional layer of poignant meaning. Mary, ignorant of her son's later fate, is free to lavish all her affection on him. Christ holds his destiny in his hand, as it were, in the form of the tiny bird. His gaze, directed towards the spectator, is a challenge to reflect upon the meaning of the Passion for mankind.

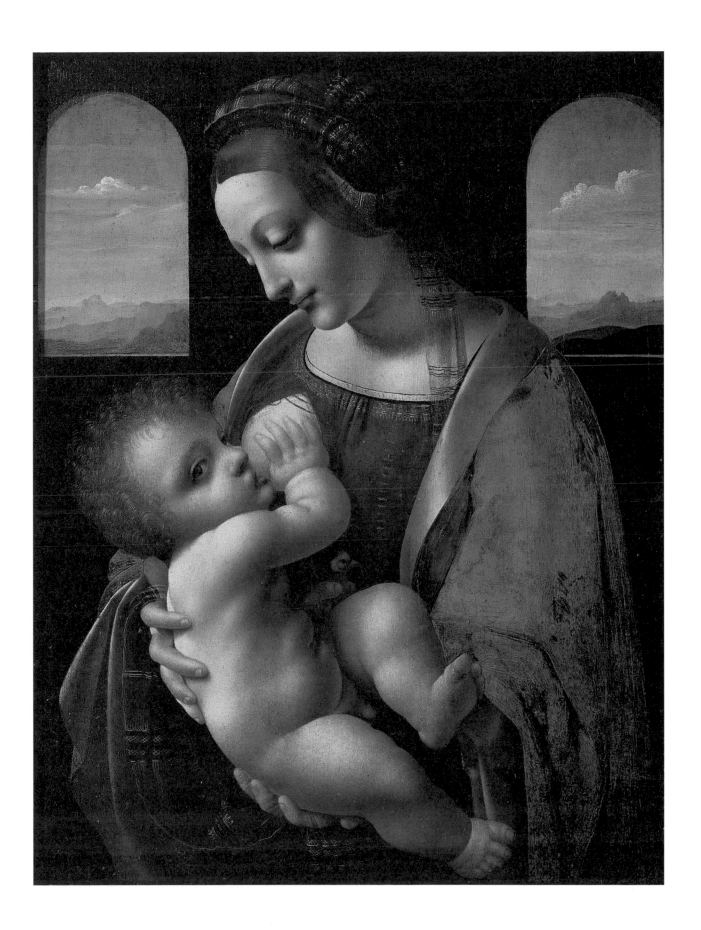

Leonardo da Vinci (attribution)
La Belle Ferronière

ca. 1490
Oil on panel
62.3x44.2 cm
Louvre, Paris

The picture's title refers to one of Henry II's mistresses, although the lady actually portrayed is somebody quite different. The picture was entered in an early inventory under this name, and the error has never been amended. The subject of the present portrait remains unidentified. Here again, the attribution to Leonardo is uncertain. The only point upon which unanimity exists is that the picture dates from the last decade of the fifteenth century.

This female portrait reflects a courtly milieu. The lady is seated behind a balustrade, a characteristic feature of Florentine painting. Only the upper part of her body, inclined slightly to the right of the central vertical axis, is visible. The background is veiled in darkness, obscuring any features that might identify the room behind her. Great attention has been lavished on the subject's clothing and jewellery, an indication of the artist's love of detail. The subject's posture is reminiscent of the "Mona Lisa", painted a good decade later.

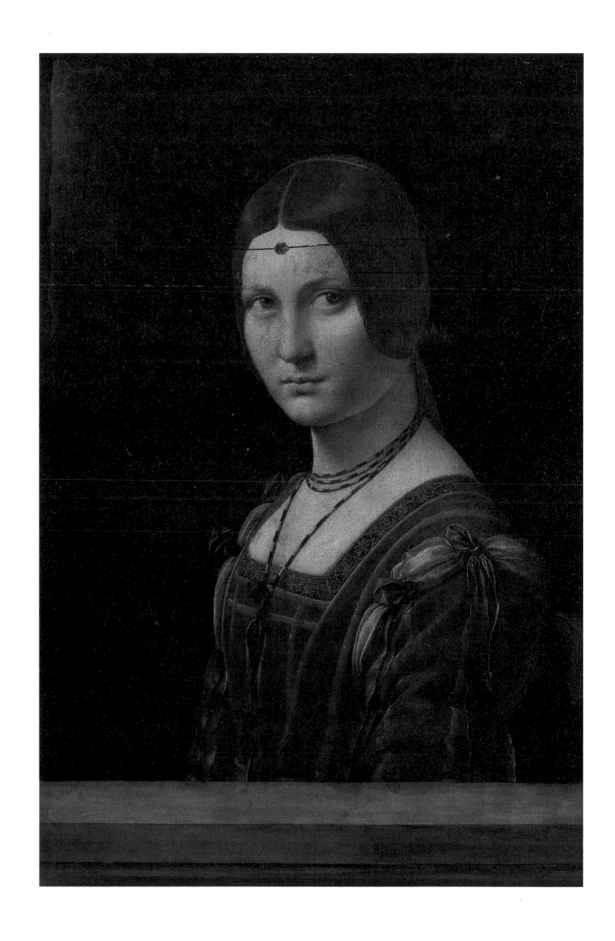

The Last Supper

1495–97
Oil-tempera mix, fresco
422×904 cm
Refectory of S. Maria delle Grazie, Milan

Alongside the "Mona Lisa" (see page 61), "The Last Supper" is Leonardo's most famous painting. As early as fifty years after its completion, Vasari described the fresco as a confusion of blotches. The ruinous impression which this painting still conveys today is largely the result of Leonardo's attempt to paint it using a new technique. Prior to this point in time, wall-paintings were executed "al fresco" in the wet plaster and thus adhered to the plaster layer. Leonardo attempted to paint "The Last Supper" in an oil-tempera mixture, but the painting was unable to resist the accumulating damp and flaked away from the wall piece by piece. Today the hues are almost entirely faded and the ornamental details are nearly completely lost. Retouching over the centuries has progressively reduced the essence of the painting. Extensive conservation and restoration measures have been carried out in recent decades.

"The Last Supper" in the Dominican Monastery of Santa Maria delle Grazie is Leonardo's main work from his Milan period. The theme of the Last Supper was a subject of debate during the 15th century in connection with the participation of the laity in the Eucharist. Contrary to the tradition, Leonardo chose the moment at which Jesus announces to his disciples that one of them will betray him. Judas is represented neither as a heretic nor is placed in isolation on the outer rim of the table, as in Castagno's painting. He shrinks back and listens to the animated discussion of the others, but without protesting. The group is characterized by a variety of gestures and expressions never previously achieved in painting. Although the Apostles are placed in four distinct groups of three, in which Leonardo has contrived a sense of spontaneity, they remain connected with one another through their various gesticulations. In many respects Leonardo broke with the tradition of the Quattrocento. The traitor among the Apostles is not yet discernible. Neither is John portrayed sleeping, as Leonardo had drawn him in his preliminary sketch, but is actively engaged in the general round of questioning which appears to consume all of those present. The viewer senses the inner conflict and tension within the group from which only Christ in the center can provide deliverance.

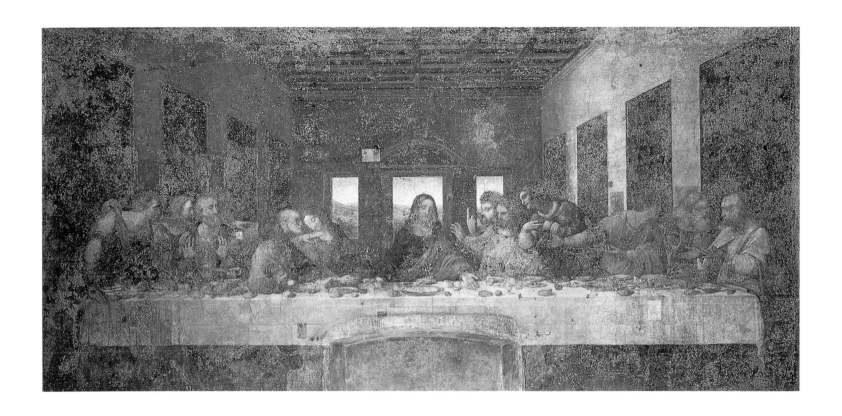

The Virgin and Child with St Anne and St John the Baptist

Burlington House Cartoon
ca. 1499–1500
Black chalk and white lead on cardboard
141.3x104 cm
National Gallery, London

This portrayal of "The Virgin and Child with St Anne and St John the Baptist" is unfinished. The cartoon was intended as the preliminary sketch for a painting and we may assume that Leonardo was commissioned to undertake the cartoon by King Louis XII in October 1499 as the king entered Milan at the head of his army. Louis XII's consort, Queen Anna, came from Brittany thus establishing a connection with this portrayal. In 1516, King Francis invited Leonardo to settle in France and expressly requested a painting of the Madonna, the Infant Christ and St Anne.

The depiction of the three generations of Anne, Mary and the Infant Christ was a frequent motif in 16th century Italian and French painting as they were revered as the central figures of the Holy Family. In the London cartoon, Leonardo added the Infant John to the group, who also appears as the precursor of Jesus. John, to whom an archangel prophesied the coming of the power of the Holy Spirit, receives a blessing from the Infant Jesus. He will be the first to recognize Jesus as the future Messiah. Their journeys through life are guided by their belief in God and this is intimated by Anne's left hand gesturing heavenwards. Jesus is later baptized in the river Jordan by John "to fulfil all righteousness" (Matt. 3.15).

The face of the Virgin Mary in this work corresponds with that of the "Madonna of the Rocks" in the Louvre (see page 43). In stark contrast with the stern, older and darker face of Anne, the face of Mary appears lovely and harmonious. The varied interplay of faces and hands illustrates Leonardo's immense interest in researching the human psyche and emotions and their pictorial representation. The foreground and background are defined by the delicate strokes of the landscape within which the group is placed.

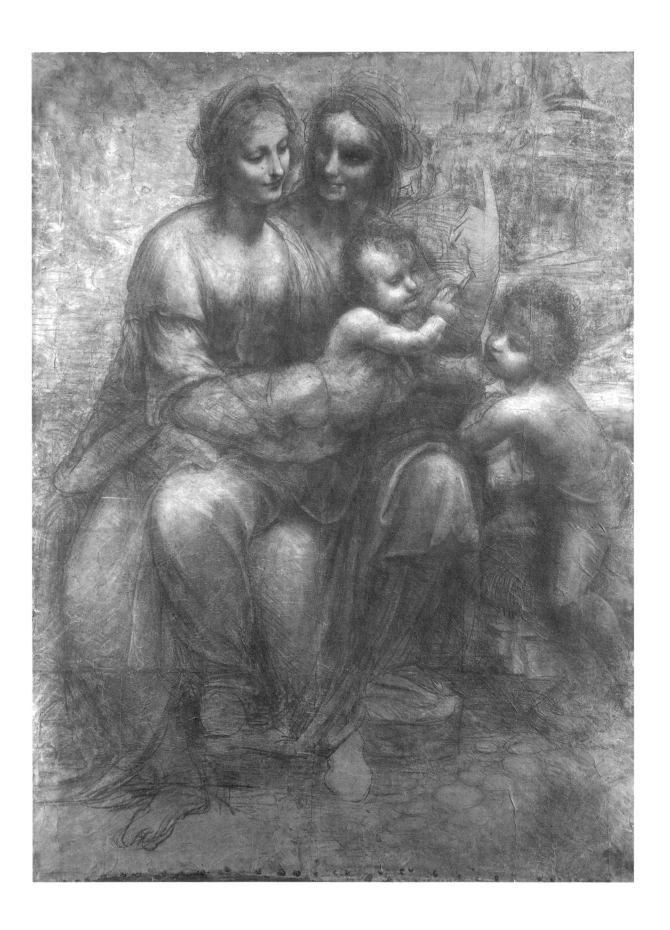

Tavola Doria (Groppo de' Cavalli)

ca. 1503–04
Oil on poplar
85x115 cm
Whereabouts unknown
Formerly in the G. Hoffmann Sammlung, Munich

This panel served as a "modello" for Leonardo's "Battle of Anghiari", which he had been commissioned to paint in the Council Chamber of the Palazzo Vecchio. The formal contract between Leonardo and the Florence City Council was concluded on May 4, 1504. Informally, though, Leonardo had received the commission in October of the previous year, since when he had been making studies of the theme. He put down his initial ideas on the coloring in this panel. The subject is the Battle of Anghiari on June 29, 1440, at which the Florentine forces (allied with the Pope) defeated a Milanese army led by Piccinino. The planned mural was to be of gigantic proportions: 7 meters high and 17.5 meters wide.

By an intriguing twist of irony, the artist commissioned to paint the matching mural on the opposite wall, the "Battle of Cascina", was the young Michelangelo. By 1505 both of them had completed their cartoon sketches. The plan of the Florentine city fathers to have two rival artists carry out the murals for one room simultaneously eventually came to nothing. It was a well-known fact that Leonardo had a poor opinion of Michelangelo and that Michelangelo despised Leonardo. Spiteful animosity was the keynote of their dealings with each other. Michelangelo poured scorn on Leonardo's presumption in seeking to revive the classical technique of mural painting and (abortively) lighting fires to dry the paint. Leonardo accused Michelangelo of ignoring nature and of depicting human emotions and passions without due regard for the rudiments of physiognomy. We know that Leonardo began work in the Palazzo Vecchio but abandoned it after only a few months. The payments stopped in the autumn of 1505. All that remains of the project is a copy by Rubens of Leonardo's cartoon. While the original cartoon is no longer extant, a fragment of the fresco in the palace has survived.

Paolo Uccelo's "Battle of San Romano" and Piero della Francesca's battle scenes in Arezzo are familiar precursors of this genre. On the present panel, the extraordinarily dynamic impact of the human figures and horses comes across immediately. They are entwined in a dense cluster, a maelstrom of furious animalism. Although Leonardo did not complete the commission in Florence, the original cartoon and Rubens' copy of it served as a model for numerous later depictions of battle scenes.

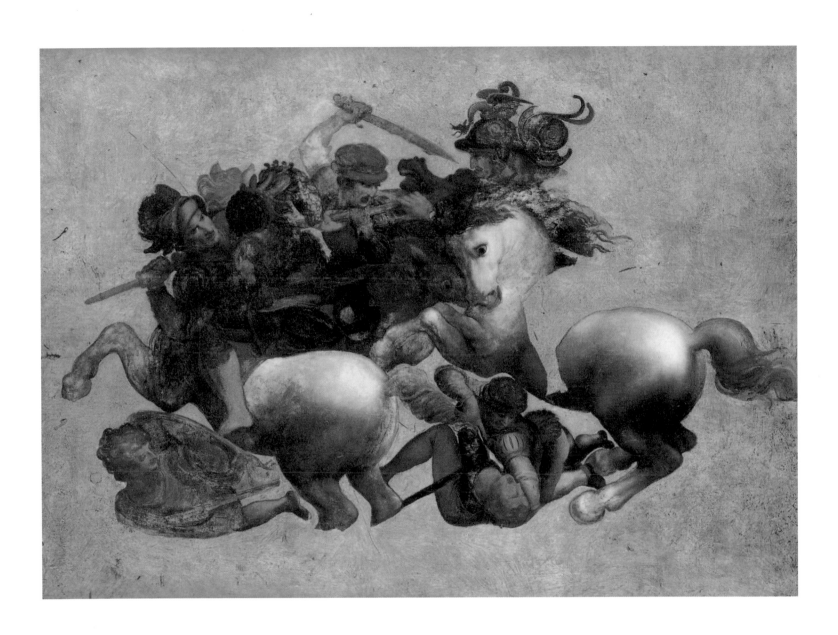

Mona Lisa (La Gioconda)

1503–07
Oil on panel
76.8 x 53 cm
Louvre, Paris

A good painter must paint two things above all others:
the person, and the intent of that person's soul.

Leonardo da Vinci

Ever since 1911, when an Italian house painter stole the "Mona Lisa" and unleashed a scandal in the art world, it has ranked as one of the world's most famous paintings. The canvas mysteriously resurfaced in Florence two years later. Up to that point, Giorgio Vasari's assessment of the portrait had been taken at face value. In his "Lives of the Artists", which was published as late as 1550, Vasari claimed that Leonardo had painted the picture after his return to Florence in 1500–1506. He did not finish it, Vasari asserted, and never handed it over to Francesco del Giocondo, who had commissioned it, but bequeathed it to his favorite student, Salai, from whose estate it found its way to the collection of the French king.

Vasari, who had a notorious weakness for anecdotes, tells us that musicians and jugglers were employed to keep the young lady entertained while her portrait was painted. Certainly, four years of sitting still would be enough to wipe the smile off anybody's face, and it is perfectly conceivable that such entertainments were the only way to induce her to go on sitting for Leonardo. Vasari had never seen the painting himself, but we can safely assume that he was drawing on first-hand information because his description of the "Mona Lisa" makes much of the painter's perfect imitation of nature. Leonardo lavished exceptional delicacy on conveying the three-dimensional depth of Lisa's head. A diaphanous veil covers her loosely curled hair. She is sitting at the parapet of a window which opens on to a landscape in the background. Her clothing reflects the Spanish fashions that were en vogue in Florence after the wedding of Lucrezia Borgia and Alfonso d'Este. Lisa's husband, who traded in precious fabrics, would have been aware of the prevailing fashions. Leonardo was acquainted with Lucrezia Borgia's brother, Cesare, and the latter's sister, Isabella d'Este.

The manner in which the subject's hands are folded conforms with the posture which the late Quattrocento established as a conventional expression of female virtue and modesty. The clothing and bearing accord with the contemporary social context, just as paintings of the Madonna tended to meet stereotype expectations by reflecting a conception of woman's calling as a domestic, virtuous being.

The technique of subtle gradations in the play of light and shade was familiar from Flemish oil painters like Jan van Eyck. Leonardo's writings on art, however, suggest that he may have been drawing on his own scientific studies and observations of nature when he evolved his technique of conveying three-dimensional depth by shading. He had begun his studies of the effects of light and shade in 1490 and continued them in 1500 after his return to Florence. The portrait of the Mona Lisa is a masterly realization of these studies.

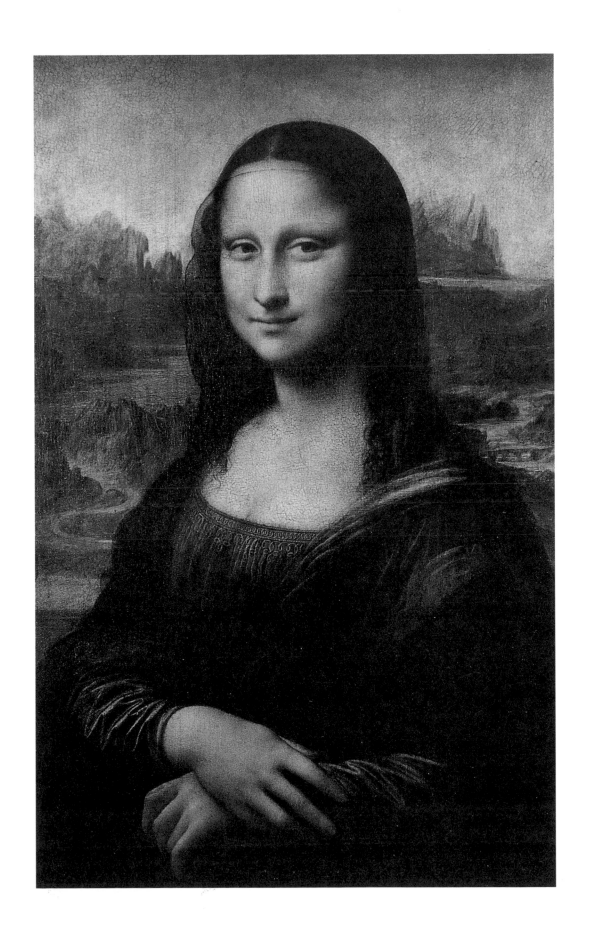

The Virgin and Child with St Anne and St John the Baptist

ca. 1506–13
Oil on panel
168.6 x 130 cm
Louvre, Paris

The motif of the Madonna and Child with St Anne occupied Leonardo da Vinci several times. The Burlington House cartoon (see page 57) was followed by two others which are now classified as lost. The unfinished painting in the Louvre is probably the fourth treatment of the subject.

The group of three figures – St Anne, Mary and the Infant Jesus – and the lamb occupy the foreground. The middle ground, made up of rocks and hills, merges into the rugged mountain landscape in the background, which in turn fades into the horizon. With Mary leaning so far forwards, the group forms a more exactly pyramidal arrangement than in the Burlington House cartoon. At the same time this composition leaves Leonardo greater scope for subtle interaction between the individual figures. Where the cartoon showed both St Anne and the Infant Jesus making dogmatic gestures, their absence here allows the painting's religious symbolism to come to the fore. The clumsy, playful movements of the Child's arms serve to integrate the lamb, a symbol of Christ's Passion. Mary is clasping her hands around her son's body. Given the idyllic atmosphere of the scene, it is unclear whether she is supporting him, unaware of the destiny that awaits him, or whether she is trying to pull him away from the animal (with its weight of symbolism). It is this ambivalence, the playful manner in which the three figures relate to each other, and the advent of Christianity as heralded by the symbolic anticipation of the Passion, which lend the picture its eloquence and its complexity.

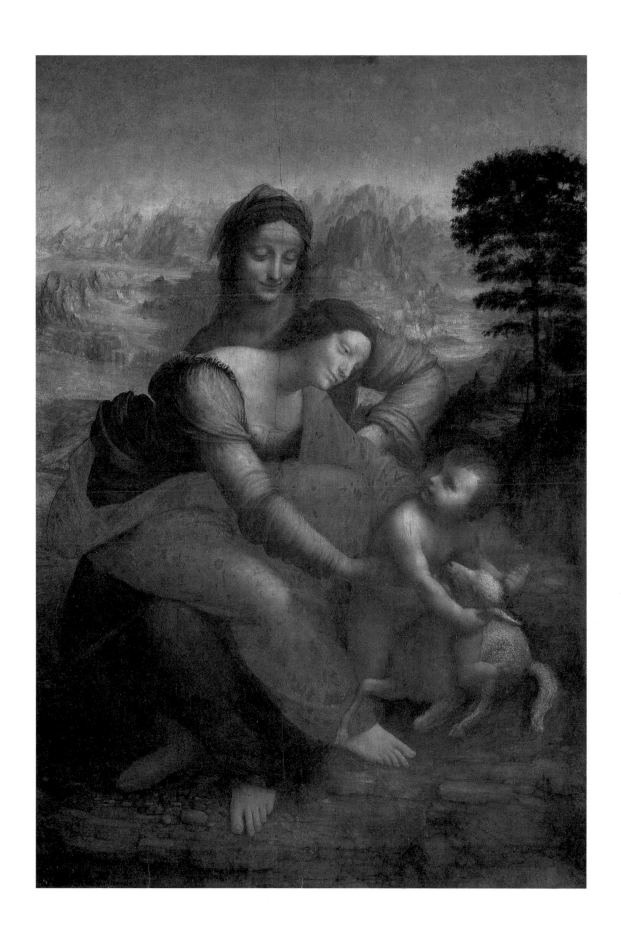

St John the Baptist

ca. 1513–16
Oil on panel
69.2 x 57.2 cm
Louvre, Paris

This is Leonardo's last extant painting. Saint John is portrayed from the waist up, clad in fur and set against a dark background. The upper part of his body is turned to one side, and he is leaning slightly backwards. This sense of rotation is enhanced by the angle of his right arm, which is pointing upwards. In his left hand he is holding a cross that extends the entire height of the picture. His head is slightly turned to one side so that his face looks directly at the spectator. His facial features appear youthfully androgynous, an impression that is reinforced by his long, curly hair.

Paintings of John the Baptist were common in Leonardo's day. As a rule, however, he was portrayed as an ascetic, while Leonardo's approach to the figure is more sensual.

The finger pointing upwards towards God and the gentle smile are familiar features of Leonardo's paintings of saints (compare "Madonna and Child with St Anne", page 57, and "The Angel in the Flesh", page 179). The combination of these gestures with the bacchanalian portrayal of the young man and the pronounced light effects on the skin against the dark background anticipate the naturalism of artists like Caravaggio.

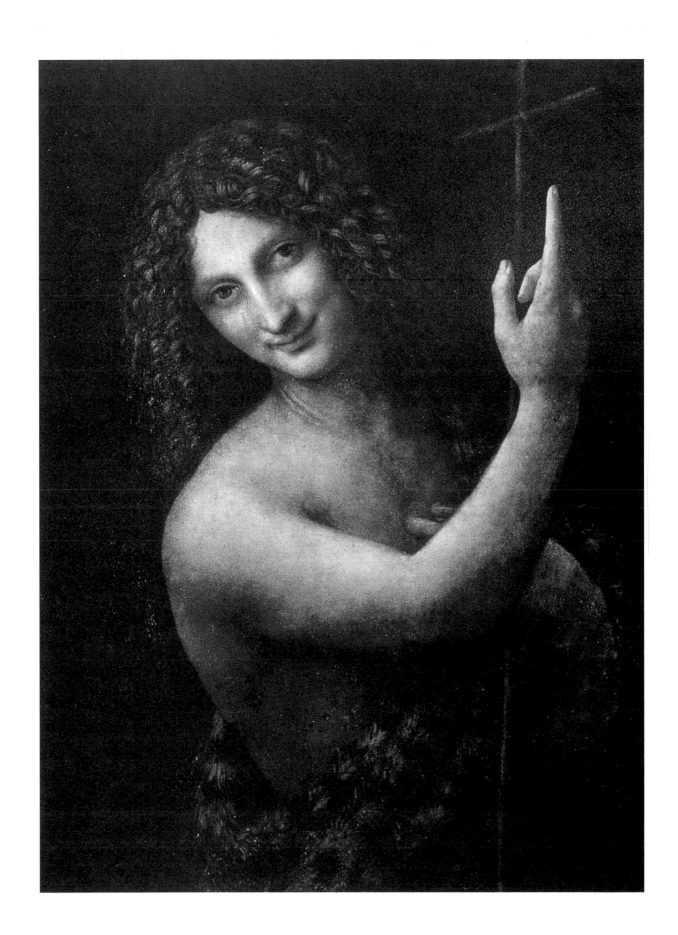

Arno landscape
August 5, 1473
Pen and ink
193x284 mm
Uffizi Galleries, Florence (GDS 1 8P)

How to represent landscapes

Landscapes should be represented in such a manner that the trees are half illuminated and half in shadow, but it is better to paint them when the sun is covered by clouds, for the trees are illuminated by the universal light of the sky and by the universal shadow of the earth. And their parts are darker, the closer those parts are to the middle of the tree and to the earth.

Leonardo da Vinci, Treatise on Painting, no. 139, fol. 41v, p. 71

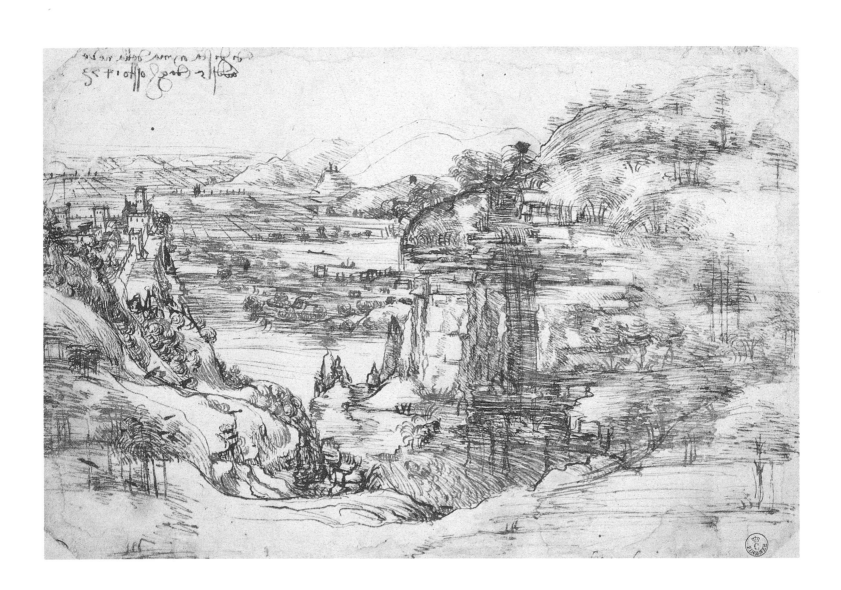

Study of drapery for a standing figure

ca. 1475

Gray tempera heightened with white lead on
gray-prepared canvas

303x205 mm

Johnson Collection, Princeton, New Jersey

Study of drapery for a standing figure

ca. 1475

Gray tempera heightened with white lead on
gray-prepared canvas

282x157 mm

Uffizi Galleries, Florence (433 E r)

Study of drapery for a kneeling figure

ca. 1475

Gray-brown tempera heightened with white lead on
gray-prepared canvas

160x167 mm

Uffizi Galleries, Florence (420 E r)

Study of drapery for a sitting figure

ca. 1475

Gray-brown tempera heightened with white lead on
gray-prepared canvas

290x200 mm

Uffizi Galleries, Florence (437 E r)

Study of drapery for a kneeling figure

ca. 1475

Gray-brown tempera heightened with white lead on
gray-prepared canvas

310x205 mm

Johnson Collection, Princeton, New Jersey

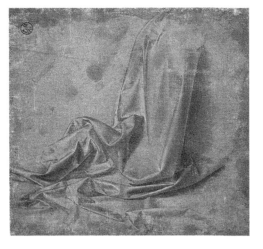

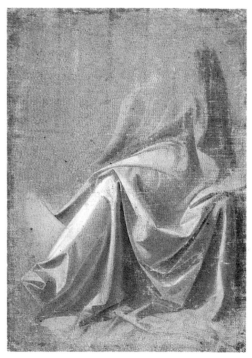

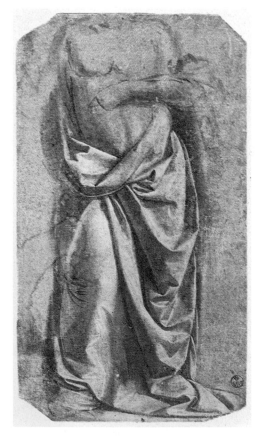

Of draperies that clothe figures

Draperies that clothe figures should show
that they cover living figures. Show the
attitude and motion of such a figure with
simple, enveloping folds, and avoid the
confusion of many folds, especially over
protruding parts of the body, so that these
may be apparent.

Leonardo da Vinci, Treatise on Painting, no. 559,
fol. 167, p. 203

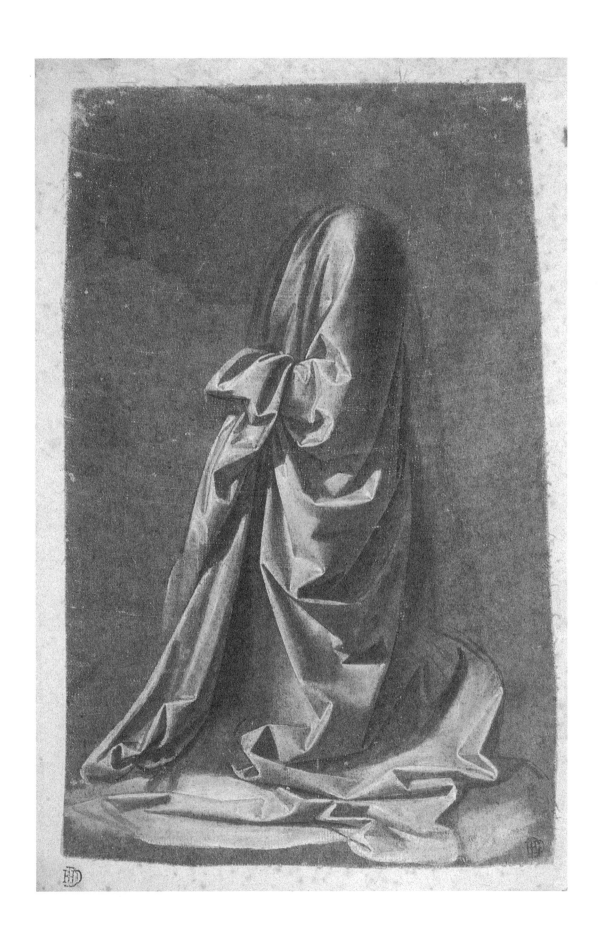

Study of a horseman
ca. 1478
Silverpoint on light-brown paper
122 x 78 mm
Carter Brown Collection, Washington, D.C.

Study of different parts of a horse
ca. 1480
Silverpoint
203 x 135 mm
Biblioteca Reale, Turin (15582 r)

Study of a horse's forelegs
ca. 1490
Silverpoint on blue-colored paper
heightened with white
153 x 203 mm
Biblioteca Reale, Turin (15580 r)

Study of a horse's hindlegs
ca. 1508
Chalk
215 x 285 mm
Biblioteca Reale, Turin (15579 r)

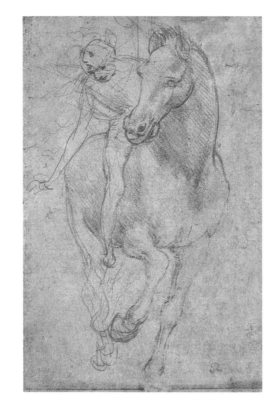

Of the motion of animals

Every living creature with two feet, when it moves lowers the side over the raised foot more than the side over the foot that rests on the ground, but the upper part of its body does just the contrary. This is seen in the hips and / shoulders of a man when he walks, and in birds the same thing happens with the head and the tail.

Leonardo da Vinci, Treatise on Painting, no. 294, fol. 124 v-125, pp. 121—122

Of the composition of the parts of animals

All the parts of any living creature should correspond to the age of the whole; that is, the limbs of the young should not be worked out with emphatic muscles, tendons and veins, as some portray them, who, to display clever and great design, spoil the whole by interchanging parts of the body, and the same thing is done by others who, through inability to draw, give old men the limbs of young ones.

Leonardo da Vinci, Treatise on Painting, no. 322, fol. 123 v, p. 127

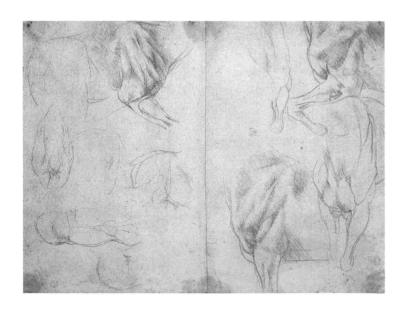

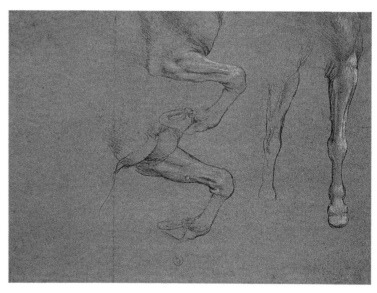

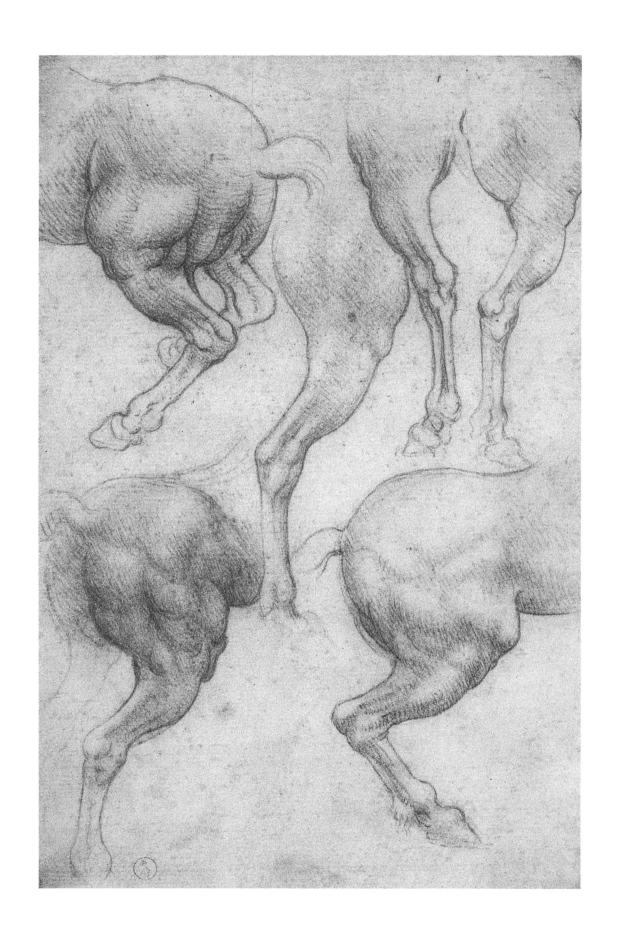

Study for The Nativity
ca. 1495
Pen over graphite
193x162 mm
Metropolitan Museum of Art, New York

Study for the Madonna with Child and cat
1480
Pen and ink, wash
127x105 mm
Uffizi Galleries, Florence (GDS 421 E r)

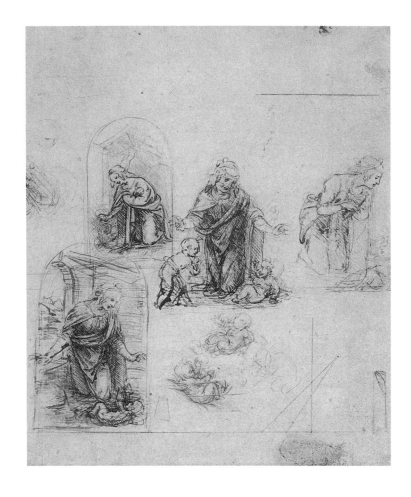

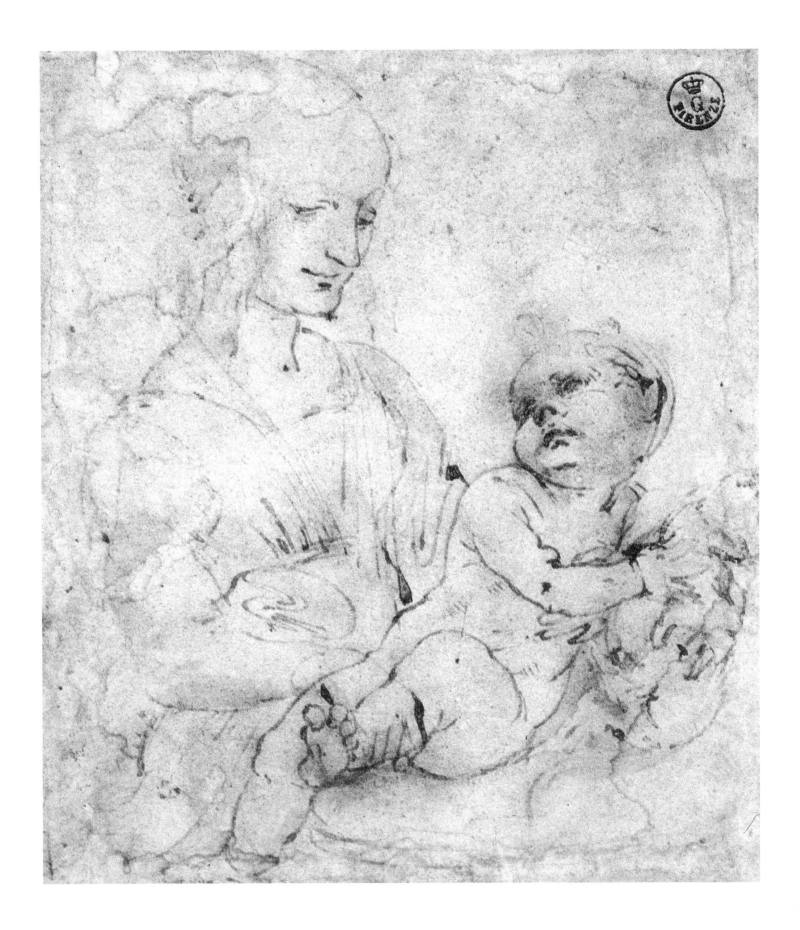

Head of a young woman
ca. 1483
Silverpoint and white lead on creme-colored paper
182 x 158 mm
Biblioteca Reale, Turin (15572 r)

Head of a young woman
ca. 1475
Pen, white lead, and bistre
275 x 195 mm
Uffizi Galleries, Florence (GDS 428 E r)

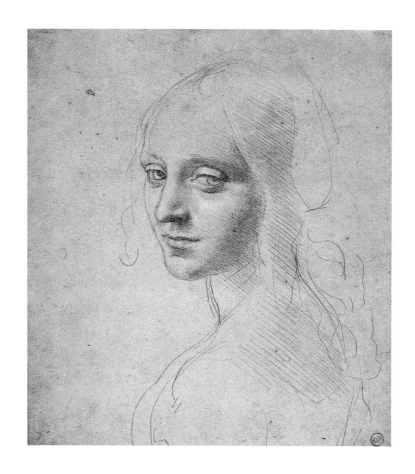

Of the selection of beautiful faces

It seems to me no small attraction that a painter / give a charming air to his figures. The painter who does not possess this grace by nature can acquire it by casual study in this manner. Look about for the good parts of many beautiful faces, parts considered beautiful by public opinion, rather than by your own preference. You can deceive yourself by selecting faces that are similar to your own, since it often seems that such similarities please us; and if you should be ugly, you would select faces that are not beautiful and you would paint ugly faces, as do many painters, whose painted figures often resemble that of their master. So choose beautiful faces as I tell you and commit them to memory.

Leonardo da Vinci, Treatise on Painting, no. 276, fol. 50 v-51, p. 112

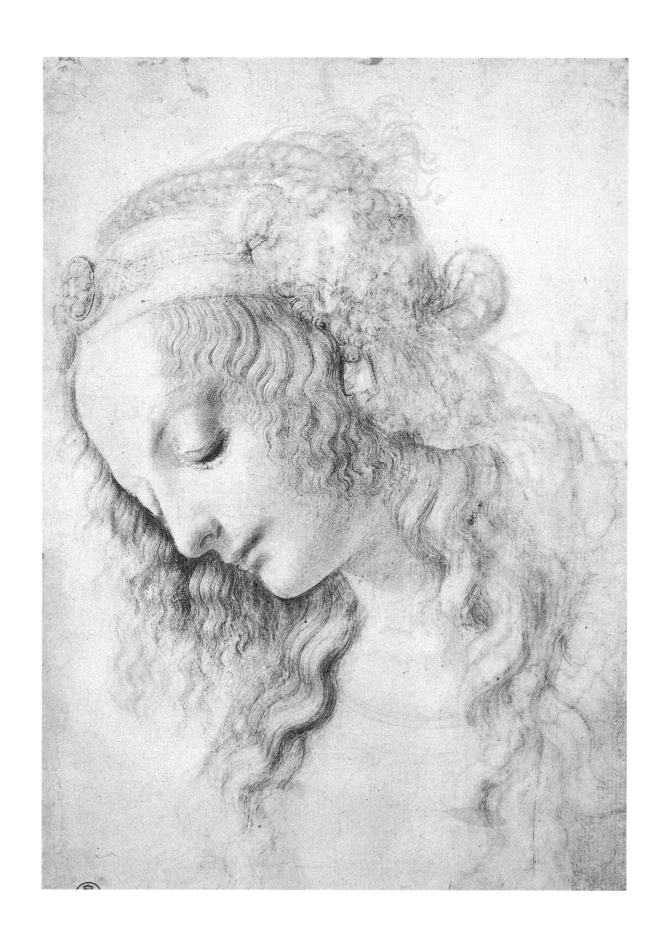

Profiles of two men and machine studies
ca. 1478
Pen and brown ink
200x265 mm
Uffizi Galleries, Florence (GDS 446 E r)

Portrait of an old man
ca. 1490
Red chalk
181x105 mm
Gabinetto Nazionale dei Disegni e delle Stampe,
Rome

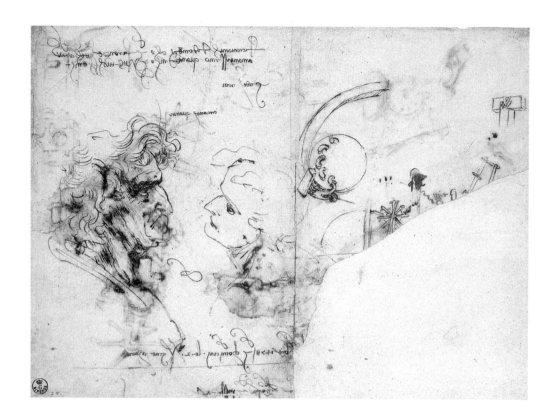

How old men should be represented

Old men should be represented with lan-
guid, slow movements, the legs bent at the
knees when they stand up, the feet parallel
but apart from one another. They should
have their backs bent, the head inclined
forward, and the arms not extending too far
from the body.

Leonardo da Vinci, Treatise on Painting, no. 254,
fol. 51v, p. 106

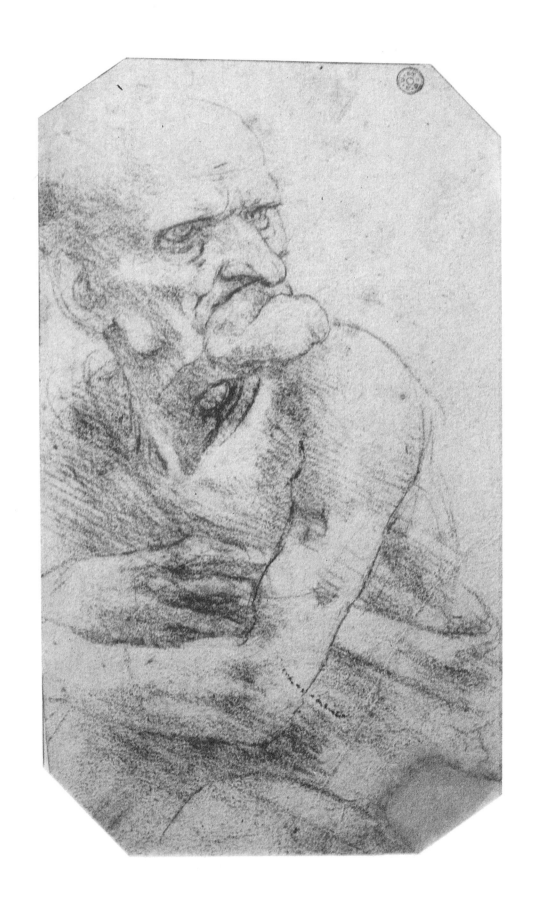

Profile of a man
ca. 1495
Pen and brown ink over black chalk
117x52 mm
Metropolitan Museum of Art, New York

Caricature of an old woman
ca. 1495
Pen and brown ink
88x75 mm
National Gallery, Washington, D.C.

Caricature of a laughing man
ca. 1495
Pen and brown ink
92x78 mm
J. Paul Getty Museum, Malibu, California
(formerly in the Großherzogliche Sammlung, Weimar)

Profiles of an old and a young man
ca. 1495
Red chalk
207x150 mm
Uffizi Galleries, Florence (GDS 423 E r)

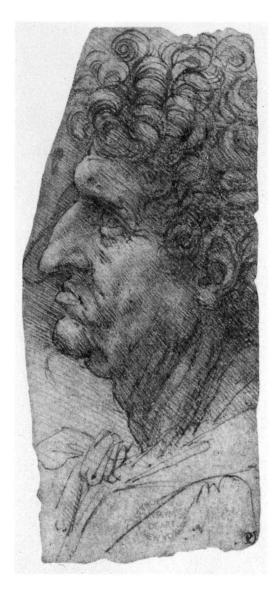

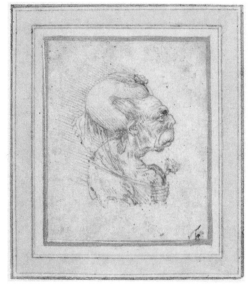

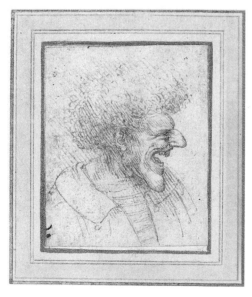

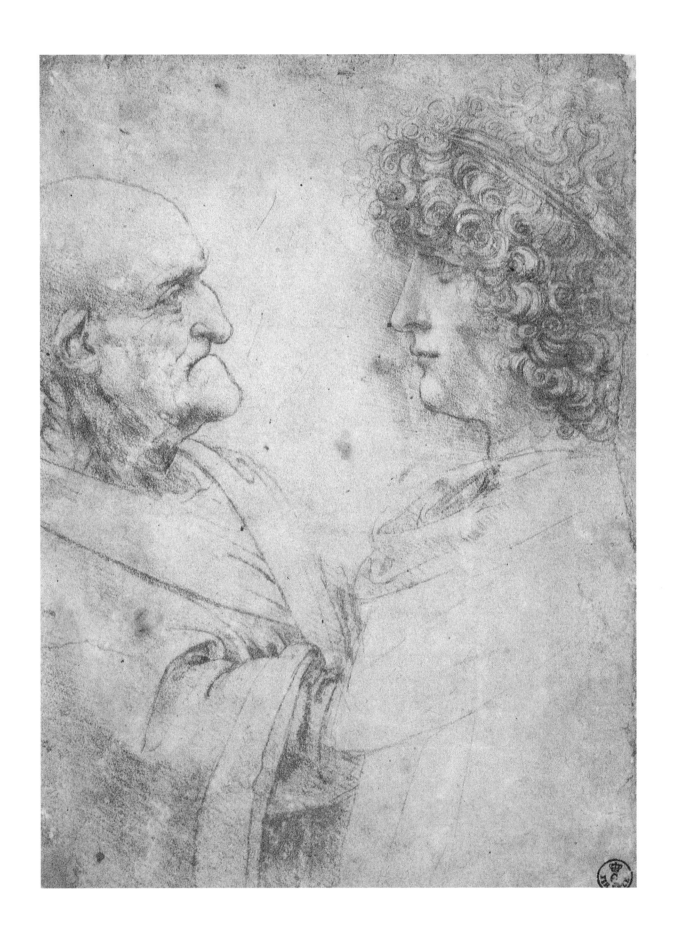

Corrected study of a hand and notes
ca. 1504
Pen and violet-gray pastel
260x180 mm
Codex Atlanticus fol. 395b (ex 146r-b)
Biblioteca Ambrosiana, Milan

Study of naked soldiers and horsemen;
sketches of women
ca. 1504
Pen and ink
255x195 mm
Biblioteca Reale, Turin (15577r)

Child with lamb
ca. 1500
Pen and ink
205x130 mm
J. Paul Getty Museum, Malibu, California
(formerly in the Großherzogliche Sammlung, Weimar)

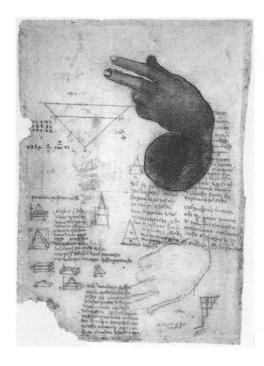

Of the joints of the fingers

The joints of the fingers of the hand thicken on every / side when they bend, and the more they are bent, the more they thicken, and they also diminish the more the fingers straighten out. The same thing happens with the toes, which change more the fleshier they are.

Leonardo da Vinci, Treatise on Painting, no. 299, fol. 103v-104, p. 123

How women should be represented

Women should be represented with modest gestures, the legs close together, the arms gathered together, heads bent and inclined to one side.

Leonardo da Vinci, Treatise on Painting, no. 253, fol. 51v, p. 106

How small children should be represented

Little children when sitting should be represented with quick, awkward, irregular movements, and when they stand up, with timid and fearful movements.

Leonardo da Vinci, Treatise on Painting, no. 252, fol. 51v, p. 106

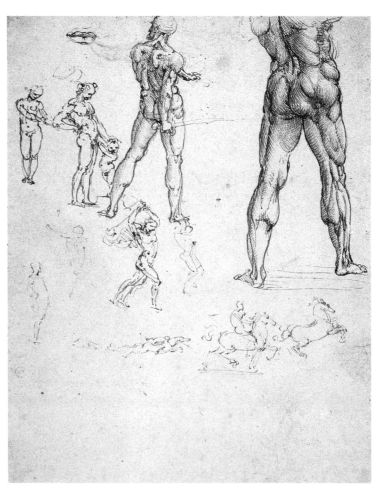

Rock strata
ca. 1508
Black chalk
165 × 200 mm
Pedretti 9 r
Royal Library, Windsor (RL 12397)

The ferry
ca. 1513
Pen and ink on yellow-colored paper
100 × 130 mm
Pedretti 51 r
Royal Library, Windsor (RL 12400)

Birch grove
ca. 1500
Red chalk
193 × 153 mm
Pedretti 8 r
Royal Library, Windsor (RL 12431)

Rock strata (horizontal)
ca. 1512
Pen and ink over preparatory drawing in black chalk
185 × 265 mm
Pedretti 53 r
Royal Library, Windsor (RL 12394)

Houses above a canal that runs
alongside a river
ca. 1513
Pen and ink
100 × 148 mm
Pedretti 50 r
Royal Library, Windsor (RL 12399)

Thunderstorm above a valley
ca. 1500
Red chalk
197 × 150 mm
Pedretti 5 r
Royal Library, Windsor (RL 12409)

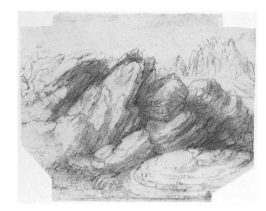

Of the growth of trees and in which direction they grow most

Larger branches do not grow toward the center of the tree. This comes about because every branch naturally seeks the air and avoids shadow, and shadows are more powerful on the lower parts of branches, which face the earth, than on those parts which turn to the sky. It therefore follows that the course of the water and dew which descends and which the night multiplies, keeps the lower part more humid than the upper and for this reason, the branches have more abundant nourishment in that part, and therefore grow more.

Leonardo da Vinci, Treatise on Painting, no. 299, fol. 103v–104, p. 123

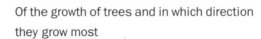

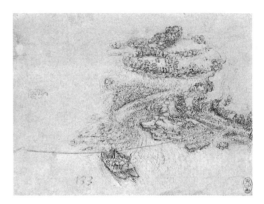

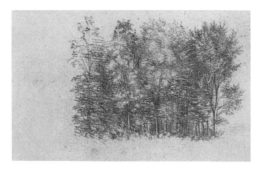

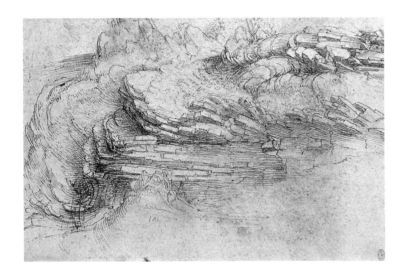

Leonardo da Vinci The Scientist

by Otto Letze

Do not, therefore, place your trust in writers
who claim to act as intermediaries between Nature and Man
merely on the basis of their conceptual thinking.

Leonardo da Vinci

Leonardo's notebooks and journals afford direct access to his scientific research. His supreme accomplishment lay in his shrewd powers of observation and in his intuitive grasp of the essential problem. This approach gave birth to a new method of scientific inquiry. We should recall that the science of the time was severely hampered by the rigidity of its premises. It is Leonardo's enduring achievement to have liberated scientific thinking from this straight-jacket by establishing the observation of nature as the starting-point of his research.

Leonardo originally studied the structure of the human body in order to be able to portray it more accurately in his pictures. In this he was not alone: other artists, like his master Verrocchio, also carried out dissections with the scalpel. But in 1488 Leonardo began studying the inner organs and their functions. His notebooks reveal that by 1515 he had dissected more than thirty corpses of both sexes and of various ages.

To enhance his understanding of the organic functions, Leonardo compared the human anatomy with that of the larger mammals. This marked the birth of comparative anatomy, a discipline which remains of fundamental importance in biology to this day. Leonardo probably planned to publish an academic work on anatomy in collaboration with Marc Antonio della Torre (1481–1512).

Leonardo's drawings of plants must rank amongst his most aesthetically satisfying drawings. Given their precision, they would still grace any modern-day botanical reference book.

Leonardo made some remarkable observations in the field of astronomy, quite independently of Copernicus. He realized that "the earth is a star... similar to the Moon" and that "it is at the center neither of the solar system nor of the universe". He believed that the sun was stationary: "Il sole non si muove." He held clear views on the earth's rotation around its own axis: "The day does not begin simultaneously all over the world, so that, when it is noon in our hemisphere, it is midnight on the other side." His lunar clock, a model of which is on display in this exhibition, incorporates the principles underlying this view.

Leonardo did not acquire a profound knowledge of mathematics and geometry until he made the acquaintance of Luca Pacioli during his years in Milan. He does not appear to have studied algebra. He summed up the significance of mathematics in the following sentence: "There can be no certainty unless one can apply one of the mathematical sciences." Leonardo was familiar with the work of Archimedes and with ancient Greek and Arabic physics. What distinguishes him from his predecessors, however, is the astuteness of his powers of observation and his determination to track down correlations and scientific principles. Leonardo's scientific method broadly falls into two stages: experimentation as a means of perception, and subsequent analysis of the underlying principles.

Anatomical studies for the proportions
of the face and eyes
ca. 1490
Pen and ink
195 x 277 mm
Biblioteca Reale, Turin (15574 r and 15576 r)

Anatomical study of a bear's paw
ca. 1493
Pen and ink heightened with white lead on
blue-colored paper
160 x 135 mm
Keele/Pedretti (12 r)
Royal Library, Windsor (RL 12372 r)

Anatomical study of the skull
ca. 1489
Pen and ink over black chalk
187 x 135 mm
Keele/Pedretti 43 r
Royal Library, Windsor (RL 19057 r)

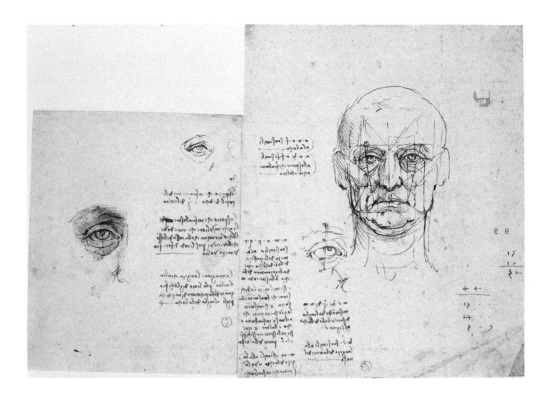

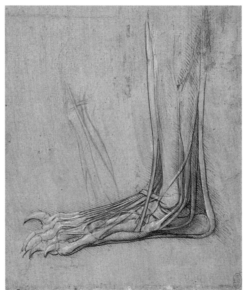

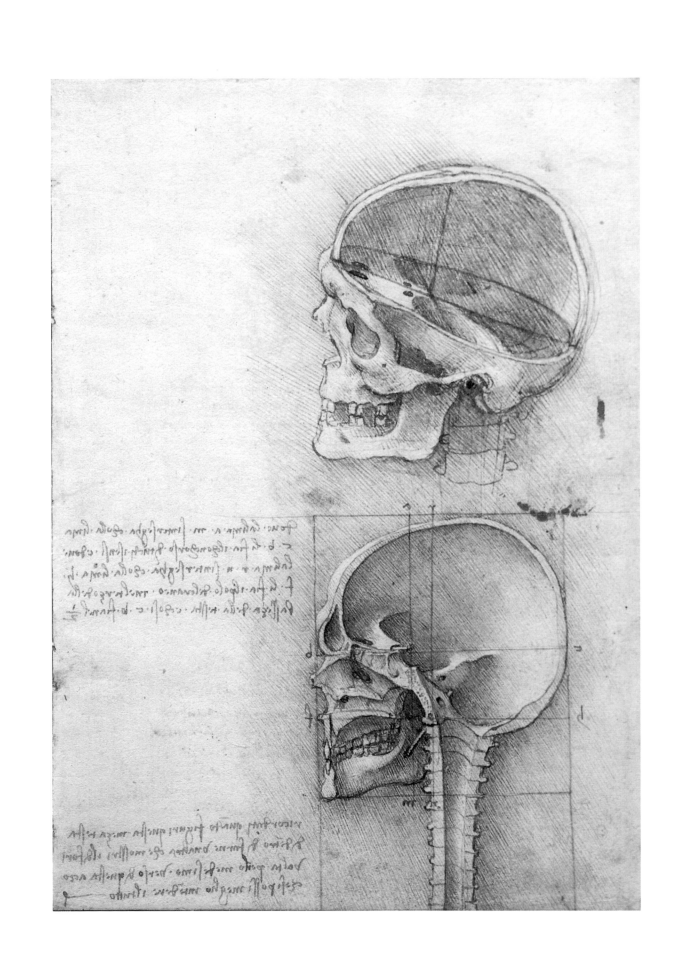

Anatomical studies of the brain and
its nerves and of the male genitals
ca. 1510
Pen and brown ink
192x135 mm
Pedretti 55 r
Schloßmuseum, Kunstsammlung zu Weimar

Anatomical studies of the male and
female urogenital apparatuses
ca. 1510
Pen and brown ink
192x135 mm
Keele/Pedretti 54 v
Schloßmuseum, Kunstsammlung zu Weimar

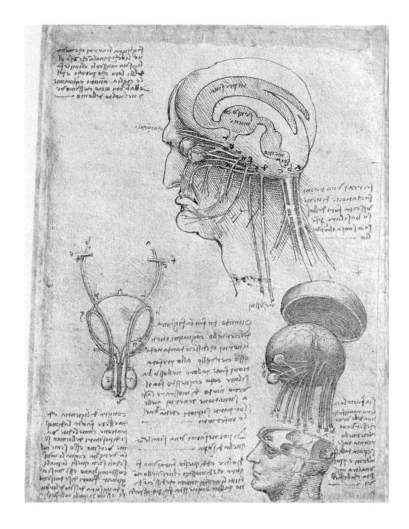

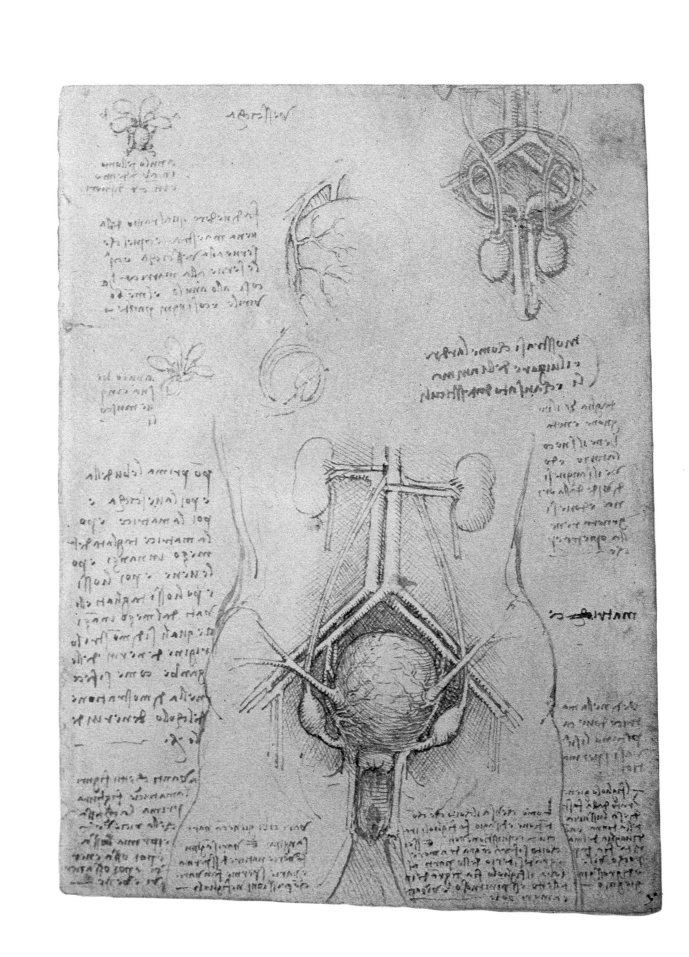

Anatomical studies of the
stomach and digestive tract
ca. 1506
Pen and ink
190x140 mm
Keele/Pedretti 73 v
Royal Library, Windsor (RL 19031 v)

Anatomical studies of the lungs,
bladder, and male sex organs
ca. 1509
Pen and ink
280x190 mm
Keele/Pedretti 106 v
Royal Library, Windsor (ex 19098 v)

Anatomical depiction of sexual intercourse
ca. 1510
Pen and ink (black pencil numbering from
the 19th century)
275x205 mm
Keele/Pedretti 35 r
Royal Library, Windsor (RL 19097 v)

Anatomical studies of the mesentry
and the vascular system
ca. 1510
Pen and ink
192x143 mm
Keele/Pedretti 57 r
Royal Library, Windsor (RL 19020 r)

Anatomical cross-section of a woman
ca. 1507
Pen and ink, wash over black chalk
328x470 mm
Keele/Pedretti 122 r
Royal Library Windsor (RL 12281 r)

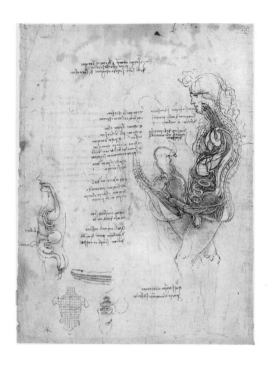

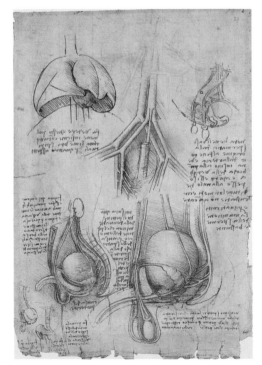

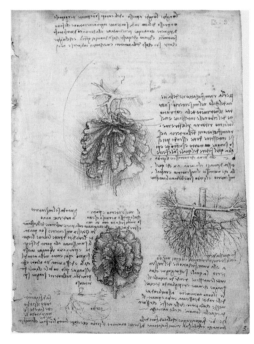

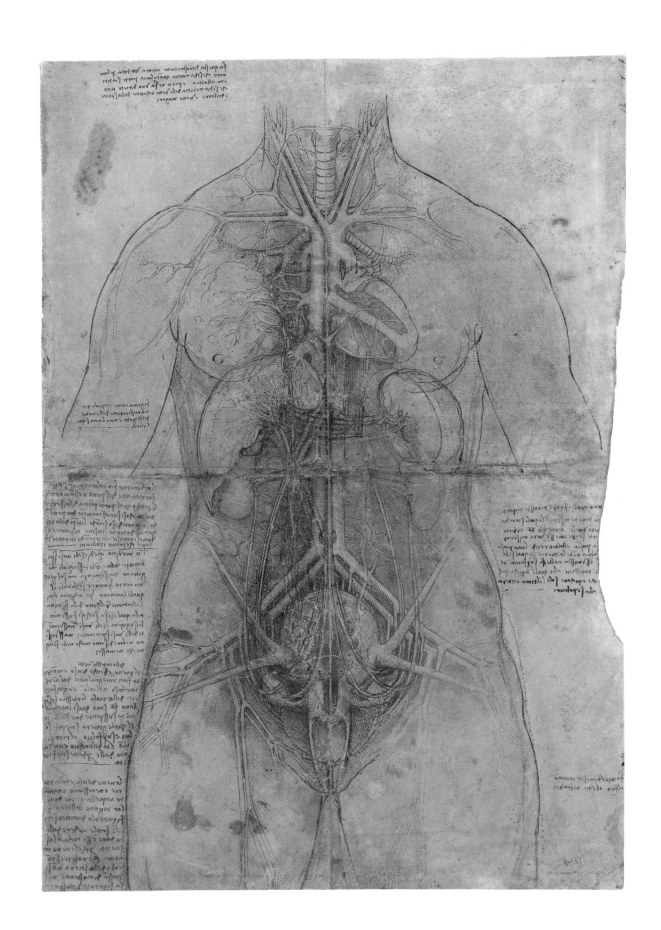

Anatomical studies of the nervous system
ca. 1510
Pen, ink, and red chalk
190x135 mm
Keele/Pedretti 76 v
Royal Library, Windsor (RL 19034 v)

Anatomical studies of arms,
hands, and faces
ca. 1510
Pen and brown ink
285x200 mm
Keele/Pedretti 142 v
Royal Library, Windsor (RL 19012 v)

Anatomical studies of the legs
ca. 1507
Pen and ink over red chalk on red-prepared paper
285x205 mm
Keele/Pedretti 95 r
Royal Library, Windsor (RL 12625 r)

Anatomical studies of the skeletal system
ca. 1510
Pen and brown ink
290x200 mm
Keele/Pedretti 142 r
Royal Library, Windsor (RL 19012 r)

Of the display or concealment of the muscles of each part in the attitudes of living creatures

I remind you, painter, that in the movements which you represent / as being made by your figures, you should make distinct only those muscles which function in the motion and action of your figure, so that the muscle which is most exercised in such case is most distinct, and that which is not exercised at all remains relaxed and soft and little apparent.

On this account I urge you to study the anatomy of the muscles, sinews and bones, without knowledge of which you will do little. If you draw from life, perhaps the model whom you select will lack good muscles in the action which you wish him to take. But you cannot always conveniently find good nude models, nor can you always draw them. It is better for you and more useful to practice such variety and to keep it in memory.

Leonardo da Vinci, Treatise on Painting, no. 313, fol. 110v-111, pp. 125–126

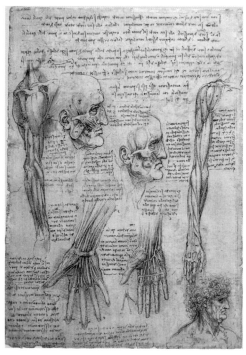

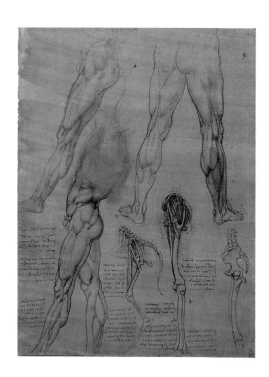

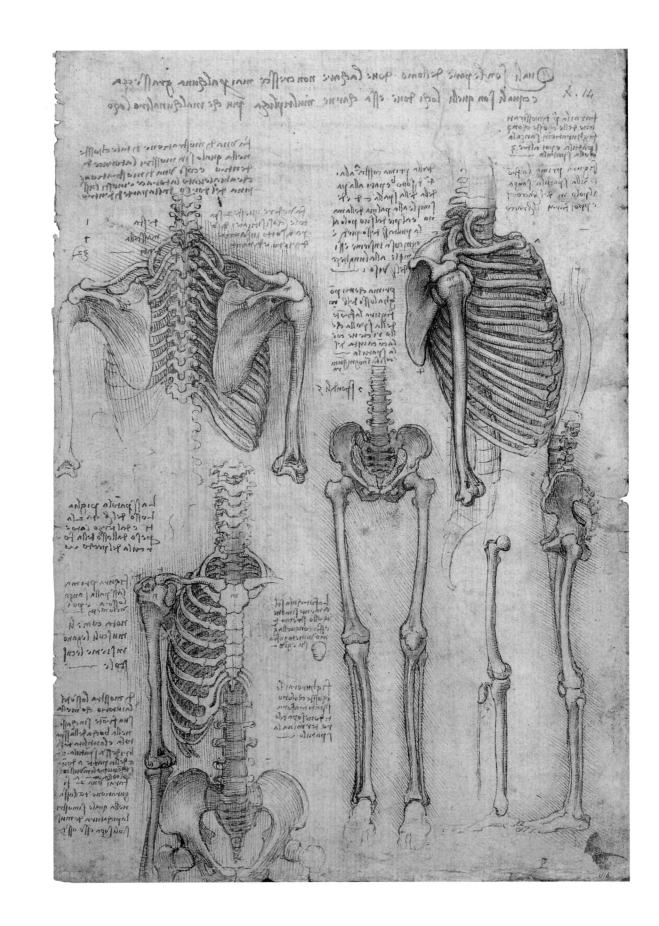

Anatomical studies of the nose and throat
ca. 1488
Pen and ink over silverpoint on blue-colored paper
205 x 285 mm
Keele/Pedretti 3 r
Royal Library, Windsor (RL 12609 r)

Anatomical studies of the larynx, bronchial tubes, and the muscles of the left leg (detail)
ca. 1510
Pen and ink over black chalk
289 x 197 mm
Keele/Pedretti 134 r
Royal Library, Windsor (RL 19002 r)

Anatomical studies of the neck and shoulder muscles
ca. 1510
Pen and brown ink
290 x 200 mm
Keele/Pedretti 137 r
Royal Library, Windsor (RL 19003 r)

Anatomical studies of the neck and shoulder muscles
ca. 1510
Pen and brown ink
290 x 200 mm
Keele/Pedrettl 137 v
Royal Library, Windsor (RL 19003 v)

Anatomical study of the neck muscles
ca. 1510
Pen and ink on blue-colored paper
276 x 210 mm
Keele/Pedretti 179 v
Royal Library, Windsor (RL 19075)

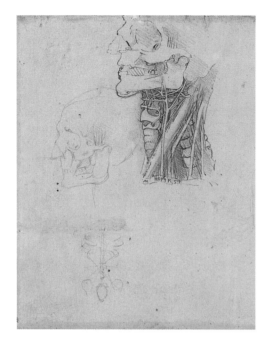

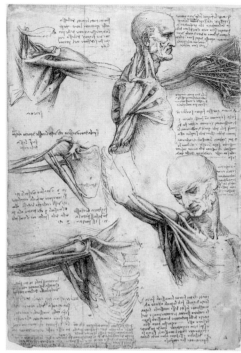

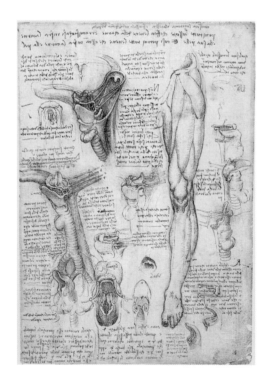

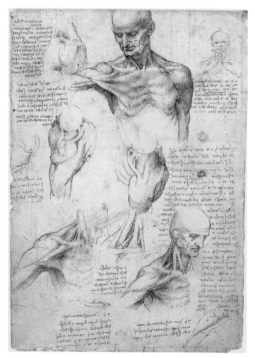

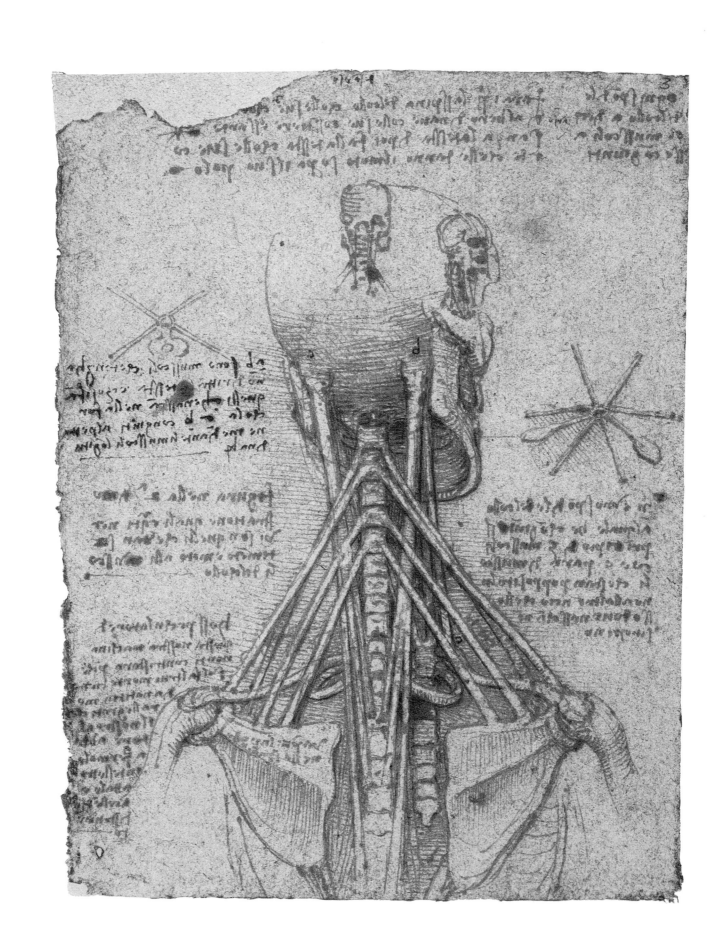

Anatomical studies of foetal development
ca. 1510
Pen and ink, red and black chalk
304 x 213 mm
Keele/Pedretti 197 v
Royal Library, Windsor (RL 19101 v)

Anatomical studies of the female
sex organs and foetal development
ca. 1510
Pen and ink
302 x 210 mm
Keele/Pedretti 197 r
Royal Library, Windsor (RL 19101 r)

Anatomical studies of the heart and lungs
of an ox
ca. 1513
Pen and ink on blue-colored paper
285 x 205 mm
Keele/Pedretti 162 r
Royal Library, Windsor (RL 19071 r)

Anatomical studies of embryonic
development
ca. 1510–13
Pen and red chalk
301 x 213 mm
Keele/Pedretti 198 r
Royal Library, Windsor (RL 19102 r)

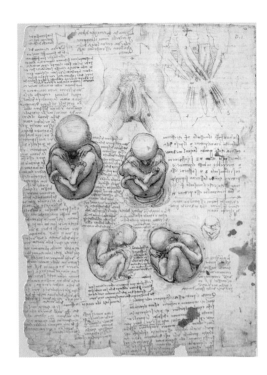

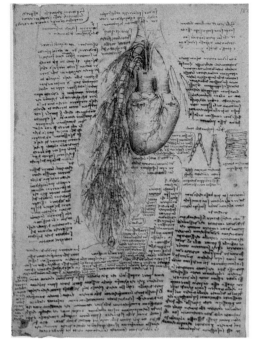

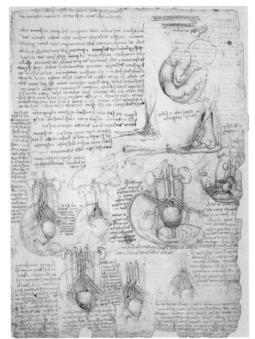

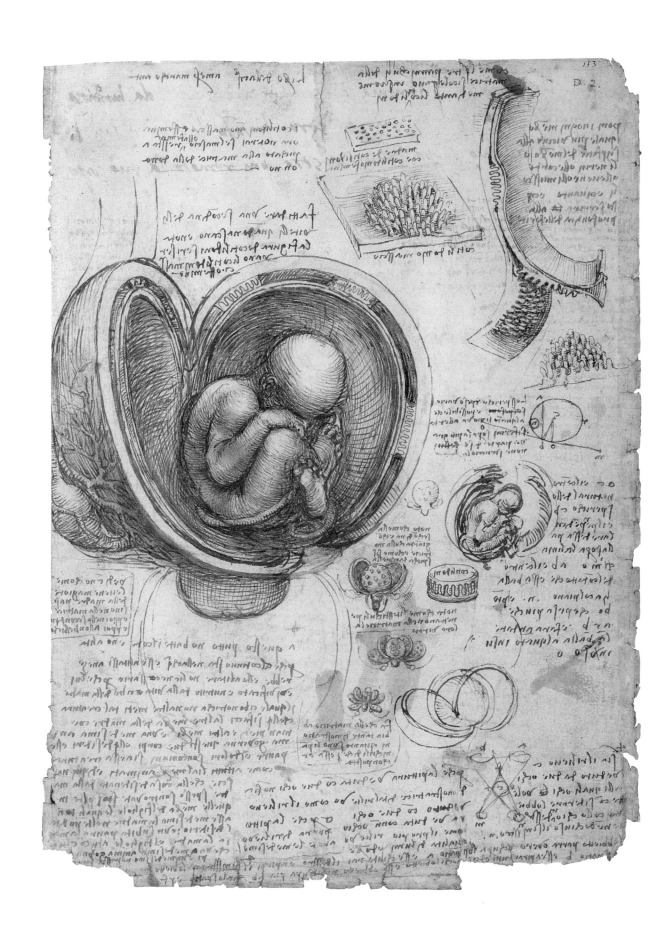

Map of Milan

ca. 1497–1500

Pen and ink

285 x 210 mm

Codex Atlanticus fol. 199 v (ex 73 v-a)

Biblioteca Ambrosiana, Milan

Travel notes from Friuli

ca. 1500

Pen, ink, and red chalk

280 x 280 mm

Codex Atlanticus fol. 638 v-d (ex 234 v-c)

Biblioteca Ambrosiana, Milan

Map and drawing of a landscape, geometrical and mechanical studies

ca. 1500

Pen, ink, and black chalk

300 x 430 mm

Codex Atlanticus fol. 393 (ex 145 r-a, 145 r-b)

Biblioteca Ambrosiana, Milan

Map of Tuscany; Vinci, and surrounding area

ca. 1503

Pen and ink

240 x 367 mm

Royal Library, Windsor (RL 12685)

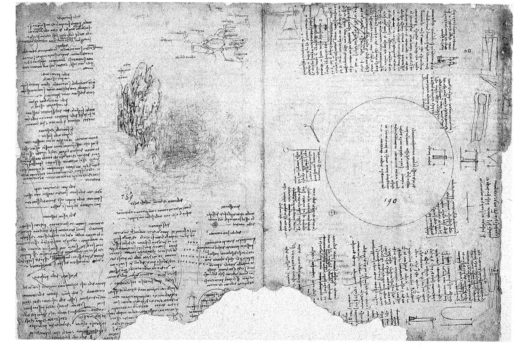

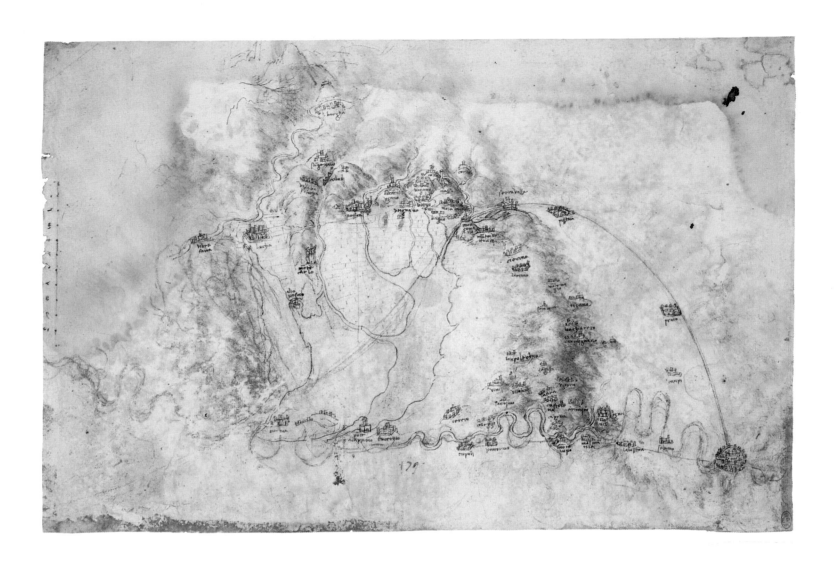

Drawing pricked for transfer

ca. 1510
Pen and ink
155x375 mm
Codex Atlanticus fol. 710 b (ex 263 v-b)
Biblioteca Ambrosiana, Milan

Study of a turbine wheel

ca. 1510
Pen and ink
Diameter 195 mm
Codex Atlanticus fol. 695 r (ex 258 r-b)
Biblioteca Ambrosiana, Milan

Polyhedron

ca. 1510
Pen and ink, wash
Diameter 120 mm
Codex Atlanticus fol. 707 r (ex 263 r-b)
Biblioteca Ambrosiana, Milan

Drawings and notes on perpetual motion

ca. 1495
Pen and ink
330x240 mm
Codex Atlanticus fol. 1062 r (ex 384 r-a)
Biblioteca Ambrosiana, Milan

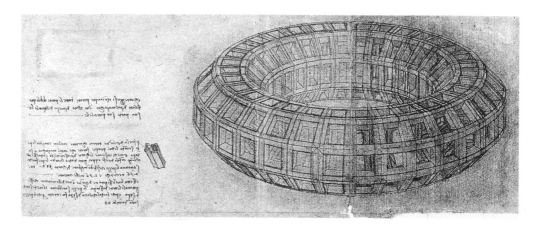

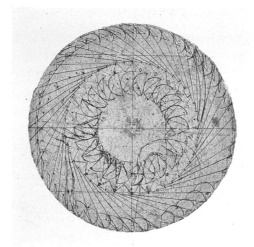

Studies of astronomy and perspective
ca. 1513
Pen and ink
270x213 mm
Codex Atlanticus fol. 555v (ex 208v-b)
Biblioteca Ambrosiana, Milan

Studies of light and shadow
ca. 1513
Pen and ink on blue-colored paper
283x410 mm
Codex Atlanticus fol. 658v (ex 241v-c/d)
Biblioteca Ambrosiana, Milan

Geometrical figure in perspective
ca. 1510
Pen and ink, wash
150x190 mm
Codex Atlanticus fol. 709r (ex 263r-d)
Biblioteca Ambrosiana, Milan

Mathematical studies
ca. 1515
Pen and ink
420×292 mm
Codex Atlanticus fol. 696r (ex 259r-a)
Biblioteca Ambrosiana, Milan

Geometrical studies
ca. 1516
Pen and ink
295×215 mm
Codex Atlanticus fol. 268r (ex 98r-a)
Biblioteca Ambrosiana, Milan

Geometrical sketches
ca. 1517
Pen and ink, partial wash
300×200 mm
Codex Atlanticus fol. 239v (ex 88v-a)
Biblioteca Ambrosiana, Milan

Geometrical studies
ca. 1517
Pen and ink, partial wash
295×210 mm
Codex Atlanticus fol. 307v (ex 110v-a)
Biblioteca Ambrosiana, Milan

Geometrical studies
ca. 1514
Pen and ink
290×195 mm
Codex Atlanticus fol. 1040v (ex 373v-a)
Biblioteca Ambrosiana, Milan

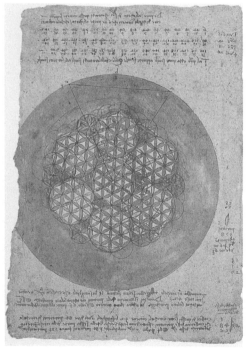

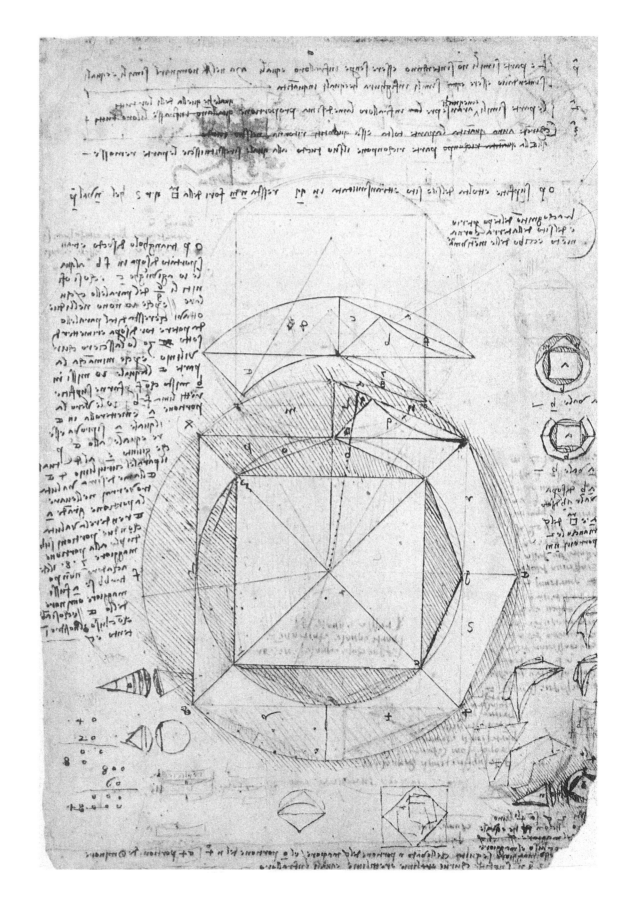

Blooming Anemones

ca. 1506

Pen and ink over light black chalk

85x140 mm

Pedretti 23 r

Royal Library, Windsor (RL 12423)

A Star of Bethlehem and other plants

ca. 1506

Pen and ink over preparatory drawing in red chalk

196x160 mm

Pedretti 16 r

Royal Library, Windsor (RL 12424)

Study of a plant with a long stem (Coix lachrymajobi)

ca. 1515

Pen and ink over light black chalk

211x225 mm

Pedretti 25 r

Royal Library, Windsor (RL 12429)

Blooming asphodelus and notes

ca. 1506

Red chalk

348x240 mm

Codex Atlanticus fol. 663 r (ex 244 r-a)

Biblioteca Ambrosiana, Milan

Study of a lily

ca. 1475

Pen and ink over black chalk, wash

(originally pricked for transfer)

313x177 mm

Pedretti 2 r

Royal Library, Windsor (RL 12418)

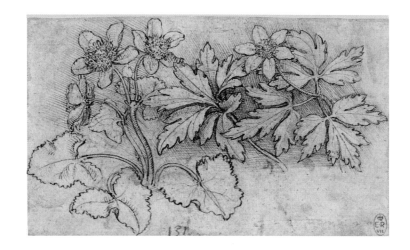

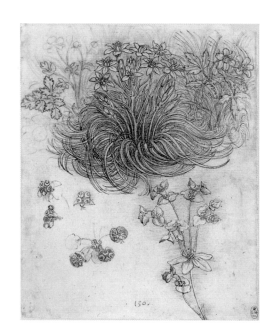

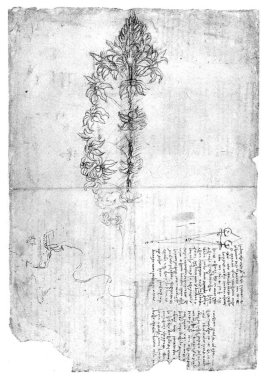

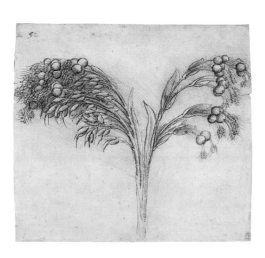

Discussion of kinds of blossoms in the flowering branches of shrubs

Some of the flowers that grow on the branches of shrubs bloom first at the very top of those branches, and others open the first flower at the very lowest part of the stem.

Leonardo da Vinci, Treatise on Painting, no. 941, fol. 243, p. 313

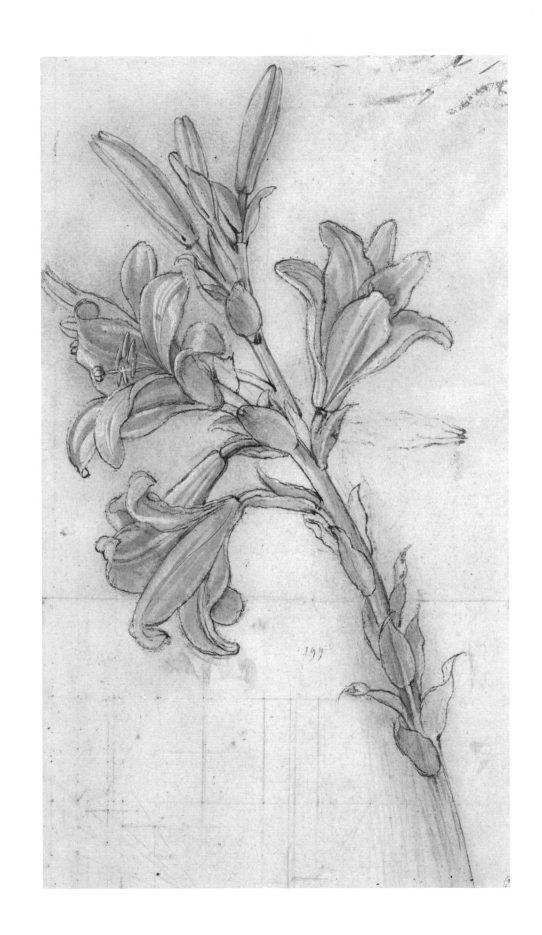

Torso of a man in profile
ca. 1490
Pen, various inks, silverpoint, red and black chalk
280x222 mm
Galleria dell' Accademia, Venice (236 r)

Bust of a man in profile
ca. 1490
Pen and ink, pencil
280x222 mm
Galleria dell' Accademia, Venice (236 v)

The human proportions according to Vitruvius
ca. 1490
Pen, ink, and light wash over silverpoint
344x245 mm
Galleria dell' Accademia, Venice (228)

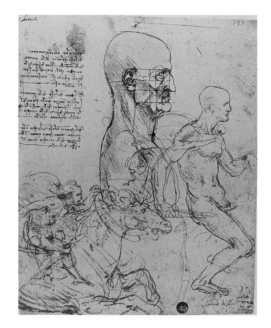
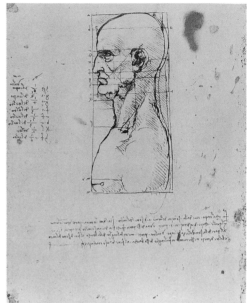

Of making a man's portrait in profile after having seen him only once

In this case it is necessary to commit to memory the varieties of the four different features in profile, which would be the nose, mouth, chin, and forehead. We shall speak first of noses, which are of three sorts, that is, straight, concave, and convex. Of the straight there are only four kinds, that is, long, short, high at the end, and low. Concave noses are of three sorts, of which some have a concavity on the upper side, others in the middle and still others on the lower side. Convex noses also vary in three ways; some have a projection on the upper part, some in the middle, and others on the lower part. Those which have a projection in the middle of the nose vary in three ways, that is, they are straight, or concave, or really convex.

Leonardo da Vinci, Treatise on Painting, no. 416, fol. 108 v and illus, p. 154

Method for remembering the shape of a face

If you wish to have facility in remembering the expression of a face, first commit to memory many heads, eyes, noses, mouths, chins, and throats, necks, and shoulders. For example, noses are of ten kinds: straight, crooked, concave, with a projection higher or lower than the middle, aquiline, flat, turned up, round, and pointed. These are good to remember insofar as the profile is concerned.
In full face, noses are of eleven kinds: even, thick in the middle, thin in the middle, with thick tips, and thin at the beginning, thin at the tip and thick at the beginning; nostrils broad and narrow, high and low, with uncovered openings and with openings covered by the tip.
You will also find diversity in the other details, things that you should draw from life and commit to memory, or when you have to draw a face from memory take with you a little book wherein are noted down similar features, and when you have glanced at the face of the person you are to portray, look then at the parts, which nose, or mouth is like his, and make a little mark to recognize it, and then at home put it together. Of monstrous faces I do not speak, since these are remembered without effort.

Leonardo da Vinci, Treatise on Painting, no. 415, fol. 109, pp. 153–154

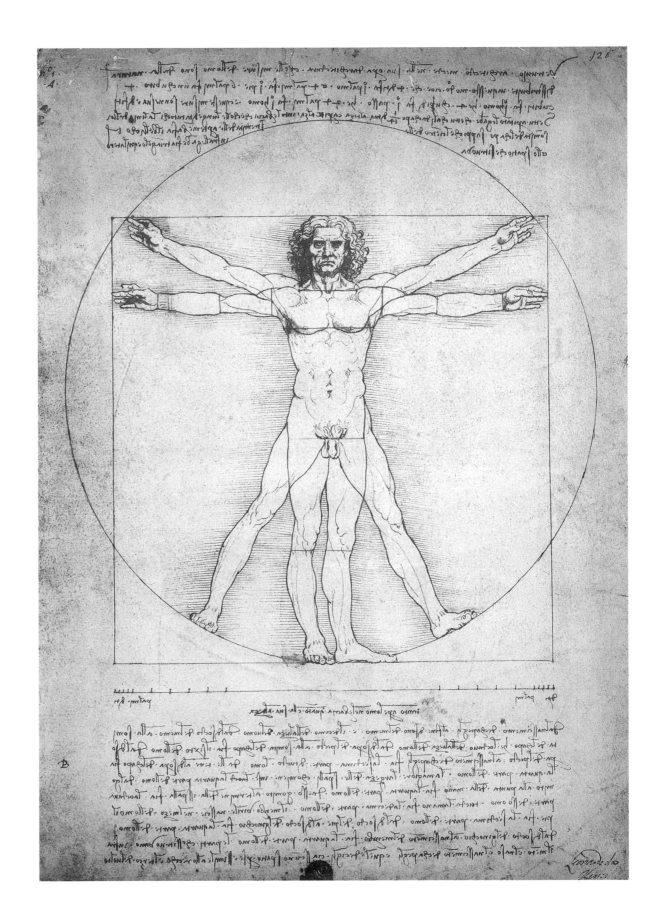

Leonardo da Vinci The Inventor

by Otto Letze

Almost half a millennium has passed since Leonardo da Vinci recorded his ideas and sketches for mechanical devices designed to facilitate a multitude of technical functions. One of his guiding tenets was "to construct machines which will enable whole worlds to be moved". The underlying principle was to make working processes faster and easier while ensuring that the result combined uniformity and precision. As an advisor to heads of state, military commanders, aristocratic families and stewards of country estates, he slipped into the guise of a technical designer, civil engineer, architect, ordnance expert and prophet. Leonardo's life coincided with a tumultuous epoch of European history. When he was born, Gutenberg had just invented the printing press. During his lifetime Vasco da Gama sailed round the Horn of Africa and pioneered the maritime route from Europe to India, while sailors and mercenary armies converged on the vast new continents which Christopher Columbus and Amerigo Vespucci had discovered. The time was ripe, then, for an inventor of genius to unfold his talents. Leonardo was well aware that his scientific insights and the inventions to which they gave rise were far ahead of his time. He was about thirty years of age when he wrote his celebrated letter to Lodovico Sforza offering his services and aptitudes (see page 161). The thirty-six skills which he places at the Prince's disposal may be taken as an accurate reflection of his interests at the time. Thirty items on the list relate to technical skills, only six to art. At the end of the list he makes almost casual reference to his artistic aptitudes in the fields of painting and the fashioning of marble and metals.

In a letter to the Turkish Sultan Bajazet II, dating from 1502, he wrote: "I, your humble servant, have heard it said that you were planning to construct a bridge from Istanbul to Galata but that you had to abandon the plan for lack of anybody who could carry out the project. I, your humble servant, can do so." Leonardo went on to design a stone bridge across the Golden Horn at Istanbul ("Ponte da Prea a Gosstantjnopoli") with a span of some 300 meters, and he offered his services as constructor. This design must rank as the crowning achievement of his studies of the statics of stone arches. In conjunction with the present exhibition, students at Stockholm Technical University conducted a technical analysis of Leonardo's plans with the help of a computer simulation and arrived at the remarkable conclusion that his bridge construction would have complied with modern-day legal technical specifications and the requirements of structural statics. Leonardo's bridge design is not – like some of his other ideas – a purely visionary concept but the logical outcome of his studies in structural mechanics. It was his inventions which contributed most to Leonardo's enduring fame. Many of his plans were realized centuries later, either exactly or approximately the way he had sketched them, and have indeed "moved whole worlds". His inventions ranged from objects of every-day use, like the link-chain-driven bicycle, to outlandish-looking military devices, like his design of a scythed chariot (see page 144), pioneering studies in the field of automotive engineering (see page 115), or instruments for the precise measurement of time (see page 131).

Part of a water wheel
Pen and brown ink
64×55 mm
Staatliche Graphische Sammlung, Munich (2152 a)

Construction of a beam
Pen and brown ink
45×140 mm
Staatliche Graphische Sammlung, Munich (2152 b)

Design of a mechanism for the processing of gold
Pen and brown ink
190×165 mm
Staatliche Graphische Sammlung, Munich (2152 r)

Study of mechanics and ship building
Pen and brown ink
190×165 mm
Staatliche Graphische Sammlung, Munich (2152 v)

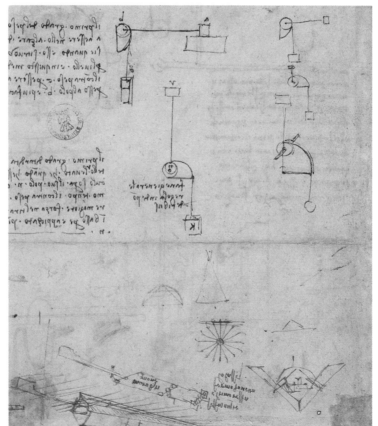

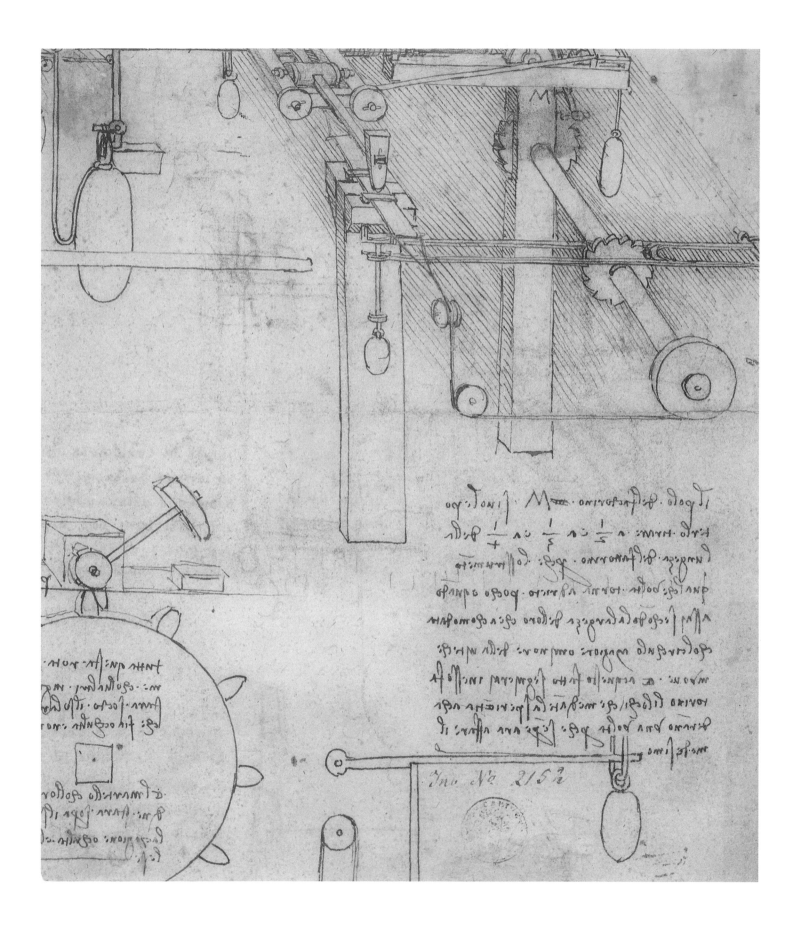

Inv. No. 215ᵃ

Model of an "automobile"
After a sketch from 1478–80
20th century
(view from the side)

Model of an "automobile"
After a sketch from 1478–80
20th century
(view from the front)

Design of an "automobile"
ca. 1478–80
Pen and ink
210x150 mm
Codex Atlanticus fol. 802r
Biblioteca Ambrosiana, Milan

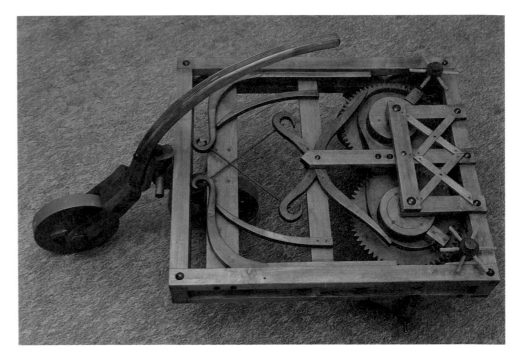

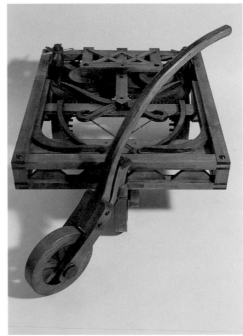

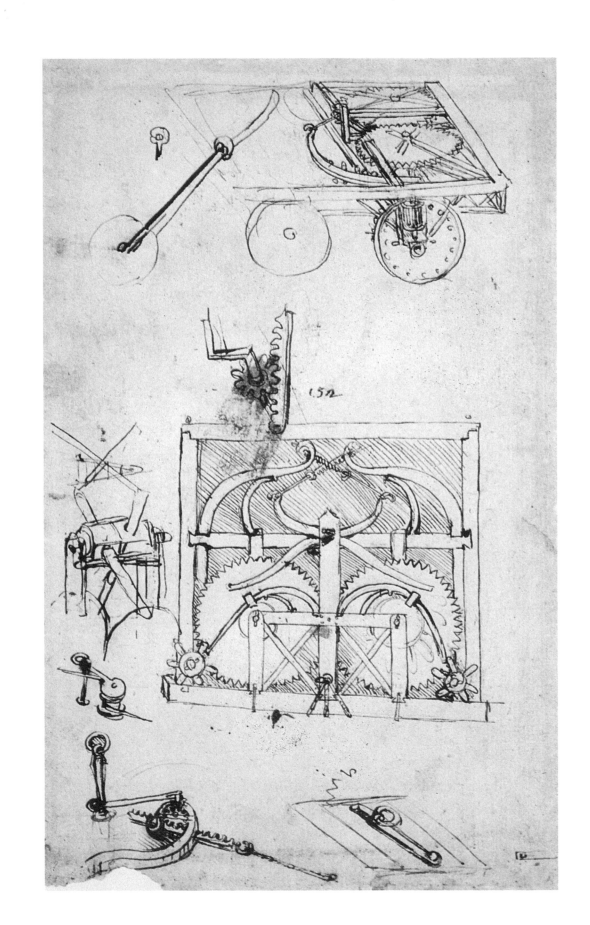

Hydraulic machines inspired
by Archimedes
ca. 1480
Pen and ink, wash
290 x 400 mm
Codex Atlanticus fol. 1069 r (ex 386 r-b)
Biblioteca Ambrosiana, Milan

Studies of various machines
ca. 1480
Pen and ink, wash
254 x 212 mm
Codex Atlanticus fol. 156 r (ex 56 r-b)
Biblioteca Ambrosiana, Milan

Studies for a flying machine
ca. 1493–95
Pen and ink over red chalk
285 x 206 mm
Codex Atlanticus fol. 846 v (ex 309 v-a)
Biblioteca Ambrosiana, Milan

Designs of machines for lifting columns
and heavy weights
ca. 1480
Pen and ink, black chalk
210 x 175 mm
Codex Atlanticus fol. 138 r (ex 49 v-a)
Biblioteca Ambrosiana, Milan

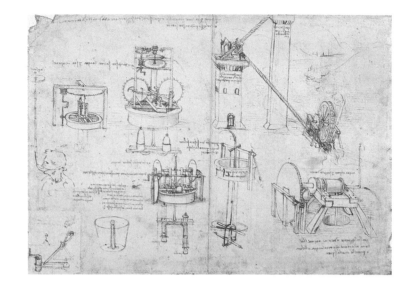

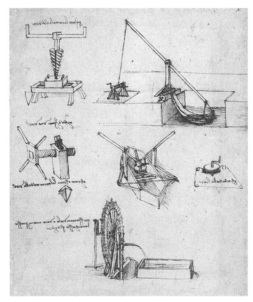

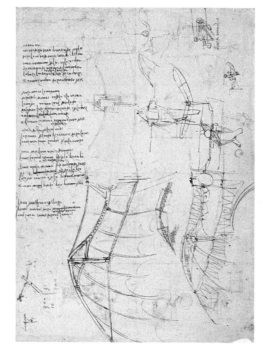

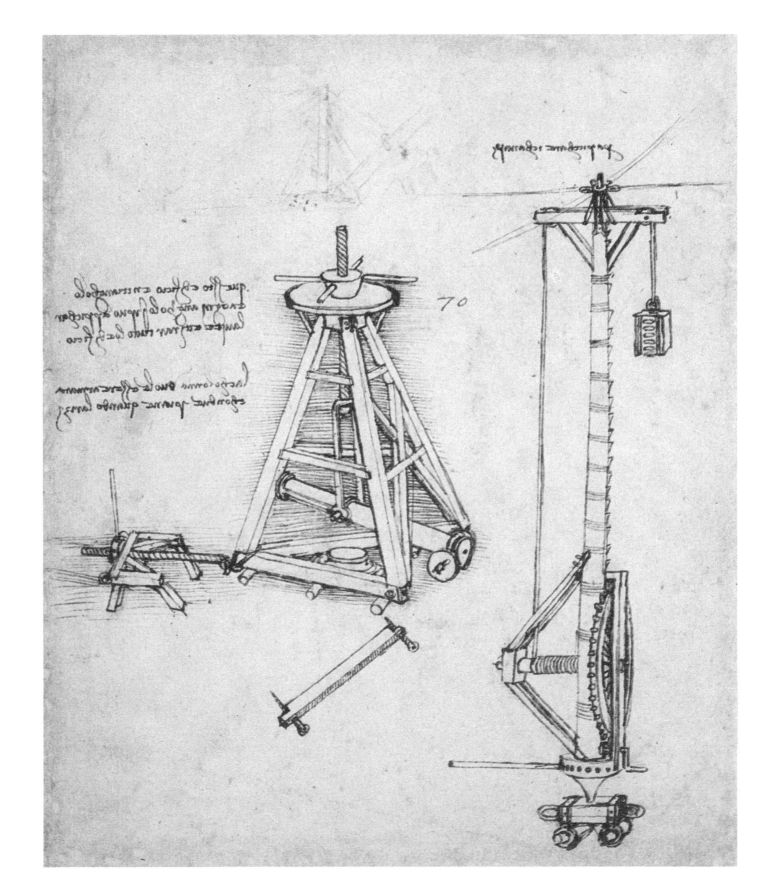

Design of a paddleboat
ca. 1495
Pen and ink
Detail
Codex Atlanticus fol. 1063r (384 r-b)
Biblioteca Ambrosiana, Milan

Model of a paddleboat
After a sketch from 1495
20th century
55 x 88 x 37 cm

Design of a pontoon bridge
ca. 1490
Pen and ink
Detail
Codex Atlanticus fol. 857r (312 v-b)
Biblioteca Ambrosiana, Milan

Design of a swivel bridge
ca. 1490
Pen and ink
Detail
Codex Atlanticus fol. 885r (312 v-a)
Biblioteca Ambrosiana, Milan

Model of a swivel bridge
After a sketch from 1490
20th century

Design of a two-story bridge
ca. 1487–89
Pen and ink
Detail
Institut de France, Paris, MS. B, fol. 23r

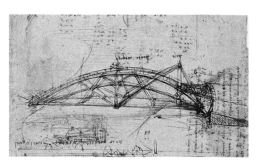
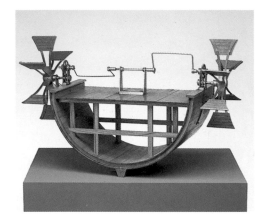
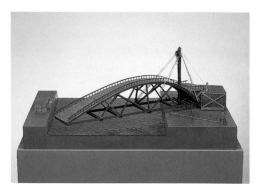
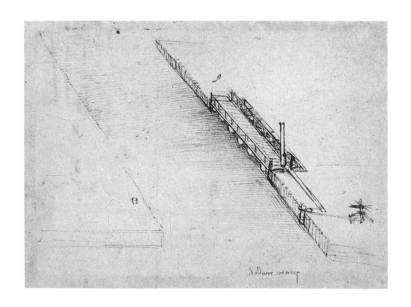

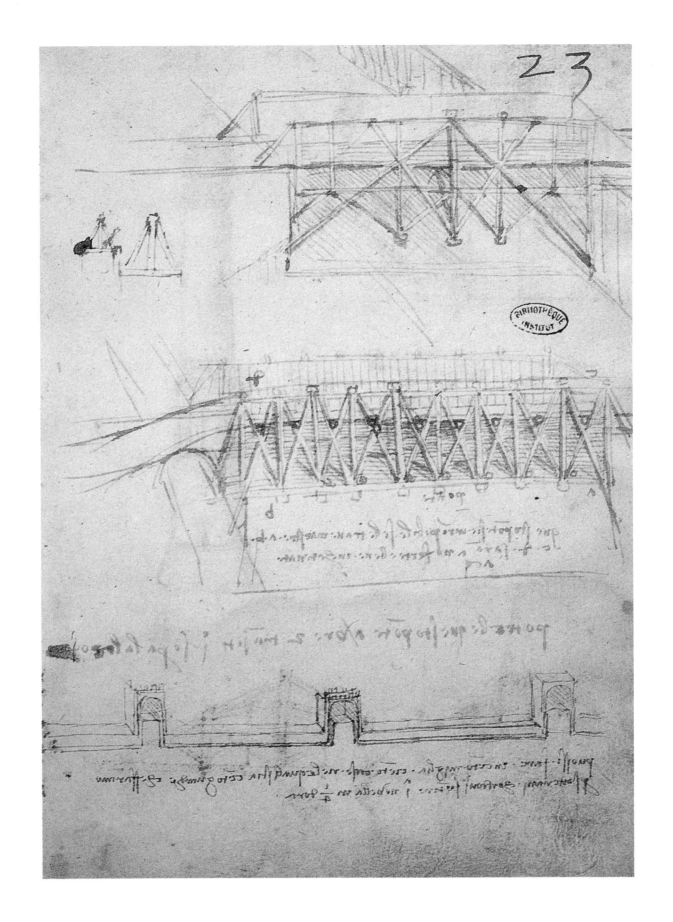

Design for a bridge over the Golden Horn
ca. 1502–03
Pen and ink
Institut de France, Paris, MS. L, fol. 66

Studies of the construction of a bridge
ca. 1500
Pen and ink
198x198 mm
Codex Atlanticus fol. 1074r (ex 387v-a)
Biblioteca Ambrosiana, Milan

Letter to Sultan Bajazet II with the
proposal for a bridge over the Golden Horn
from Stambul to Galata
ca. 1502
Pen and ink
300x120 mm
Topkapi Müzesi, Istanbul

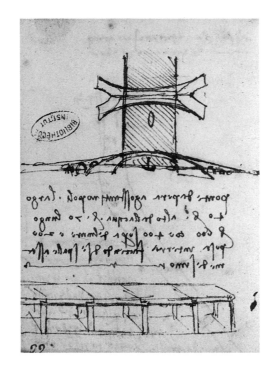

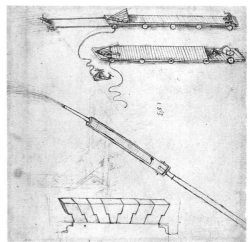

Of the shadows cast by bridges upon water

The shadows of bridges are never seen immediately above the water, unless the water has first lost its function of reflection because of turbulence. This is proved by the fact that clear water has a lustrous and polished surface, and reflects the bridge in all places at equal angles between the eye and the bridge, and reflects air underneath the bridge where the shadow of the bridge is. But turbid water cannot do this, because it does not reflect, but receives the shadow as would, indeed, a dusty road.

Leonardo da Vinci, Treatise on Painting, no. 545, fol. 158v and illus, p. 195

جمعوزدن طارد اولدكافو كوندرروكی ملکوت صورتی در

بن قلوكوز دكرمن حصوصنی شمديا دكين ماكوليدرت الله خايبلم بر

وصهام جار . بولدُم که بر تصفیه ایله صوصوز همان بیل ایله دكرمن

ایدرم که دكزده اولان دكرمندن دحی ازیاده حاصل اولد وكم طقه

ده آسانك وكم قدره اولورایسه اوثور ودحی الله حاجی بكا نصیب ایدب ه

که بر تصفیه ایله ایا ایهوز واوزرنا نصورمكی نك صونی جغارم بر دولادیب ایله

که کندو هنه وبن قلوكك غویلم اتقدم که اسنا بولدن عالقیه بر كوبجه یابمق

قصدنده امس . اما بلورلقم بولوصدردعربیدن یابامفل سز بن قلوكك

بلورین بر یابی که یوکسك قالدرم که یوکلکفدن ه به مکنه اوزرندن یوکلکفدن کمکه

كاضر اولیه . اما به ماک ایلدرم که بر جنماایهم انه فصهاكه صویه جغارم وقا

زقار و قیام غویله ایدم که اشفادن همان یكین بیلم بوملی چقاً وكریه؟

ایهم که قالقم که اشدركلدب وقت اماطرچی يقاسنه کجُ . اما صولار

قایم اقد و عجون كنارگز یغور اول حوصول جون بر تصفینك ایلیم

که اول اقان صویه اشفادن اقرب کنار . ضدز ایلمیه سندن صدک ه

اولان یا دشنام کر قولادب خرجلمه ییالر بو صوز لردوص ان نغار الله

که بمکک بالمک ودنه قلوكوز قایم حذمتاكه د بلوورب یبورردی

بو مکتوب بولبوس انیك اجمدر . یازلمش در

حذت آیه فز

Canal with locks and weirs
ca. 1482
Pen, ink, and black chalk
278x210 mm
Codex Atlanticus fol. 90v (ex 33v-a)
Biblioteca Ambrosiana, Milan

Plan for the Florentine canal
ca. 1495
Pen and ink
270x200 mm
Codex Atlanticus fol. 127r (ex 46r-b)
Biblioteca Ambrosiana, Milan

Plan for the Florentine canal
ca. 1495
Pen and ink
270x200 mm
Codex Atlanticus fol. 126v (ex 46v-a)
Biblioteca Ambrosiana, Milan

The Ivrea-canal for sailboats
ca. 1495
Pen and ink
185x275 mm
Codex Atlanticus fol. 563r (ex 211v-a)
Biblioteca Ambrosiana, Milan

Design of a rotary crane
ca. 1497
Pen and ink
155x146 mm
Codex Atlanticus fol. 146r (ex 52r-b)
Biblioteca Ambrosiana, Milan

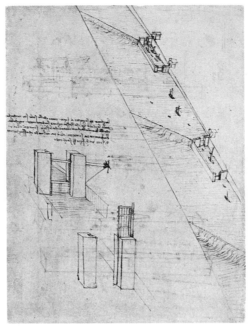

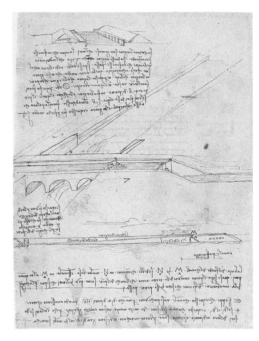

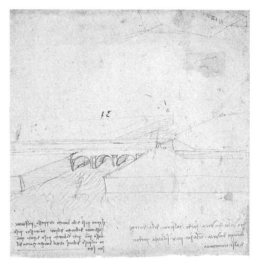

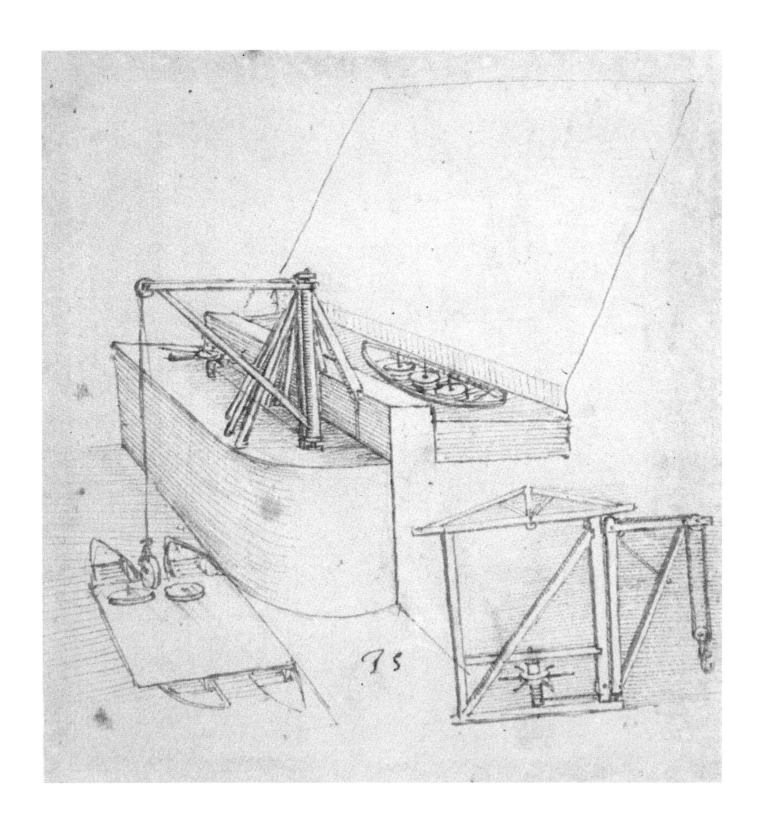

Study of a fortification system
ca. 1508
Pen and ink, wash
200x215 mm
Codex Atlanticus fol. 604r (ex 223v-a)
Biblioteca Ambrosiana, Milan

Drawing for a fortress
ca. 1505–10
Pen and ink, wash
290x435 mm
Codex Atlanticus fol. 116r (ex 41v-a)
Biblioteca Ambrosiana, Milan

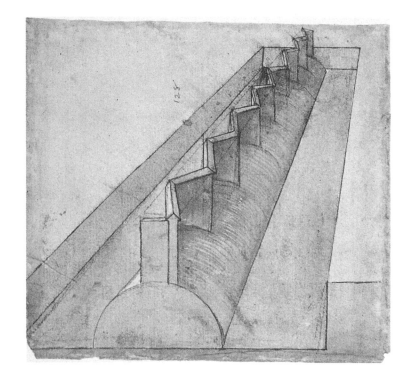

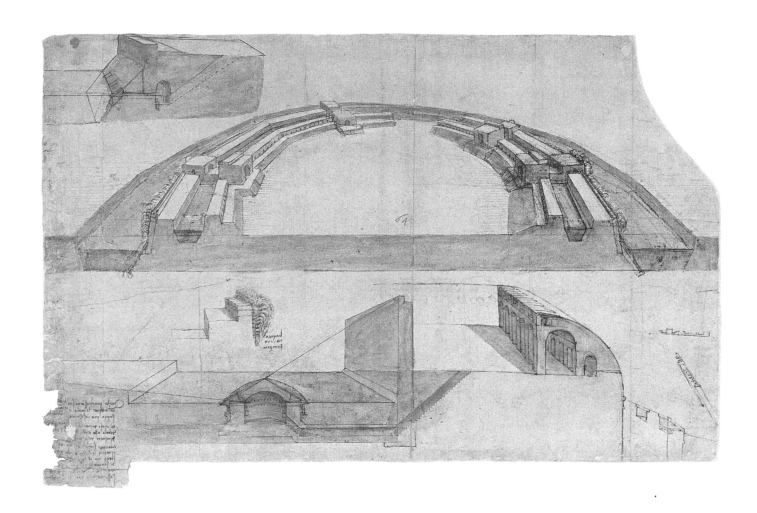

Notes on the Naviglio Canal
ca. 1508
Pen and ink
310x215 mm
Codex Atlanticus fol. 183r (ex 65 r-a)
Biblioteca Ambrosiana, Milan

The San Cristoforo Canal
May 3, 1509
Pen and ink, wash
203x295 mm
Codex Atlanticus fol. 1097r (ex 395 r-a)
Biblioteca Ambrosiana, Milan

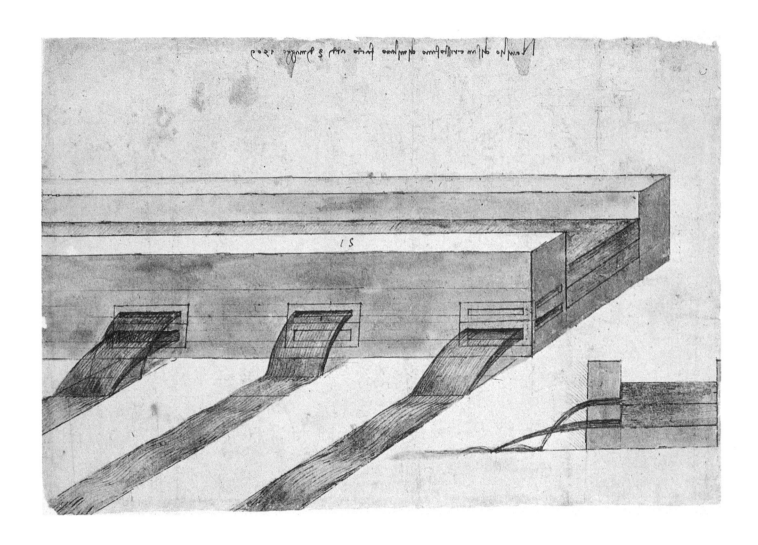

Design of a parachute
ca. 1485
Pen and ink
Detail
Codex Atlanticus fol. 1058v (ex 381v-a)
Biblioteca Ambrosiana, Milan

Model of a parachute
After a sketch from 1485
20th century

Study of a bird in flight
ca. 1507
Pen and ink
312×206 mm
Codex Atlanticus fol. 571v-a (214v-a)
Biblioteca Ambrosiana, Milan

Study of human flight
ca. 1485
Pen and ink
287×214 mm
Codex Atlanticus fol. 1058v (ex 381v-a)
Biblioteca Ambrosiana, Milan

Flying machine
ca. 1508
Pen and ink
Bibliothèque de l'Institut de France, Paris, MS. D,
fol. 89r

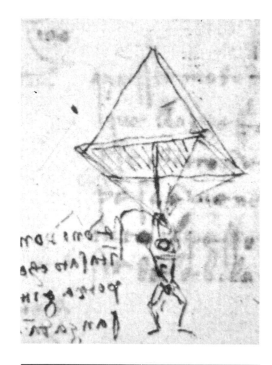

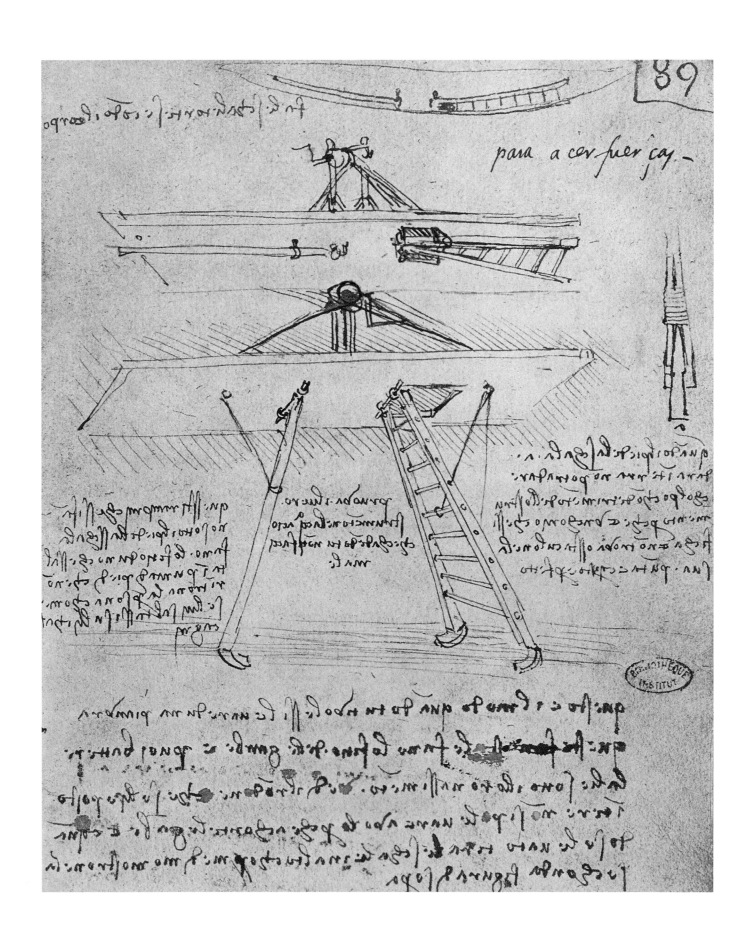

Chronometry

Time and again Leonardo devoted his attention to a wide variety of time-keeping instruments. He designed relatively simple hour glasses (Codex Arundel, 191 v and 242 v) as well as more complex instruments inspired by antique models such as the water-clock in the Codex Atlanticus (943 r). The passage of time is shown by water which slowly flows past a marking. In the Codex Hammer (fol. 9 B to 28 r) he describes how the headway of ships can be measured with the help of a potter's wheel and an hour glass.

During his first sojourn in Florence, around 1478–80, he designed a system for the representation of a sundial (Codex Atlanticus, fol. 1022 v). A design for a sundial which today exists as a fragment (Royal Library, Windsor, RL 19106) bears the ambiguously captivating inscription "Oh Sun/ Only for Thee my Hours were Made". For a long time this statement was misinterpreted as an autobiographical profession: the erratic Leonardo, squandering his time. He continued to be interested in sundials until the end of his life, as fol. 920 r from 1517 in the Codex Atlanticus makes clear. Leonardo's horological research was also rewarded. He made a "Drawing of a Clock" for the sponsor of the "Adoration of the Magi" (Uffizi, Florence; see p. 41) between 1479 and 1482 for which he received one Lira and six wood thalers.

Leonardo was, however, fascinated most by mechanical wheel clocks which, for the first time, made it possible to measure the passage of time exactly. The manuscripts of the Madrid Codex which were rediscovered in 1966 have increased our knowledge about Leonardo's researches on the exact measurement of time. Leonardo frequently revised his early studies and supplemented them with new thoughts. He achieved an extraordinary aesthetic level by pursuing continual analysis in this way. He represents clocks in all their detail in the first Madrid manuscript — their driving power and transmission ratios, their hands and dials, balance-wheels and cogwheels, flywheels and escapement, pendulum wheels and chimes. He even attempted to subdue the sounds produced: "and this ran quite without noise" (MS. Madrid I, 8 v). Again and again he drew parallels between clock mechanisms and other machines.

The musically talented Leonardo was also particularly interested in chimes and bells. In the Paris manuscript MS. L, fol. 25 v, he drew a clock fitted with a small cogwheel-driven hammer for the chimes.

The ingenious inventor even drew a hydraulic clock with a mechanical figure to strike the hours around 1508–10 (Royal Library, Windsor, RL 12688 and 12716). He also investigated the problems arising in connection with the weighted clock, developed particular types of spring, constructed special endless screw threads and refined the mechanisms of various flywheels and flywheel rims.

Almost a century before Galileo (1583) and long before Huygens (1657), Leonardo developed fundamental knowledge about chronometry which was way ahead of its time.

The Anatomy of a Clock

Analogies are to be found again and again in Leonardo's artistic work and research, be it in his designs for machines, the studies for his paintings, the anatomical drawings of the human body or in his investigations of the cosmos.

In order to be able to draw a clock in all its complexity, Leonardo studied its "anatomy". He dismantled its individual components and searched for the universal in the particular. He examined the statics of the structure and observed the dynamism of its motion. Leonardo sought to grasp materials and methods of working as well as elementary forms and principles in order to draft "new machines" for a "new world".

Leonardo's intensive study of clocks and weaving machinery deserves to be emphasized. A series of sketches and notes on this theme can be found in the Codex Atlanticus (Biblioteca Ambrosiana, Milan) and in the Madrid manuscript (National Library). They were made during Leonardo's first sojourn in Milan between 1493 and 1497.

Alessandro Vezzosi

Study of a spring drive mechanism
in a time instrument
ca. 1495–98
Pen and ink
210 x 150 mm
Codex Madrid I fol. 45 r
Biblioteca Nacional, Madrid

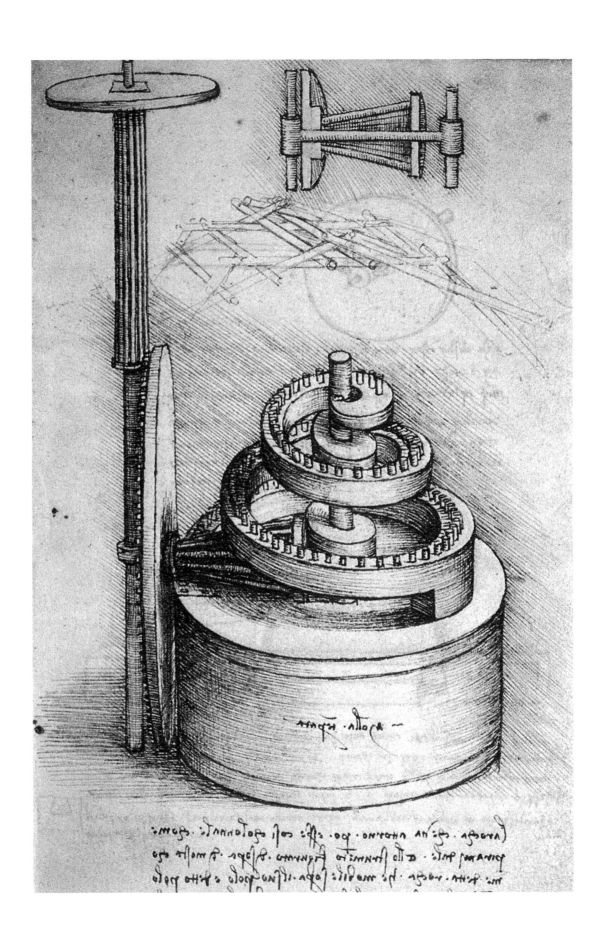

Drawing of a clockwork mechanism
ca. 1493
Pen, ink, and red chalk
Codex Atlanticus fol. 863r (314 r-b)
Biblioteca Ambrosiana, Milan

Model of a clockwork mechanism
After a sketch from 1493
20th century
Codex Atlanticus, fol. 863r
Museo Ideale, Vinci

Clock mechanism with bell
ca. 1495–98
Pen and ink
Codex Madrid I fol. 27v
Biblioteca Nacional, Madrid

The Clockwork Motor of the Flying Machine

Leonardo studied the similarities in the technical apparatus of the pendulum clock and mill machinery (Codex Atlanticus, 1059r, 1065r; Codex Forster, 46r; MS. H, 110v). He was also interested in machines which "made wind" (Codex Atlanticus, 691r) and in turning lathes (Windsor 12667).

On one of the best known study folios for a flying machine from the Codex Atlanticus (fol. 863r, ca. 1493) he superimposed a clock mechanism. The realization of Leonardo's study in a model (by Alberto Gorla) demonstrates that the design is an exact reproduction of a clockwork mechanism.

The Astronomical Clock

Leonardo da Vinci was very well informed about the important clocks of his time. He was familiar, for example, with the clocks by Brunelleschi and Alberti. In the Codex Atlanticus he mentions the old clock of the Abbey of Chiaravalle near Milan for the first time. He later revised this clock again in the Madrid manuscript.

He knew the astronomical clock by Lorenzo della Volpaia in the Palazzo Vecchio in Florence as well as that of the Dondi in the ducal library in Pavia. He described the latter as a clock of divine significance, exceeding the powers of human imagination. The Dondi astrological clock was considered one of the mechanical wonders of the time and was furnished with a chronometric mechanism, a calendar for all the religious feasts and a symbol dial with the five known planets.

Leonardo was exhilarated by this wonder-work and described it in countless sketches. Bramante traveled to Pavia himself in order to make the drawings for the iconography of the clock face. The frescos in the ducal palace at Vigevano are closely connected with these iconographic representations. Some of the drawings by Leonardo in Manuscript L in the Institut de France, Paris, appear to be related to the figures on the clock face: the Venus (fol. 92v) and Mars (fol. 93v).

Alessandro Vezzosi

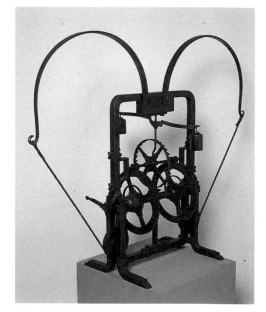

Design of a hydraulic machine

ca. 1490

Pen and ink

240x190 mm

Codex Atlanticus fol. 137r (ex 49r-b)

Biblioteca Ambrosiana, Milan

Design of a spinning machine

ca. 1495

Pen and ink

286x415 mm

Codex Atlanticus fol. 1090v (ex 393v-a)

Biblioteca Ambrosiana, Milan

Model of gears

After a sketch from 1497–1500

in Codex Atlanticus fol. 210v (77v-a)

20th century

Design of a hydraulic machine

ca. 1490

Pen and ink

280x180 mm

Codex Atlanticus fol. 179v (ex 63v-a)

Biblioteca Ambrosiana, Milan

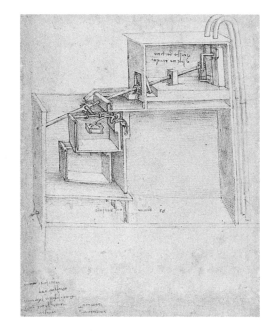

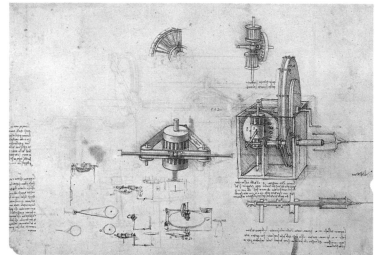

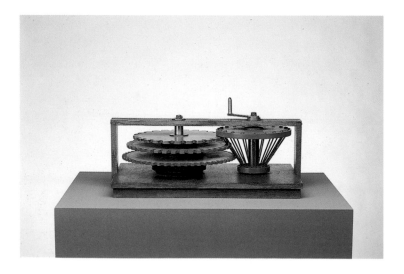

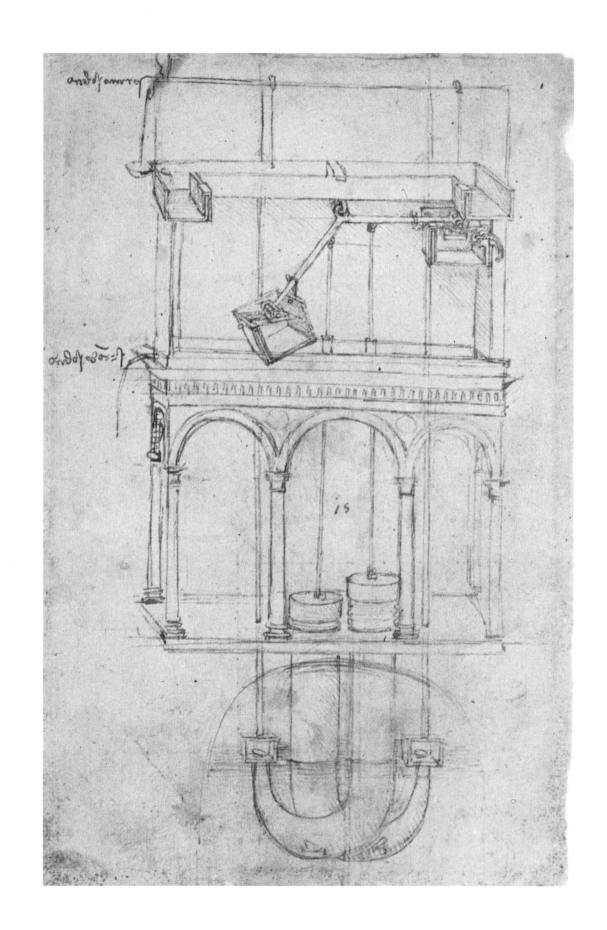

Designs for the grinding of optical
instruments
ca. 1505–08
Pen and ink
195x135 mm
Codex Atlanticus fol. 1103v (ex 396v-f)
Biblioteca Ambrosiana, Milan

Oil lamp with reflecting mirror
ca. 1505
Pen and ink
235x170 mm
Codex Atlanticus fol. 1027r (ex 368r-b)
Biblioteca Ambrosiana, Milan

Design for an ignition mechanism
ca. 1513
Pen and ink
172x287 mm
Codex Atlanticus fol. 158r (ex 56v-b)
Biblioteca Ambrosiana, Milan

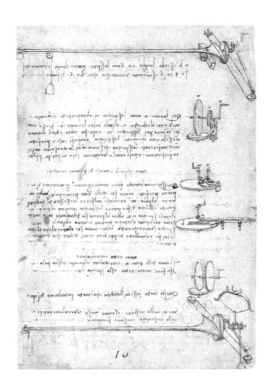

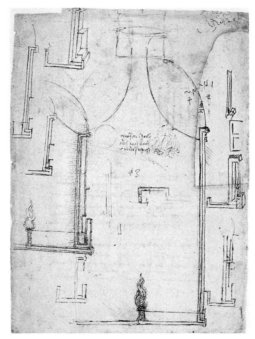

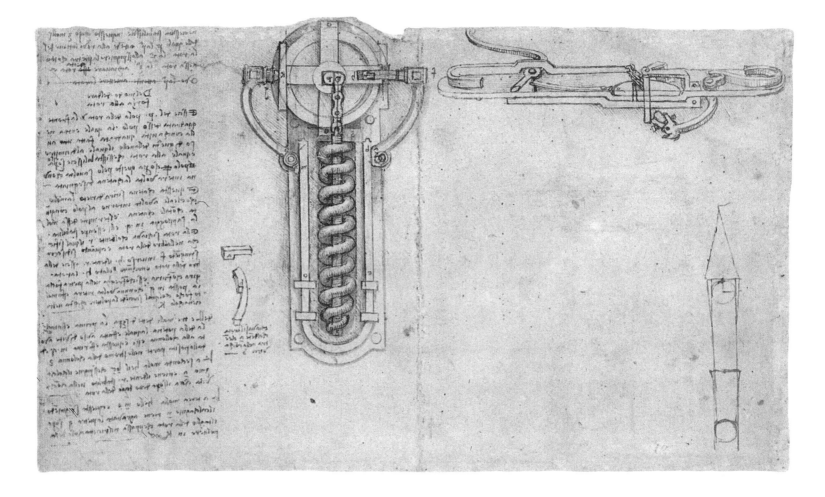

Model of a lyre
After a sketch from ca. 1492
Bronze
47x30x25 cm
Museo Ideale, Vinci

Study for a lyre
ca. 1492
Pen and ink
270x175 mm
Institut de France, Paris, MS. Ash. 2037

Studies for a musical instrument
ca. 1493
Pen, ink, and red chalk
270x175 mm
Codex Atlanticus fol. 93r (ex 34 v-b)
Biblioteca Ambrosiana, Milan

How music must be called a sister, a younger sister, of painting

Music is to be termed the sister of painting, for it is subject to the sense of hearing, a sense second to the eye. It composes harmony with the conjunction of proportioned parts sounded at the same time. It is obliged to be born and to die in one or a number of harmonic rhythms, / rhythms that surround the proportion of its parts, and create a harmony which is not composed otherwise than is the line which surrounds the forms from which human beauty is derived.
But painting excels and lords over music, because it does not die immediately after its creation, as does unfortunate music. Thus it remains in being and shows you as alive what is in fact only an inanimate representation.
Marvelous science of painting! You preserve alive the ephemeral beauties of mortals, which through you become more permanent than the works of nature, which vary continually with time, leading them to expected old age. Such a science bears the same relation to divine nature as its works do to the works of nature, and therefore it is adored.

Leonardo da Vinci, Treatise on Painting, no. 39, fol. 16–16v, pp. 25–26

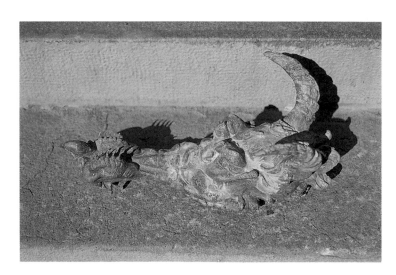

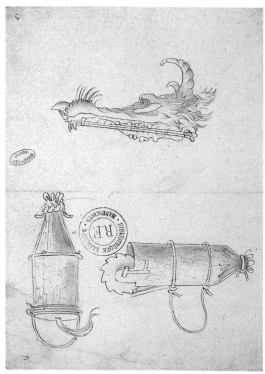

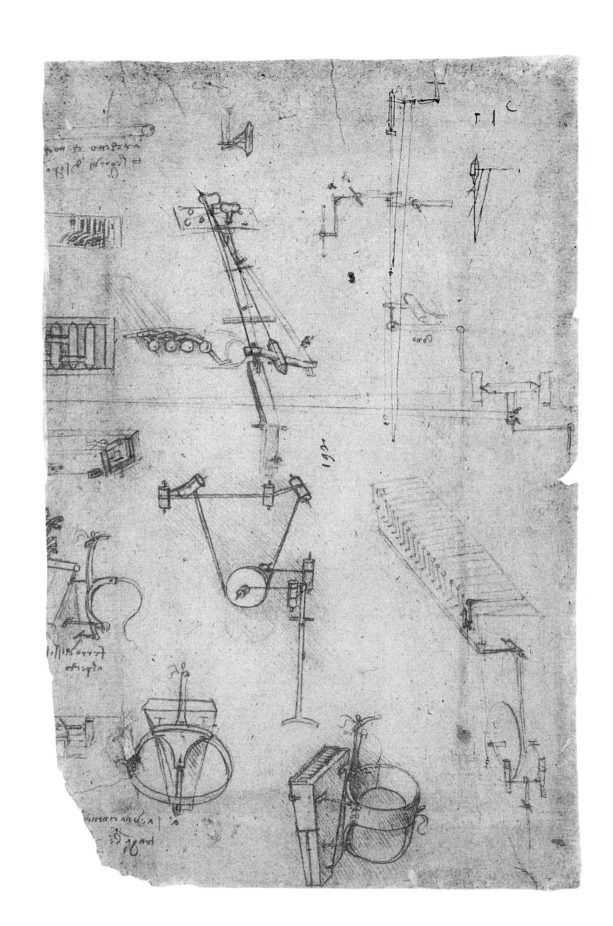

Studies of whirlpools and waterfalls

ca. 1513
Pen and ink
180 x 268 mm
Pedretti 47 r
Royal Library, Windsor (RL 12662)

Depiction of whirlpools and a study of a musing old man

ca. 1513
Pen and ink
152 x 213 mm
Pedretti 48 r
Royal Library, Windsor (RL 12579)

Architectural studies, water studies, and notes

ca. 1513
Pen and ink
204 x 245 mm
Codex Atlanticus fol. 1098 (ex 395 r-b)
Biblioteca Ambrosiana, Milan

Study of the flow of water

ca. 1508–09
Pen and ink over black chalk
295 x 205 mm
Pedretti 42 r
Royal Library, Windsor (RL 12669 v)

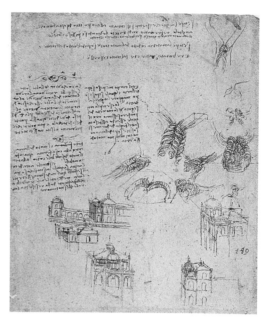

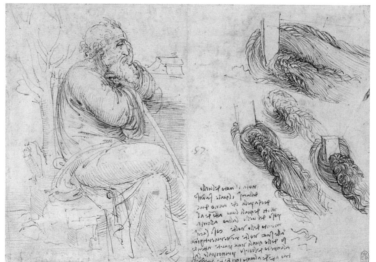

Of the foam of water

The foam of water appears least white when it is farthest from the surface of the water. This is proved by the fourth proposition of this book, wherein it is stated: That submerged object will be the most transmuted from its natural color into the green color of the water that has the greatest amount of water above it.

Leonardo da Vinci, Treatise on Painting, no. 525, fol. 160, p. 189

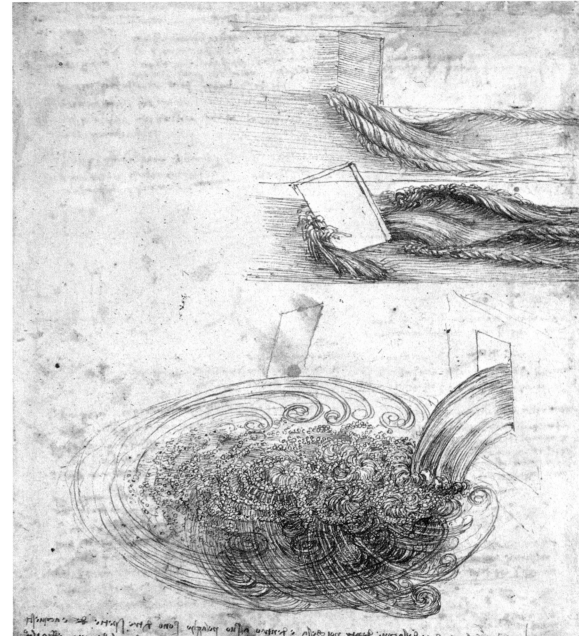

Design for a siege machine

ca. 1480
Pen and ink
270×195 mm
Codex Atlanticus fol. 1084r (ex 391v-a)
Biblioteca Ambrosiana, Milan

Drawing for a mechanism of defense against siege ladders

ca. 1482
Pen and ink over chalk
256×196 mm
Codex Atlanticus fol. 139r (ex 49v-b)
Biblioteca Ambrosiana, Milan

Design of a tank

ca. 1485
Pen and ink
Detail
British Museum, London BB 1030

Model of a tank

After a sketch from 1485
20th century

Model of a machine gun

After a sketch from ca. 1482
20th century

Design for a machine gun

ca. 1482
Pen and ink
265×185 mm
Codex Atlanticus fol. 157v (ex 56v-a)
Biblioteca Ambrosiana, Milan

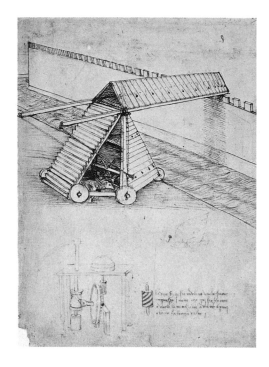

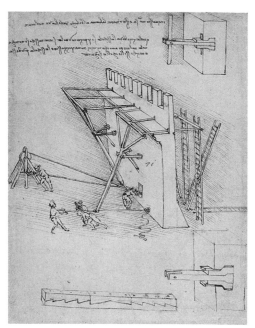

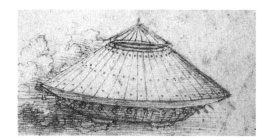

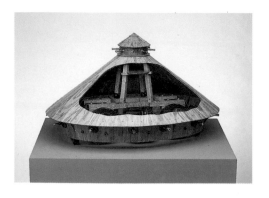

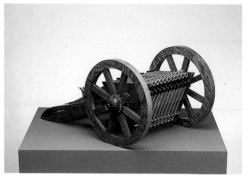

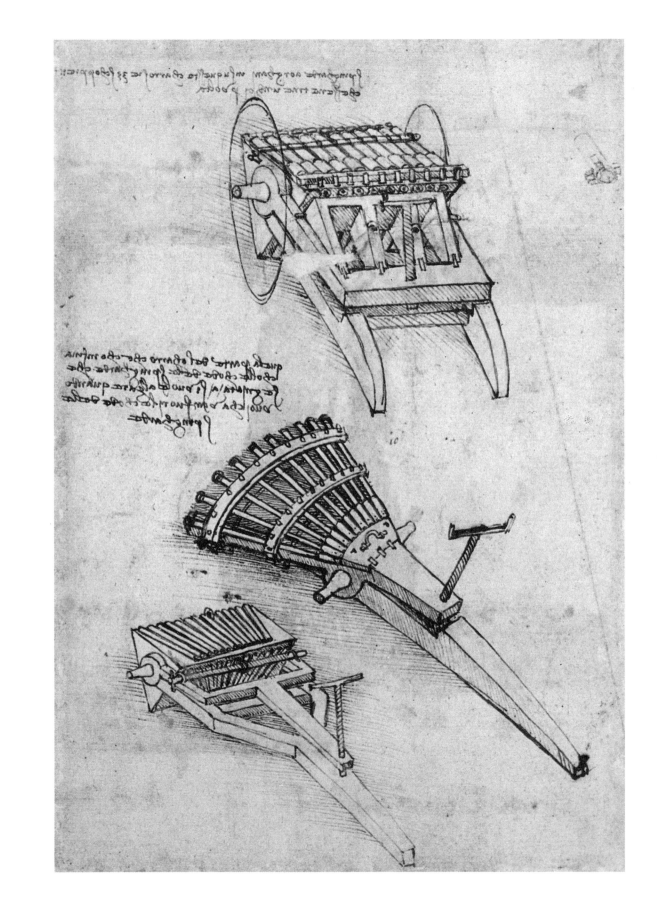

Design of a war machine
ca. 1485
Pen and ink
180x260 mm
Codex Atlanticus fol. 159a (ex 57r-b)
Biblioteca Ambrosiana, Milan

Design of a war machine for hurling
stones
ca. 1485
Pen and ink
205x260 mm
Codex Atlanticus fol. 159b (ex 57r-b)
Biblioteca Ambrosiana, Milan

Design of a war machine for hurling
stones
ca. 1485
Pen and ink
177x240 mm
Codex Atlanticus fol. 160r-a (ex 57v-a)
Biblioteca Ambrosiana, Milan

Design of a war machine for hurling
stones
ca. 1485
Pen and ink
200x235 mm
Codex Atlanticus fol. 160r-b (ex 57v-b)
Biblioteca Ambrosiana, Milan

Design of catapult for stones and bombs
ca. 1485
Pen and ink
170x305 mm
Codex Atlanticus fol. 145r (ex 51v-b)
Biblioteca Ambrosiana, Milan

Design of war chariots with sickles
ca. 1485
Pen, brown ink, and bistre wash
210x290 mm
Biblioteca Reale, Turin 14r (15583r)

Design of a war machine with
four crossbows
ca. 1485
Pen and ink
183x250 mm
Codex Atlanticus fol. 1070r (ex 387r-a)
Biblioteca Ambrosiana, Milan

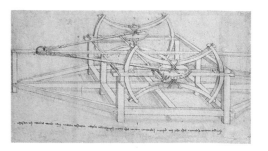
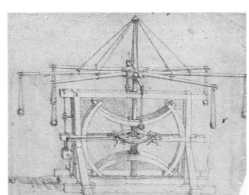
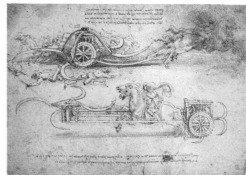
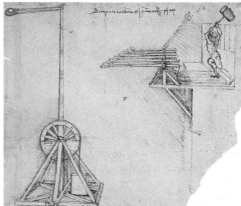

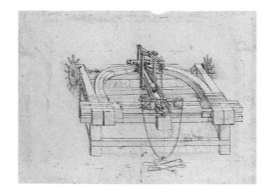

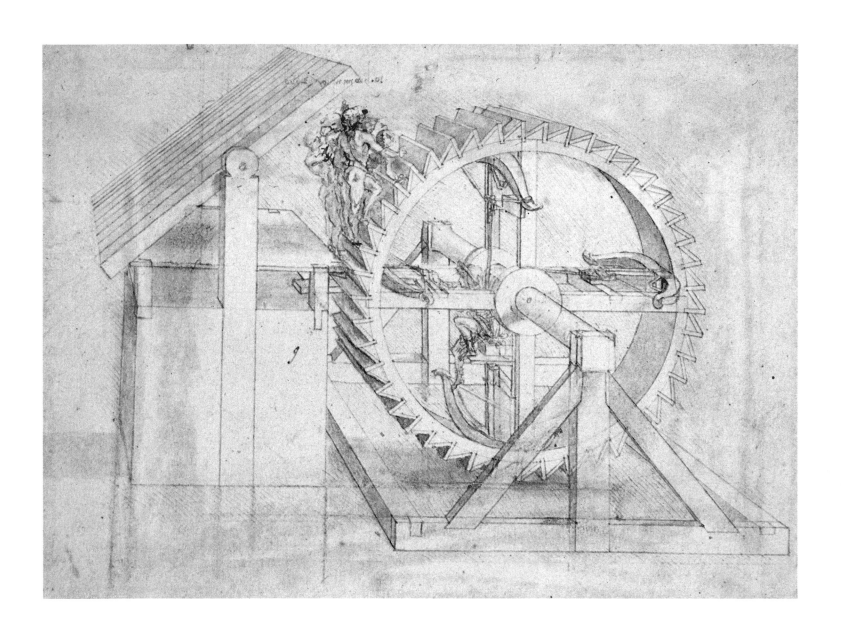

Technological studies

ca. 1487

Pen and ink

280 x 200 mm

Pierpont-Morgan Library, New York (6 r)

Design of a catapult

ca. 1485

Pen and ink

217 x 297 mm

Codex Atlanticus fol. 182b (ex 64 v-a)

Biblioteca Ambrosiana, Milan

Design of a war machine with sixteen crossbows

ca. 1485

Pen and ink

217 x 298 mm

Codex Atlanticus fol. 182 r-b (ex 64 v-b)

Biblioteca Ambrosiana, Milan

Design of a steam canon

ca. 1487–89

Pen and ink

Detail

Institut de France, Paris, MS. B fol. 33

Model of a steam canon

After a sketch from 1487–89

20th century

Design of a gigantic crossbow

ca. 1485

Pen and ink over chalk

205 x 275 mm

Codex Atlanticus fol. 149 r-b (ex 53 v-b)

Biblioteca Ambrosiana, Milan

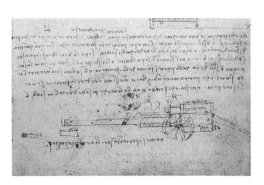

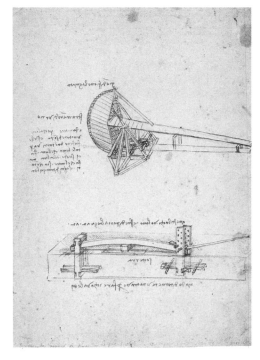

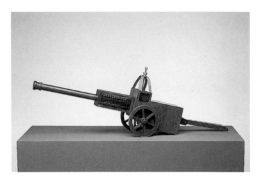

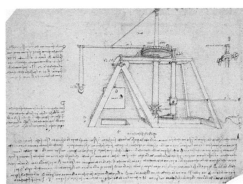

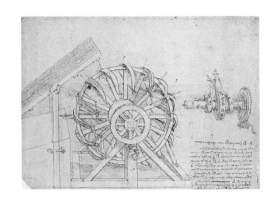

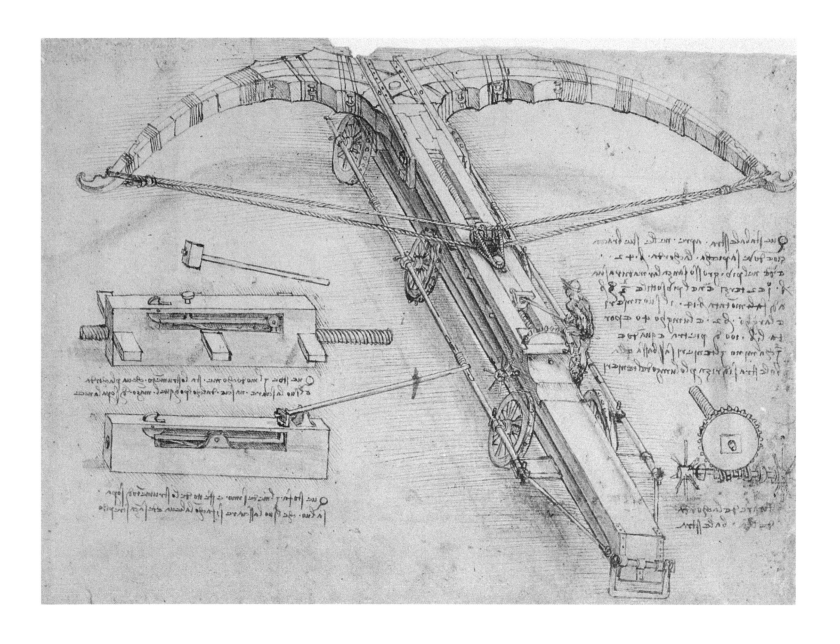

Study of a fortification system

ca. 1503

Pen and ink

225x310 mm

Codex Atlanticus fol. 121v (ex 43v-b)

Biblioteca Ambrosiana, Milan

Balestrieri's wheel

ca. 1510

Pen and ink

255x118 mm

Codex Atlanticus fol. 624v (ex 229v-b)

Biblioteca Ambrosiana, Milan

Design of a siege ladder

ca. 1505

Pen and ink

Detail

Codex Forster I fol. 46v

Victoria and Albert Museum, London

Model of a siege ladder

After a sketch from 1505

20th century

Study of a fortification system

ca. 1503

Pen and ink

230x300 mm

Codex Atlanticus fol. 120v (ex 43v-a)

Biblioteca Ambrosiana, Milan

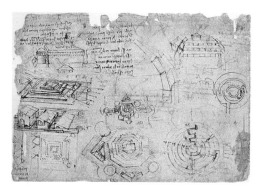

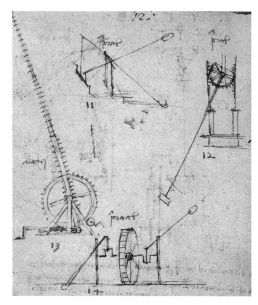

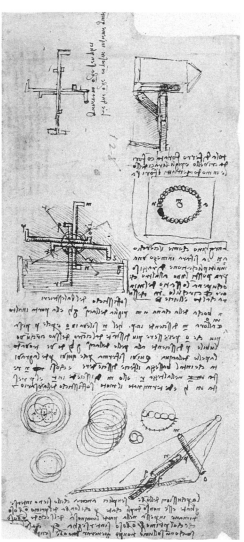

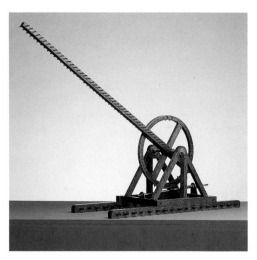

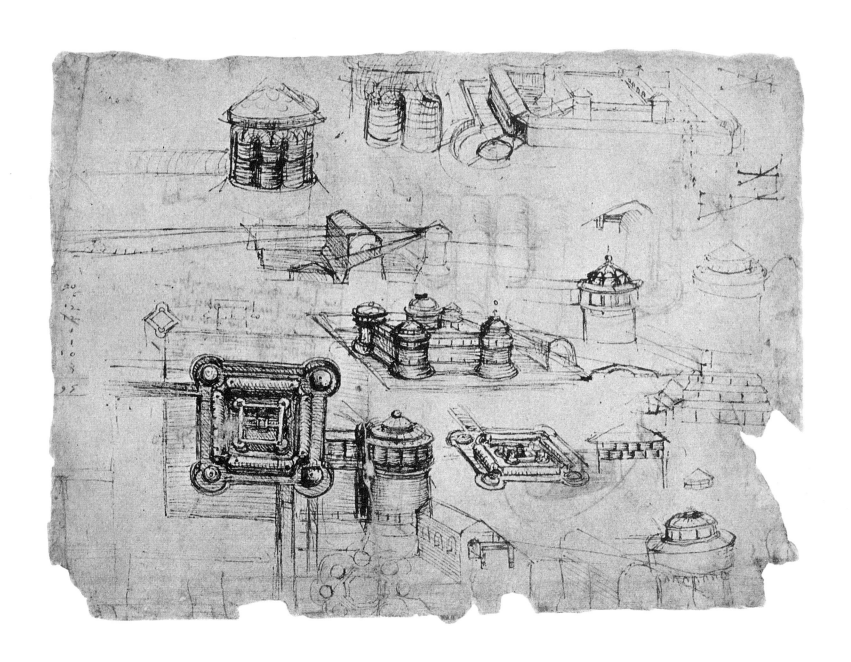

Thunderstorm in a bay
ca. 1515
Pen and ink over black chalk
163 x 206 mm
Pedretti 56 r
Royal Library, Windsor (RL 12401)

Description of a flood
notes on the waves of Piombino
ca. 1516
Pen and ink
304 x 213 mm
Pedretti 67 v
Royal Library, Windsor (RL 12665)

Apocalyptic storm
ca. 1517
Pen and ink over black chalk, wash,
heightened with white
267 x 408 mm
Pedretti 68 r
Royal Library, Windsor (RL 12376)

Notes and sketches on the Great Flood
with remarks from a pupil
ca. 1516
Pen and ink
298 x 200 mm
Codex Atlanticus fol. 215 r (ex 79 r-c)
Biblioteca Ambrosiana, Milan

Flood over fallen trees
ca. 1516
Black chalk on coarse, creme-colored paper
161 x 210 mm
Pedretti 65 r
Royal Library, Windsor (RL 12386)

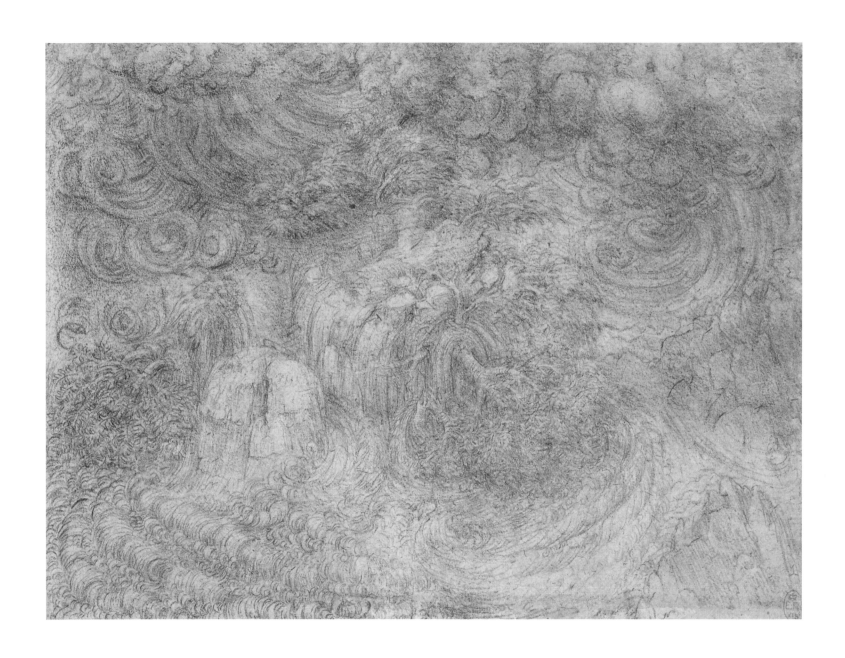

Of the arrangement of a storm of winds and of rain

The air is seen tinged with nebulous darkness at the approach of a tempest or storm at sea. This is a mixture of rain and wind, with serpentine twistings in the tortuous course of threatening lightning bolts. The trees bend to earth, with the leaves turned inside out on the bent branches, which seem as though they would fly away, as if frightened by the blasts of the horrible and terrifying wind, amid which is diffused the vertiginous course of the turbulent dust and sand from the seashore. The obscure horizon of the sky makes a background of smoky clouds, which, struck by the sun's rays, penetrating through openings in the clouds opposite, descend to the earth, lighting it up with their beams. The winds that drive the dust raise it into the air in globular masses, and these masses have an ash color mingled with reddish rays of the sun that penetrate them. The animals, without a guide to lead them to safety, are terrified and run about in circles. / Claps of thunder, created by the globular clouds, throw off infuriated bolts of lightning, and their light illuminates the shadowed countryside in various places.

Leonardo da Vinci, Treatise on Painting, no. 553, fol. 158–158v, pp. 198–199

How to represent a storm

If you wish to represent a storm well, consider and place before your mind the effects of the wind, blowing over the surface of the sea and the earth, as it removes and carries with it those things which are not firmly imbedded in the mass of the earth. In order to represent the storm well first of all paint the clouds, torn and rent, swept along by the course of the wind, together with the sandy powder lifted from the seashores; include branches and leaves, raised by the powerful fury of the wind, scattered through the air, as well as many other light objects. The trees and grass are bent against the earth, seeming almost as if they were trying to follow the course of the winds, with their branches twisted out of their natural direction, their leaves battered and turned upside down. Some of the men there have fallen and, wrapped in their clothing, are almost unrecognizable because of the dust, while those who are still standing are under some tree, hugging it so the wind will not tear them away. Others, with their hands before their eyes because of the dust, are bent down to the earth, and their garments and hair stream in the direction of the wind. The turbulent and tempestuous sea is filled with whirlpools of foam between the high waves, with the wind raising the thinnest foam, amid the striving air, in the fashion of a thick, enveloping mist. Depict some of the ships in the painting with torn sail, the pieces flapping in the air with some ropes torn apart, some masts broken and gone overboard, the ship cracking up and broken by the tempestuous waves, while men shout and cling to the wreck of the ship.

Leonardo da Vinci, Treatise on Painting, no. 281, fol. 52v, p. 114

The Great Flood
ca. 1516
Black chalk on coarse, creme-colored paper
158x210 mm
Pedretti 66r
Royal Library, Windsor (RL 12383)

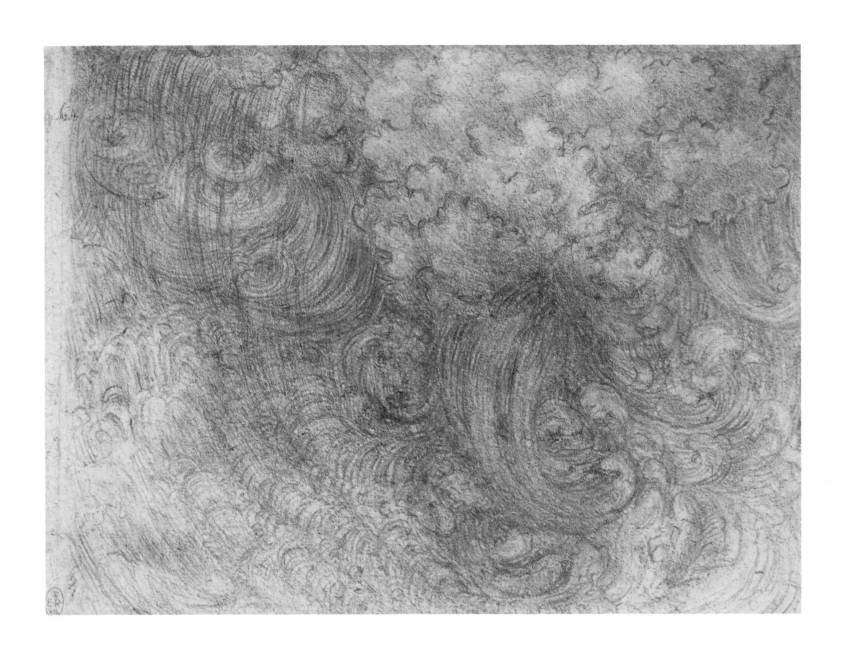

Studies of nature's destructive power
and notes
ca. 1517
Pen and ink over traces of black chalk on coarse,
brown paper
300×203 mm
Pedretti 70 r
Royal Library, Windsor (RL 12388)

Cloudburst above a city
ca. 1516
Black chalk
158×210 mm
Pedretti 60 r
Royal Library, Windsor (RL 12385)

The Great Flood
ca. 1516
Pen, ink, and black chalk
162×203 mm
Pedretti 59 r
Royal Library, Windsor (RL 12380)

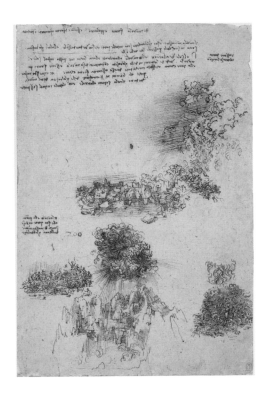

Of painted wind

In the representation of the wind, beside the bending of branches and the twisting of leaves in a direction contrary to that from which the wind comes, there should be represented the whirling of fine dust, mixed with the murky air.

Leonardo da Vinci, Treatise on Painting, no. 551,
fol. 157 v, p. 198

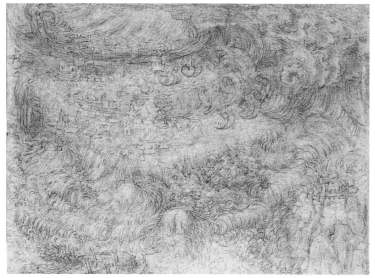

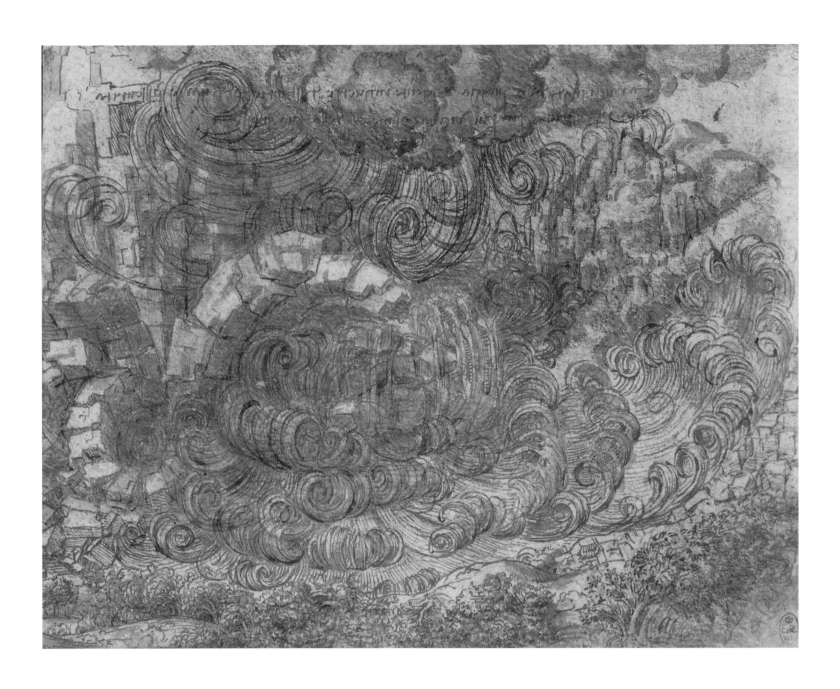

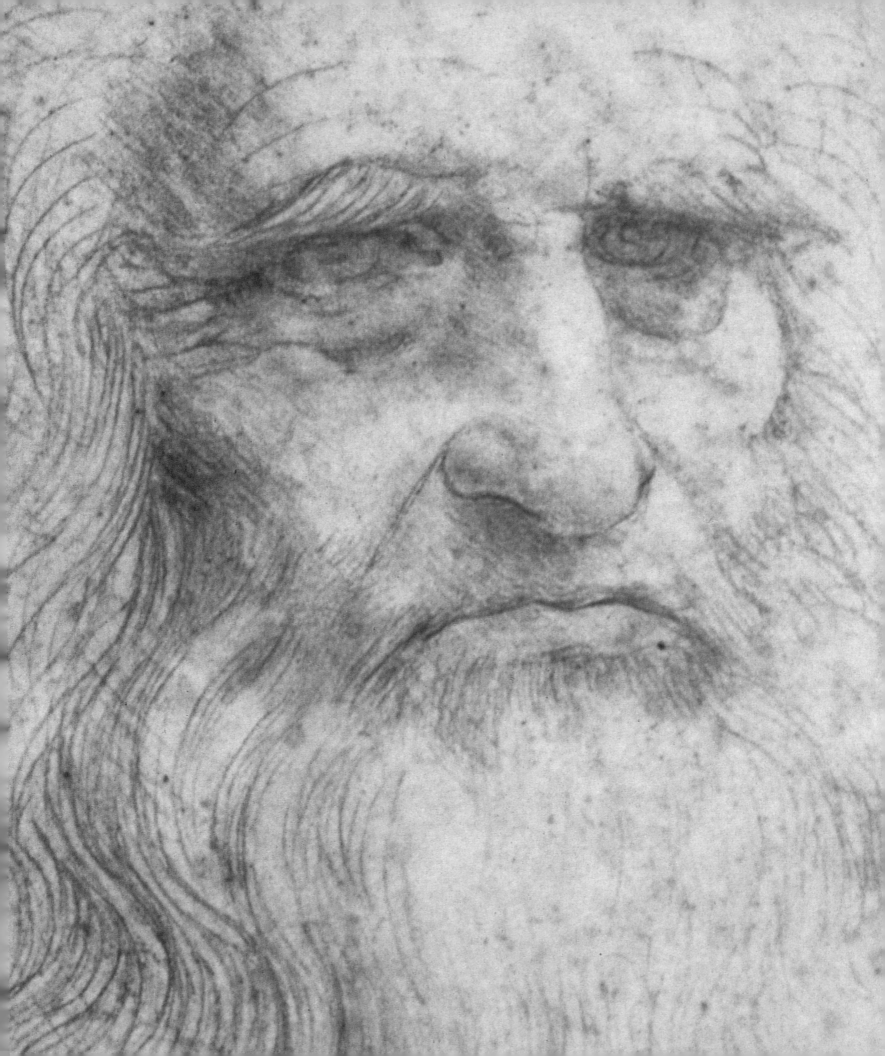

The Life of Leonardo da Vinci

by Alessandro Vezzosi

The manuscripts of Leonardo da Vinci, handed down and kept in various collections across the world, as well as other contemporary sources, enable almost all the different phases of his life to be reconstructed. The written work, sketches, drawings and paintings which have been left to us bear witness to an extraordinary person. Leonardo's genius was extolled on more than one occasion by contemporaries, such as Luca Pacioli.

Origins and Childhood (1452—1469)

1452

"Lionardo" was born in Vinci "on Saturday, 15 April, at three o'clock in the morning". We owe this precise time and date to Leonardo's paternal grandfather, Antonio da Vinci, who also remembered the name of the christening priest and no less than nine witnesses (neighbors): he conceals nothing, even though Leonardo is the illegitimate son of the 25-year old notary Ser Piero and Caterina. Ser Piero took custody of the child and married the 16-year old Albiera Amadori in the same year. Caterina, the mother, married the pottery proprietor Accattabriga (the quarrelsome) in the following year and lived together with him in the neighbouring S. Pantaleo. The paternal house in which Leonardo was to live primarily for seventeen years, was situated "in the Borgo Vinci, in the garden" opposite the "Loggia del Comune". According to a 19th century tradition, Leonardo is said to have been born on the hill of Anchiano. The history of the da Vinci family in Florence can be traced back to the 14th century.

House in Anchiano, in which Leonardo da Vinci was born
photography 1994

Vinci, Leonardo's birthplace

1454

A daughter is born to Caterina and Accattabriga who, almost as a mark of their esteem for Ser Piero, they name Piera. She is the first of Leonardo's five sisters on his mother's side.

1458

"5 July 1458": enigmatic entry in the Codex Atlanticus (fol. 81r, ca. 1510).

1462

Leonardo's father works as the notary of Cosimo de' Medici, among other duties on the endowment of the silver cross for the Church of S. Lorenzo and in the arbitration proceedings between Santi di Ercole Bentivoglio, the Signoria of Bologna and the "maestro di murare" (master mason) Zanobi d'Antonio.

1466

In Florence, Antonia de' Brancacci, the wife of Matteo di Giorgio del Maestro Cristofano, appoints Ser Piero as her procurator.

1468

Leonardo continues to live with his father in Vinci. He certainly already enjoys access to various erudite texts within the family circle. It is significant that in his home town and other localities between Empoli and Pistoia a considerable painting tradition had developed since the 13th century, a tradition which encompassed Masolino and the Donatello circle, and which was to be continued by the school of Verrocchio, the workshop of Della Robbia and others.

First Sojourn in Florence (1469–1482)

1469

Ser Piero is the procurator of the Convent of S. Martire in Florence and moves into a house opposite the Palazzo Vecchio with his family. Leonardo is to work in the "workshop" of Verrocchio, together with Perugino, Botticelli, Ghirlandaio and Lorenzo di Credi.

1470

Works in various genres emerge from the legendary "Verrocchio workshop" between 1470 and 1475, in which the contribution of Leonardo is thought to be discernible – or they were attributed to him – including the "Madonna Ruskin" and "Madonna Dreyfus" or the "Adoration" in Detroit; or they include works of particular complexity, such as the "Baptism of Christ" (see page 29) and the "Annunciation" (see page 31) in the Uffizi, Florence; or also sculptures, such as "The Lady with the Bouquet" in the Barghello, Florence (ca. 1475).

1471

Verrocchio erects the copper sphere on the lantern of Florence cathedral. Leonardo recollects its erection in a series of studies of parabolic reflectors during his period in Rome (ca. 1515).

1472

In June "Lionardo" is already registered in the Guild of Florentine Painters and is the Guild's debtor. The "exceedingly fine paintings" of which Vasari speaks are monochrome paintings with studies of robes dating from before 1478 (Uffizi, Florence; Louvre, Paris; Johnson Collection, Princeton).

1473

"A Wide View over a Plain" (5 August) with a view of the Montalbano towards Valdarno and Valdinievole: first reliable point of reference in the chronological index of Leonardo's works; in connection with similar studies, he is also to paint the landscape in Verrochio's "Baptism of Christ".

1475

Leonardo's wall hanging for the King of Portugal. Own works, such as "Ginevra de' Benci" (see page 35) and others, the attribution of which is contentious, are produced; the "Annunciation", already mentioned, in the Uffizi, the "Madonna with the Carnation" (see page 33), also known as the "Madonna with Vase", ca. 1475–77, in the Alte Pinakothek in Munich, the drawing "Sleeping Nymph with Eros" (Uffizi, Florence) and the predellas for the "Annunciation" in Pistoia including the "Annunciation" (see page 30) in the Louvre, Paris.

1476

Leonardo is charged with homosexuality and is released on probation. He continues to work in Verrocchio's workshop. "Profile of a Warrior" in the British Museum, London.

1477

Antonio, son of Ser Piero and the latter's third wife Margherita, is born, Leonardo's first brother on his father's side. Twelve brothers and sisters are to follow.

1478

First folios in the Codex Atlanticus (Biblioteca Ambrosiana, Milan). The name of this collection of miscellaneous writings is derived from the form of an atlas. The collection contains over 1700 folios and fragments, mainly drawn up by Leonardo himself and dating from before 1518, with texts and drawings of a technical and natural scientific character, but also concerning geographical and mathematical subjects, poems, notes on painting and architectural projects, anecdotes and memorandums. A large number of the fragments of sketches on "artistic" themes as well as important anatomical and geographical studies taken from the folios of the Codex Atlanticus are to be found in the Royal Library in Windsor.

Letter to Ludovico Sforza,
Duke of Milan
ca. 1482
Pen and ink
250x190 mm
Codex Atlanticus fol. 1082r (ex 391r-a)
Biblioteca Ambrosiana, Milan

Another miscellaneous collection, the Codex Arundel 263 (1478–1518), is in the keeping of the British Museum, London.

Studies are made for the "Adoration of the Shepherds", on the folio in the Uffizi, in which Leonardo refers to two of his Madonna paintings: possibly to the "Madonna with the Carnation" and "Madonna Benois" (see pages 33, 37) in the Hermitage in St Petersburg. First own commission: altarpiece for a chapel in the Palazzo Vecchio.

1479

Leonardo draws "The Hanged" (Museum in Bayonne); machines are produced in the style of Brunelleschi, which are also comparable with studies by Francesco di Giorgio, Bonaccorso Ghiberti and Giuliano da Sangallo.

1480

Leonardo works for Lorenzo Magnifico in the garden of S. Marco. He designs weapons, engines of war, burning glasses and an oil press on Archimedean principles. In the Codex Arundel (British Museum, London) is to be found an ideal autobiography as a fantastic and symbolic representation: the explorer in the grotto. His father, Ser Piero da Vinci, is "Notary and Procurator in the 'palagio del podestà' (Palace of the Foremost Signor) of Florence".

1481

Leonardo concludes a contract with the monks of S. Donato in Scopeto for an altarpiece: the "Adoration of the Magi" (Uffizi, Florence; see page 41). He carries out water and hydraulic studies, comparable with the principles of Alberti and Francesco di Giorgio, studies for a flying and diving device, and "St Jerome" (see page 39), which remains unfinished and can be seen in the Vatican Museum, Rome.

First Sojourn in Milan (1482–1500)

1482

Leonardo makes his way to Milan, sent by Lorenzo Magnifico, to the court of Sforza. He arranges for a letter to be written to Ludovico il Moro in which he offers all number of wonder-works and services in the art of war and mentions a monument for Francesco Sforza. He draws studies for "Madonna with the Cat".

1483

Leonardo concludes a contract for an altarpiece for the Chapel of S. Francesco Grande Milan: The "Virgin of the Rocks" (Louvre, Paris; see page 43), and undertakes preliminary negotiations for the Sforza monument.

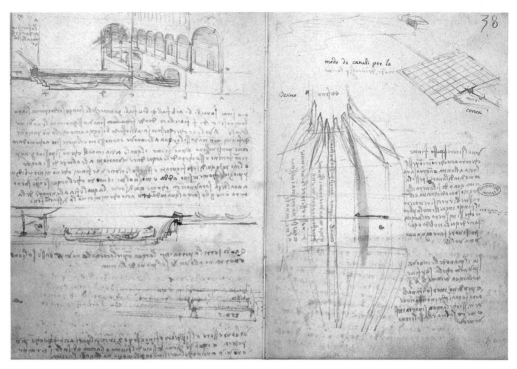

Study of a canal system for
a utopian city
ca. 1487—90
Pen and ink
Institut de France, Paris, MS. B, fol. 37v-38r

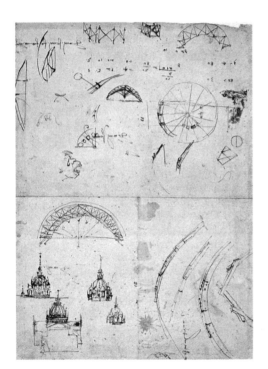

Studies for a cathedral dome
ca. 1487
Pen and ink
375 × 270 mm
Codex Atlanticus fol. 719r (ex 266r-a/b)
Biblioteca Ambrosiana, Milan

1485

Leonardo probably receives the commission for a "Madonna" for Matthias Corvinus, King of Hungary. Studies of interlace works, catapults and crossbows, mortars with exploding shot, flying machines and a parachute are produced as is the allegory "Aristotle and Phyllis" from Hamburg.

1487

"Letters on a Giant" in the Codex Atlanticus in the Biblioteca Ambrosiana, Milan. In July a model of the cupola of Milan Cathedral based on Leonardo's drawings is finished. He begins the MS. B, fol. 91—100 which makes up the MS. Ashburnham 2037, both of which are in the library of the Institut de France in Paris. The Paris codices were removed from the Biblioteca Ambrosiana on Napoleon's orders and remained in France. They contain nature studies, studies for flying machines and weapons, of geometry, municipal construction and canalization, mechanics, military and religious architecture, dated prior to 1490. "Tanks" and "war vehicles" are designed, combat devices, "submarines", studies for military bridges, offensive weapons and machines, a drawing of a "foundry" and the first anatomical studies (Royal Library, Windsor). Dating from this period (1487—90) are: the Codex Trivulzio (Castello Sforzesco, Milan) with lexical lists and into which studies of the arts of war, mechanics, architecture and grotesques are inserted, and the second part of the MS. Forster I (Victoria and Albert Museum, London) with studies of hydraulic machines.

1488

In January Leonardo receives further payments for the project modeling the cupola of Milan Cathedral. He draws folios with rebuses (Royal Library, Windsor).

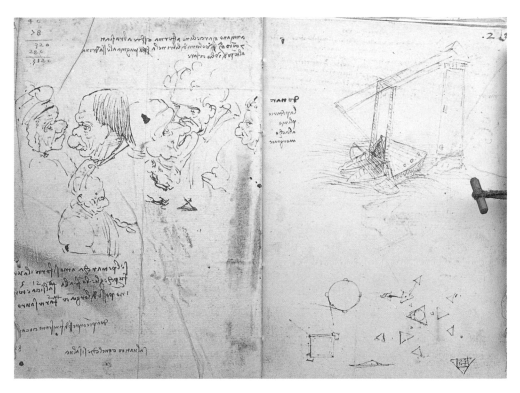

Studies of caricatures
and a siege ladder
ca. 1487–90
Pen and ink
Codex Trivulzio fol. 1v-2r
Castello Sforzesco, Milan

1489

Anatomical studies: "2 April. Book with the title 'On the Human Figure'" (Royal Library, Windsor). Pietro Alamanni writes to Lorenzo Magnifico from Milan: Il Moro beseeches him to send founders for the Sforza Monument, the commission for which had been transferred to Leonardo, and appears to doubt whether the work will be completed.

1490

The "Feast of Paradise" is performed in Milan Castle with stage decorations by Leonardo on the occasion of the wedding of Gian Galeazzo Sforza and Isabella d'Aragon. MS. C in the Institut de France in Paris with notes on hydraulics, mechanics, optics and the theory of shadows, no later than 1491 ("I began this book on 23 April 1490 and commenced with the horse"). He calls himself a "student of experience"; polemical comments on the "man without a script" (Codex Atlanticus, Biblioteca Ambrosiana, Milan). "Proportions of the Human Body after Vitruvius" (Accademia, Venice). Caricatures and grotesques (Biblioteca Ambrosiana, Milan; Royal Library, Windsor; Devonshire Collection, Chatsworth). Studies of fountains after Heron, water studies, hydraulics and canalization in Lombardy. Leonardo takes in Salai "at the age of 10 years". In June he is in Pavia with Francesco di Giorgio in connection with the project for the new cathedral. The "Portrait of a Musician" can be dated to the closing years of the eighties (Pinacoteca Ambrosiana, Milan).

1491

26 January: Leonardo is to be found "in the house of Galeazzo da Sanseverino to prepare Sanseverino's festival tournament in honour of Ludovico il Moro and Beatrice". 2 April:

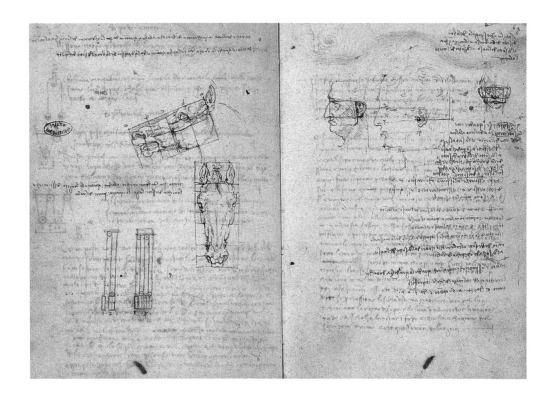

Comparative studies for the theory
of proportions
ca. 1491–92
Pen and ink
Institut de France, Paris, MS. A, fol. 62 v-63 r

"Giannantonio" (Boltraffio) leaves a silver slate pencil lying on a drawing which is stolen by Salai. Projects for the casting of the Sforza Monument, in the fascicle added to the MS. II (8936) (fol. 141–157) in the National Library in Madrid, dated 1491–93. The studies for the preceding folios belong to the years 1503–05. A list of books in the Codex Atlanticus indexes the following works: engines of war by Valturius, Aristotelian Science and Philosophy by Albertus Magnus, Arabic physics, chiromancy, arithmetic, Ovid and Petrarch, The Travels of Mandeville, "Vite dei filosofi" by Diogenes Laertius, "Platonic Theology" by Ficino as well as Plinius, "Acerba" by Cecco d'Ascoli and "Fior di virtù" upon which Leonardo's fantastic bestiary in the MS. H is based.

1492
Notes on travels to Como, Valtellina, Valsassina, Bellagio, Ivrea (Codex Atlanticus, Biblioteca Ambrosiana, Milan) as well as the MS. A in the Institut de France, Paris – also comprising the MS. Ashburnham 2038 (fol. 81–114) – with notes on painting, perspective, mechanics, physics, geometry, hydraulics and architecture, some of which date from the years 1489–90. "The Painter's Studio" and theorems on conceptual painting and philosophy. Giuliano da Sangallo and Leonardo discuss problems relating to the casting process.

1493
MS. I in the National Library in Madrid, dated "1 January" on fol. 1v is started; MS. II, also in Madrid, bears the date "21 December", fol. 151v. Leonardo begins the third part of the Paris MS. H with studies of interlacing, hydraulics, mechanics, engineering, architecture

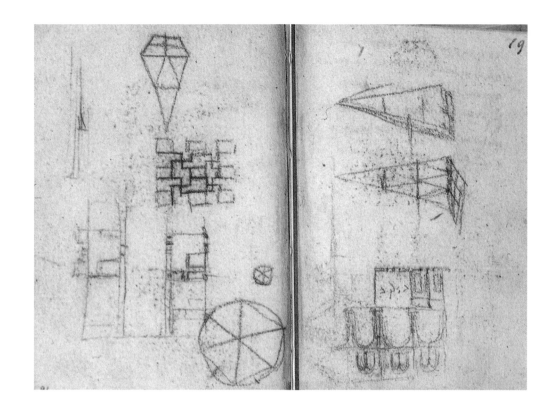

Architectural studies
ca. 1493
Pen and ink
Codex Forster III fol. 15v-16r
Victoria and Albert Museum, London

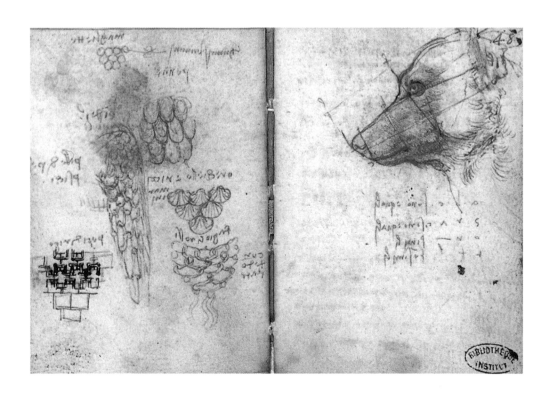

Ornamental studies based on nature
and study of a head of a dog
ca. 1497—99
Pen and ink
Institut de France, Paris, MS. I, fol. 47v-48r

and Latin grammar, and MS. Forster III (before 1496) in the Victoria and Albert Museum, London, with notes on architecture and town planning, mechanics and geometry, "formulas" for casting and literary compositions. 16 July: "Caterina came" (presumably his mother). On 30 December the clay horse for the Sforza Monument is apparently finished. On 20 December Leonardo decides "to cast the horse in a lying position without the tail" (MS. II, National Library, Madrid); but then Il Moro sends the pre-prepared bronze work to Ercole d'Este to have canons made from it. Bellincioni eulogizes a "Portrait of Cecilia Gallerani" in his "Rhymes" and calls Leonardo "an Apelles from Florence". Leonardo annotates the "Clock" by Chiaravalle (Codex Atlanticus, Biblioteca Ambrosiana, Milan; MS. I, National Library, Madrid), draws anatomical studies with embracing figures and drafts hydraulic equipment for the perpetuum mobile and studies for the wings of a flying machine.

1494
Leonardo stays in Vigevano. Studies of characters, passions and grotesques. From January onwards dated folios are to be found in the first, second and third parts of the MS. H in the Institut de France, Paris. Caterina is mentioned twice in Leonardo's "Promemoria"; her name turns up again in a note on funeral expenses in the MS. Forster II, Victoria and Albert Museum, London.

1495
Leonardo draws geometrical studies and studies for the theory of proportions in the first part of the MS. Forster II (Victoria and Albert Museum, London) and on mechanics in the second part, dated prior to 1497. The first folios of the MS. M in the Institut de France are drawn up. Ludovico commissions Leonardo with "The Last Supper" for the refectory of S. Maria delle Grazie (see page 55). Giovanni da Montorfano paints the "Crucifixion" on the opposite wall; Leonardo was supposed to add the portraits of Moro, Beatrice and her first-born, Massimiliano. He starts work on the embellishment of the "Chambers" in the Castello Sforzesco and makes drawings of "gold beating machines", coining dies and studies of weaving machines.

1496
Studies of the "Danae" of the Baldassare Taccone in the Metropolitan Museum, New York. Drawings for "De Divina Proportione" by Luca Pacioli. Disputes relating to the decoration of the "Chambers": Il Moro maintains that Leonardo "has definitely caused a scandal" and resolves to replace him with Perugino. Letter drafted to the Cathedral Masons' Guild by Piacenza: Leonardo offers to make the bronze doors for the cathedral.

1497
First (fol. 1—48, dated prior to 1499) and second (fol. 49—139) part of the MS. I in the Institut de France, Paris, with notes on architecture, decoration, Euclidean geometry, mechanics and hydraulics. Leonardo works on "The Last Supper" (see page 55) with students who learn from his drawings and help with the mural painting. In June "The Last Supper" is

almost finished and he "continues to shape the wonderful clay horse". He designs the "Casa Guiscardi" in Milan and draws a "Portrait of Lucrezia Crivelli", the Moro's new mistress. MS. I (8937) in the National Library, Madrid, with engineering studies in treatise form, studies of "machine parts", gliders and "lifting devices" as well as a commentary on Curio's mobile theatre. With the exception of a part dated prior to 1490–93, this manuscript is continued until 1499 and beyond 1500, with supplements up to about 1508. Leonardo begins the MS. L in Paris with notes dating from up to 1502 (possibly up to 1504) on the arts of war and architecture, arithmetic, hydraulics, mechanics, planimetry and fortification projects. Studies for the mechanism of a war robot in the Codex Atlanticus, Biblioteca Ambrosiana, Milan.

1498

"Folios" of the "Accademia Leonardi Vinci". Pacioli recollects the "laudable scientific dispute" in the Castello Sforzocoo between theologians, doctors, astrologists, lawyers and the "brilliant architect, engineer and inventor Leonardo, who did justice to his name in sculpture, casting and painting to all of those present" (vince = he triumphs); in his dedication to Il Moro for the "De Divina Proportione" he lauds Leonardo for "The Last Supper" which is almost finished (see page 55) and the "Equestrian Statue", "12 cubits" high and weighing "approximately 200000 pounds" which will stir the envy of "Phidias and Praxiteles from Monte Cavallo". In March Leonardo travels to Genoa Harbor: notes on the ruined quay. In October he works in the "Sala delle Asse", which should be finished by September. In October he receives a vineyard between the monasteries of S. Vittore and S. Maria delle Grazie as a gift from the Moro. Isabella d'Este wishes to compare her portrait by Giovanni Bellini and that of Cecilia Gallerani by Leonardo: the "Lady with the Ermine" (Czartoryski Museum, Cracow; see page 49). Leonardo's father owns a "manor house" and a "potter's workshop" in Bacchereto, a ceramics center.

1499

Leonardo studies contrivances for the baths of the Duchess Isabella (Codex Arundel, British Museum, London; Codex Atlanticus, Biblioteca Ambrosiana, Milan; MS. I, Institut de France, Paris) and makes notes on the drawbridge by Bramante (Codex Atlanticus, Biblioteca Ambrosiana, Milan; MS. M, Institut de France, Paris). In October Louis XII occupies Milan; he views "The Last Supper" and wishes it to be removed from the wall and taken to France. In the "Memorandum Ligny" (Codex Atlanticus, Biblioteca Ambrosiana, Milan) the intention is expressed to go to Rome, Naples and Vinci. On 14 December Leonardo sends 600 gold florins to Florence.

Second Sojourn in Florence (1500–1508)

1500

Leonardo leaves Milan with Pacioli and several students and travels as Gonzaga's guest to Mantua. He inspects and drafts the fortifications in the Friaul for the Venetian Senate. First

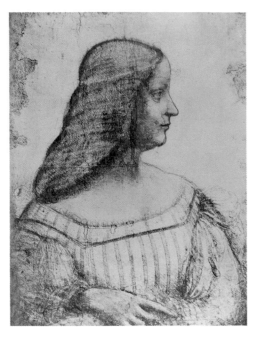

Portrait of Isabella d'Este
ca. 1500
Black chalk with charcoal and pastel
632×460 mm
Louvre, Paris

portrait of Isabella d'Este (cartoon in the Louvre, Paris). Together with Boltraffio, Leonardo was probably the guest of Casio in Bologna. He is already in Florence on 24 April; he advises on the construction of the S. Miniato campanile following a drawing by Baccio d'Agnolo for the safeguarding of the Church of S. Salvatore. Work is taken up again on the Villa Tovaglia project near Florence for the Marchioness of Mantua. "In old Tivoli", mention of Hadrian's villa near Rome (Codex Atlanticus, Biblioteca Ambrosiana, Milan).

1501

Leonardo draws the first studies for "St Anne". The "Weimar folio", now in the Getty Museum in Malibu, contains studies for "Child with the Lamb" (1501) and for a rolling mill (1497). Incipit to a geometry codex by the Arab Savasorda. March: Isabella d'Este requests a replica of her portrait. April: Leonardo paints the "Madonna of the Yarnwinder" for Robertet, Louis XII's secretary, "very impatiently with the brush". He engages in scientific and mathematical studies, intervenes in the painting being continued for him by two of his assistants – the "Buccleuch" and "ex-Reford" versions in Montreal, now in New York. September: Ercole I d'Este asks for the "horse" moulds for the Sforza Monument by Leonardo from the French governor in Milan.

1502

In May, Isabella d'Este asks for Leonardo's assessment of antique vases which previously belonged to Lorenzo Magnifico. On 18 August, Cesare Borgia issues Leonardo with a patent as "family architect and general engineer". Leonardo studies military architecture, field defences and cartography: he draws up a map of Imola, Tuscany, Umbria, Val di Chiana, Castiglion Fiorentino and a hydrographical system of Tuscany and environs. Notes are made in the MS. L (Institut de France, Paris) on Urbino, Plombino, Pesaro, Cesena, Rimini, Porto di Cesenatico, Siena and designs for the a bridge over the Golden Horn in Constantinople.

1503

In June, Leonardo stays on the Camposanto in Pisa to decide on the diverting of the Arno. Sketches are made of Monte Verruca and the Pisan mountains, landscape pictures with the Florentine hills, studies of artillery bombardment systems and fortifications, designs for the canalization of the Arno and cartography of maritime Tuscany and the environs of Pisa (Royal Library, Windsor; Codex Atlanticus, Biblioteca Ambrosiana, Milan; MS. II, National Library, Madrid), as well as engines of war, musical studies and studies for excavation machines for the sluice over the Lecceto and S. Lorenzo rivulets and for the "Doccia Mil" at Vinci. In October, he receives the key to the Papal apartments in S. Maria Novella which are to serve him as a workshop for the cartoon of the "Battle of Anghiari" (see page 59).

1504

First and second parts (fol. 1–48 and 49–80) of the MS. K in the Institut de France, Paris, also including notes from 1503–05: geometry, optics, hydraulics and the flight of birds. In January, he gives his opinions regarding the erection of Michelangelo's "David". In February

and May, he receives payments for the "Battle of Anghiari" (see page 59). Isabella d'Este requests a picture of the "Infant Christ". On 9 July, Leonardo receives news of the death of his father (Codex Arundel, British Museum, London; Codex Atlanticus, Biblioteca Ambrosiana, Milan). In August: Will of his uncle Francesco bequeathing goods to Leonardo; the work on the diverting of the Arno begins to be interrupted again in October; the failure leads to fierce criticism. Leonardo works on projects for Piombino and notes on painting in November which, together with theories and figures taken from the texts of Francesco di Girogio and comments on geometry with versions based on Euclid, are to be found in the MS. II in the National Library, Madrid. During the night of 30 November, Leonardo writes that he has discovered "the end" of the squaring of the circle. Marginal notes in a codex by Francesco di Giorigo (Biblioteca Laurenziana, Florence). Sketches and drawings for "Kneeling Leda" (Royal Library, Windsor; Devonshire Collection, Chatsworth; Museum Boymans-van Beuningen, Rotterdam) and "Neptune" (RL 12470) as well as a memorandum in the Codex Atlanticus on Florentine libraries, Pacioli, Sansovino and Michelangelo, "my atlas, in the hands of Giovanni Benci", and others (Biblioteca Ambrosiana, Milan).

1505

Studies and speculations on flying near Fiesole; "Codex on the Flight of Birds" in the Biblioteca Reale, Turin, with other nature studies: anatomy, architecture, mechanics, hydraulics. The Duke of Ferrara expresses the wish to acquire a "Bacchus" by Leonardo from Pallavicino which he has already promised to the Cardinal of Rouen. At the end of April, Leonardo receives a "bundle of his clothes which he had arranged to be sent from Rome". Up to August, further payments are made to him and his assistants – the Spaniard Raffaello d'Antonio di Biagio and Tommaso, who "grinds colors" – for the "Battle of Anghiari" (see page 59). Emblematic entry about this wall-painting on the first folio of the MS. II in the National Library, Madrid: "On Friday, 6 June 1505, at the stroke of three, I began painting in the palace...."; followed by vague presentiments. First part of the MS. Forster I (fol. 1–40) in the Victoria and Albert Museum, London, with studies of geometry/stereometry. Nature studies (Royal Library, Windsor) and studies for the standing "Leda with the Swan" (approx. 1505–15): see "Leda by Vinci", formerly in the Spiridon Collection. Leonardo works on notes on the "earth", the "spirit of the bird" (Codex Atlanticus, Biblioteca Ambrosiana, Milan) and the "existence of nullity" (Codex Arundel, British Museum, London).

Second Sojourn in Milan (1506–1513)

1506

The Codex Leicester contains studies of water, hydraulics, cosmology and astronomy which can be dated prior to 1509. Third part of the MS. K in the Institut de France, Paris (fol. 81–128) with notes on geometry, anatomy, the flight of birds, hydrology and canalization, optics and architecture dating from before 1508–09. Descriptions and cost estimates for the tomb of Marshall Trivulzio with marble sarcophagus and bronze horse are made in this

Pump mechanism for a fountain,
drawings on perpetual motion,
and sketches of Archimedes' Screws
for the raising of water
ca. 1505
Pen and ink
Codex Forster I fol. 41v-42r
Victoria and Albert Museum, London

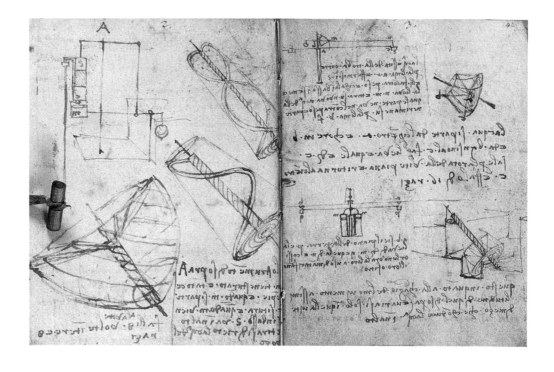

Studies of comparative anatomy
and studies on mechanics
ca. 1507
Pen and ink
Institut de France, Paris, MS. K, fol. 109v-110r

period. The uncle Francesco dies, leaving Leonardo as sole heir. In May, an exchange of letters takes place between Isabella d'Este and Alessandro Amadori (the brother of Ser Piero's first wife) relating to "those figures which we have beseeched from Leonardo". On 30 May, before departing for Milan, Leonardo is required to bind himself contractually to returning to Florence within three months in order to finish the "Battle of Anghiari" (see page 59). On 18 August, the Marshall of France entreats the Signoria of Florence for respite to enable Leonardo to finish a series of works in Milan. The Signoria register their protests in October. On 16 December, Charles d'Amboise insists on detaining Leonardo for a period of time and lauds his "excellent works". Raphael, after Leonardo's creation: "Leda with the Swan", the "Battle of Anghiari", "Maddalena Doni" in a composition reminiscent of the "Mona Lisa", the "Holy Family" with the child "riding" on a lamb (after an preliminary idea for "The Virgin and Child with St Anne").

1507

Notes on water conduits, executed by Fra Giocondo in Blois (MS. K III, Institut de France, Paris). On 12 January, the Florentine ambassador to the French court in Blois informs the Signoria that Louis XII intends to "make use of the services" of Leonardo — he regards him as "the beloved and esteemed painter and engineer of Our trust". In March, Leonardo is in Florence with Salai. Anatomical studies in S. Maria Nuova, Etruscan Mausoleum (Louvre, Paris). Studies of musical instruments in the Codex Arundel (British Museum, London). In Milan, Leonardo makes the acquaintance of Francesco Melzi, his new favorite. Studies of the Adda and the environs of Charles d'Amboise's villa near S. Babila. On 26 July, Robertet entreats the Florentine Signoria in the name of the King of France to intervene in inheritance matters with Leonardo's brothers and sisters in Leonardo's favor. Leonardo travels to Florence and Charles d'Amboise demands that the Signoria ensure that Leonardo can return to Milan again to finish an "extremely valuable" panel for the King. Aerial view and schematic plan of Milan; studies for a church with central ground plan, with a sketch of the Pazzi Chapel by Brunelleschi (Codex Atlanticus, British Museum, London). Comparative anatomical studies are made at the start of his second sojourn in Milan and, in the same connection, a (lost) treatise on the anatomy of the horse. Studies of "Orfeo" by Poliziano with stage-set for the "Mountain which opens" (Codex Arundel, British Museum, London).

1508

Codex Arundel, fol. 79 r: "began in the house of Piero di Braccio Martelli [where he lived with the sculptor Rustici] on 22 March 1508. This is a collection with no order and with many pages which I have copied here in the hope of being able to order it at a later time...". In Milan, Leonardo lives in the parish of S. Babila beyond the eastern town gate. Notes on painting in the "Libro A", now lost: Francesco Melzi is to add them to the Codex Urbinate of the "Trattato della Pittura" (Biblioteca Vaticana, Rome). Studies of water-clocks with an automatic mechanism for striking the hours and a description of the "Garden of wonder-works" with water games for Charles d'Amboise's villa in Milan (Codex Atlanticus, Biblioteca Ambrosiana, Milan; Royal Library, Windsor). The most probable dating of the "Scapiliata" in

the Pinacoteca, Parma. On 18 August, he charges Predis with issuing a receipt for the "Virgin of the Rocks" on the condition that it will be possible to copy the painting by taking it from the altar on working days. MS. F (Institut de France, Paris) with studies and notes on astronomy, geology, hydraulics, the flight of birds, optics, the theory of shadows, with references to Alberti and Vitruvius and examinations of mixtures: "Begun in Milan on 12 September 1508". MS. D (Institut de France, Paris) with notes on optics and the physiology of the eye, possibly dating from 1509, in connection with the MSS. K III and F (both Institut de France, Paris) and the folios in the Royal Library, Windsor and in the Codex Atlanticus, Biblioteca Ambrosiana, Milan. Notes on two "Madonnas" for the King of France, from whom he receives a "stipend". Anatomy of an old Florentine. Section of the organs and arterial system of a woman.

1509

Notes on travels through Savoy. Leonardo is engaged in hydrographic and geological studies of the Lombardian valleys and Lake Iseo. At the end of April, he makes a note (Royal Library, Windsor, 19145) to the effect that he has solved one of the geometrical problems — "le falcate" (scythe-like surfaces) — which had long occupied him.

1510

Leonardo begins the "The Virgin and Child with St Anne", now in the Louvre (see page 63), and makes further studies for "Leda". MS. G in Paris: Notes on painting (plans and landscape), perspective, geometry, mechanics, engineering, anatomy, hydrology, possibly dating from 1511 and taken up again during the period in Rome. On 21 October, his help is requested in connection with the choir stalls for Milan Cathedral. Anatomical studies, possibly with Marcantonio della Torre at the University of Pavia. Studies of navigation on the Adda.

1511

He continues to draw an annual stipend as a painter from King Louis XII. On 2 January, he is at a marble quarry "above Saluzzo". On 10 and 18 December, Leonardo is in Milan and mentions the fires started in Desio by the Swiss army in alliance with Massimiliano Sforza, son of the Moro, who intended to reconquer the Duchy. A series of landscape pictures in red chalk on red-dyed paper are made (Royal Library, Windsor). Bramantino is commissioned with fitting out Leonardo's equestrian monument for Trivulzio.

1512

Further landscape, river and canal studies in Lombardy. "John the Baptist" (see page 65), "Bacchus"/"John the Baptist in the Wilderness" (approx. 1508–17): from the picture in the Louvre to the now lost drawing of the Sacro Monte in Varese.

1513

Anatomical studies on blue paper; memorandum in which Boltraffio and the Vaprio mill are mentioned (Royal Library, Windsor). Studies for "Salvator Mundi" (Redeemer), approxi-

mately 1510—15, as well as for fountains and hydraulic equipment after Heron. Notes on the extension of the Villa Melzi in Vaprio d'Adda. On 25 March, Leonardo is mentioned in the register of the Cathedral Masons' Guild. MS. E (Institut de France, Paris, formerly "Book B") with notes on painting, perspective, geometry, anatomy, physics, the flight of birds, hydrology, mechanics, "shadow and light", possibly dating from 1514. On fol. I r: "Set off from Milan for Rome on 24 September with Giovan Francesco, Salai, Lorenzo and Fanfoia". A workshop is set up for Leonardo in Rome in December. According to Vasari, his father, "that extremely brilliant man of spirit" Ser Piero, is working on the stage-set for the election celebrations of Pope Leo X, the brother of Giuliano de Medici, one of Leonardo's patrons. But Leonardo's father had already died in 1504 — presumably it was his brother, Giuliano da Vinci who was meant.

Sojourn in Rome (1513—1516)

1514

Leonardo paints the "Mona Lisa" for Giuliano de' Medici, the portrait "from nature" of Isabella Gualanda, also known as "La Gioconda" (see page 61). Leonardo draws the "Ariadne" in the Belvedere of the Vatican on a lined folio and with "the left hand" (Codex Atlanticus, Biblioteca Ambrosiana, Milan). Drawings and descriptions of the Deluge (with marginal notes "sea waves of Piombino", Royal Library, Windsor, 12665r). Notes for "Trattato della Pittura". Notes in the Codex Atlanticus with comments on geometry and the note: "7 July, 11 pm, in the Belvedere workshop made for me by Il Magnifico"; followed by

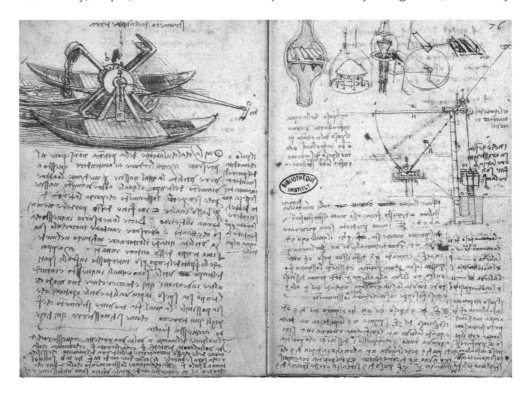

Dredger, various valves,
and a pneumatic pump

ca. 1513—14

Pen and ink

Institut de France, Paris, MS. E, fol. 75 v - 76 r

comments on Giuliano de' Medici. The following note can be found on fol. 80 r of the MS. E (Institut de France, Paris): "in Parma on 25 September", and on fol. 96 r: "on the banks of the Po, 27 September". Civitavecchia: archaeological studies and studies of the harbor. Cartography for a drainage project for the Pontine Marshes.

1515

In an account of his travels, Andrea Corsali describes Leonardo as a vegetarian. On 9 January, he notes in the MS. G (started about 1510; Institut de France, Paris) that Giuliano Magnifico departs from Rome for Savoy where he is to marry. Leonardo has difficulties with a German assistant, a "lens maker". He is interested in mechanics and anatomy, is however expelled from the Hospital S. Spirito accused of pursuing black magic. He offers to search for fossilized mussels on Monte Mario and draws up plans for the stables of Giuliano Magnifico and a new Medici Palace in Florence. These are followed by studies of geometry and compasses, a "mechanical lion" for the coronation procession of Francis I in Lyon, figures in theater costumes and allegories of an Alsatian at the rudder of a boat based on the Imperial Eagle (Royal Library, Windsor). On 9 December, Leonardo writes from Milan to his steward in Fiesole about the poor wine and gives instructions for improving its quality. He travels across Emilia from Firenzuola to Bologna and designs an ideal plan of Florence with an index of the gates of Milan added by Melzi.

The "Pointing Lady"
ca. 1516
Black chalk
208x135 mm
Pedretti 55 r
Royal Library, Windsor (RL 12581)

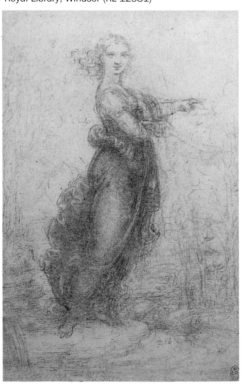

Sojourn in France (1516–1519)

1516

On 13 March, Leonardo commits the solution to a geometrical problem to paper. In August, he measures out S. Paolo fuori le Mura (Codex Atlanticus, Biblioteca Ambrosiana, Milan). On the death of Giuliano de' Medici, 17 March, Leonardo notes bitterly: "The Medici made me, and destroyed me". He sets off for France with Melzi and Salai. Drawings of the Deluge, and "Pointing Lady" (Royal Library, Windsor; see page 174), a self-portrait (Biblioteca Reale, Turin), "Dancers" (Accademia, Venice) and – on the occasion of the arrival of the French in Italy from Lyon to Venice – notes on mortars. In the Codex Atlanticus in the Biblioteca Ambrosiana, Milan, are to be found notes on Gradisca. In the Codex Arundel (British Library, London) Leonardo mentions a "printed" book by his forerunner Roger Bacon.

1517

In January, Leonardo is in Romorantin with Francis I in connection with a project for the Royal Palace (Royal Library, Windsor; Codex Atlanticus, Biblioteca Ambrosiana, Milan; Codex Arundel, British Museum, London). In May, he is the guest of the King in Cloux for whose celebration in Argentan on 1 October he designs a "mechanical lion". Once again "lunulae" and "geometrical games" are made, a study of robes for the Virgin Mary from "The Virgin and Child with St Anne" in the Louvre (see page 63) and studies of cats, horses, dragons and St George. On 10 October, Leonardo receives a visit from the Cardinal of Aragon. The

Plans for a new royal residence
at Romorantin, France
ca. 1517
Pen and ink
260x177 mm
Codex Atlanticus fol. 583r (ex 217v-b)
Biblioteca Ambrosiana, Milan

Cardinal's secretary mentions a portrait (the "Mona Lisa"; see page 61), "John the Baptist" (see page 65) and "St Anne", anatomical studies, studies on the nature of water and of various machines, all compiled in countless volumes. The artist suffers from paralysis of the right hand but is still able to make drawings and to teach others, and had "trained a Milanese pupil" – Francesco Melzi – who "works very well".

1518

Leonardo carries out topographical studies in the Loire Valley for a royal fountain "without water" in Amboise. Architectonic studies are made and designs for a Medici ring on the occasion of a visit by Piero de' Medici in Amboise; also studies for an arena and volumetric analyses of Bramante's "St Peter" (Codex Atlanticus, Biblioteca Ambrosiana, Milan) and studies of perspective and architecture in fragments of the Swiss Geigy-Hagenbach Collection, University Library, Basel. Celebrations take place in Amboise and Cloux Castle in May and June in honour of Francis I on the occasion of the wedding of his niece Maddalena with Lorenzo de' Medici. The "Feast of Paradise", originally conceived around 1490, is performed in Amboise once again. The "pension" for the "Master Leonardo da Vinci, painter" amounts to 2,000 Scudi ("soleil") every two years; Melzi, "nobleman", receives 800 Gold Scudi and Salai just 100.

1519

Leonardo's will is dated 23 April. Melzi is the executor and is bequeathed all the manuscripts, tools and "works of the painter". Other heirs are Salai and Battista de Vilanis, his paternal brothers and sisters, the churches of St Florentin and St Denis and the poor of the Hôtel de Dieux and St Lazare in Amboise. Leonardo dies on 2 May in Cloux (Clos-Lucé). Francis I is absent, but Vasari and legend have it that Leonardo "breathed his last" in the arms of the monarch.

Leonardo da Vinci The Legacy

by Otto Letze

Leonardo da Vinci's achievements in the field of art are undisputed. By the application of his scientific inquiries he arrived at a whole new perception of the world, which he then sought to articulate in his paintings. Vasari remarks that "his insights were praised by posterity". Even before Michelangelo and Raphael arrived on the scene, Leonardo had established a new image of the artist. He selected his patrons on the basis of whether they would allow him enough scope for his artistic development. The present-day view of the artist as a "social outsider" can be traced back to Leonardo. At a time when art still ranked as one of the crafts, Leonardo was bound to appear unorthodox, and this inevitably drew criticism.

Leonardo did pioneering work in the field of anatomy. He derided his rival Michelangelo for the muscles of his nudes which, he said, resembled bags of nuts. Such critical attitudes established new standards in the artistic world.

Leonardo's studies of anatomy were the key to his precise portrayal of movement. It was only by examining the functions of the facial muscles that he was able to depict the human physiognomy with such accuracy and thus realistically to capture — or on occasions to caricature — facial expressions and emotional states.

Leonardo employed his knowledge of optics to analyze the play of light and shadow. When he speaks of chromatic qualities whose effects change according to the time of day, or of the need to select the right location for lending objects "an appealing relief", Leonardo is postulating an artistic approach which almost four centuries later, with the advent of the Barbizon School and the Impressionists, was to produce revolutionary insights: the need to observe and record natural phenomena outdoors. Leonardo's studies of the subtle transition of shadows "losing themselves on the fringes of light" and his ability to convey endless nuances of light and dark were innovations that had a lasting impact on later generations of artists. Leonardo himself left us exemplary demonstrations of these techniques in his "Madonna and Child with St Anne" and his "Mona Lisa" (see pages 61 and 63).

Although Leonardo and his workshop produced so few finished paintings, his pioneering achievements were taken up and refined by other artists. His workshop was never a "bottega" in the sense of being a commercial undertaking. His students and assistants worked under one roof, but they retained a large measure of independence. We know that Leonardo was reluctant to pick up a brush and would make the necessary corrections with a minimum of strokes. He regarded painting as an opportunity for experimentation and appears to have taken little interest in the advantages and drawbacks of the various techniques. His "Last Supper" testifies to this indifference. As a mural executed in oils, it threatened to peel off the wall even during his own lifetime.

The paintings and drawings on the following pages bear witness to the enormous impact which Leonardo and his pictorial innovations had on his students and his artistic environment. The originals are on display in the exhibition. Each picture is accompanied by an explanatory text pointing out the links with Leonardo and his work. The artist Leonardo da Vinci, whom we met in the survey on pages 27 to 64 of this book, reappears in the subtle interpretations of his successors and admirers.

Leonardo da Vinci
The Angel in the Flesh

ca. 1513–15
Chalk or charcoal on coarse, blue paper
268x197 mm
Private collection, Germany

Verso of The Angel in the Flesh
with Leonardo da Vinci's handwriting

School versions of the angel from the "Annunciation" are known, as is a student drawing on a sheet of Leonardo's studies for the "Battle of Anghiari" (1505). The angel can be seen from the front until just below the waist and is as a result partially hidden in the painted versions. We see a foreshortened view of an erect male member. The angelic smile is transformed into a faun-like grin further reinforced by the animal structure of the head. The pointing hand is merely sketched. The hand which is moving towards the breast and holding a veil, which hangs over the male member, is elaborated in considerably greater detail, from which it may be concluded that the artist worked from right to left on the figure which was first sketched with sharp, dry charcoal. The body of the "angel" has female characteristics which are emphasized by the prominent breast. The picture thus represents an androgyne or hermaphrodite.

On the reverse side are three Greek words in Leonardo's handwriting: "Astrapen, Bronten, Ceraunobolian". The words were initially written in small letters with red chalk, almost entirely erased and then added again in bold letters with black chalk.

The Greek words originate from Pliny's account of Apelles' legendary artistic feat of depicting precisely that which cannot be depicted, atmospheric phenomena such as lightening, storms and thunderbolts: the same Greek words written by Leonardo here. The style of the drawing, the handwriting as well as the paper and technique all indicate the period during which Leonardo devoted his energies to the "Deluge", around 1515 or later. The same type of blue paper is found in the anatomical manuscript at Windsor know as "C II" and dated 1513, though some of its notes and drawings might have been added as late as 1518. A pen and ink profile of a young man of comparable features is found on a sheet of this series, RL 19093 r (C II 23) which is almost identical in size (258x198 mm). Newly discovered evidence suggests that the present sheet was originally part of the Leonardo papers now at Windsor.

Recent research has located a possible source for Leonardo's bold idea of the "Angel in the Flesh". This is Antonio Pucci's "Historia della bella reina d'Oriente", a fourteenth-century poem certainly known to Leonardo in that he quotes from it an octave about a grotesque giant. A few octaves before (III.xlii), the erotic scene of the young monarch who had just been transformed by divine intervention from a beautiful girl into an exuberant young man, is described. To the wife wondering about his exceptional male attribute, he explains how it was given to him by the Angel Gabriel. Hence her comment: "No wonder that it is so good and beautiful, if it's Heaven where it comes from!" And so the gesture of the pointing finger in Leonardo's drawing acquires even greater poignancy of meaning.

Carlo Pedretti

Bibliography
ALV Journal, IV, 1991, 34–48; Carlo Pedretti, in: ALV Journal, IX, 1995, p. 210.

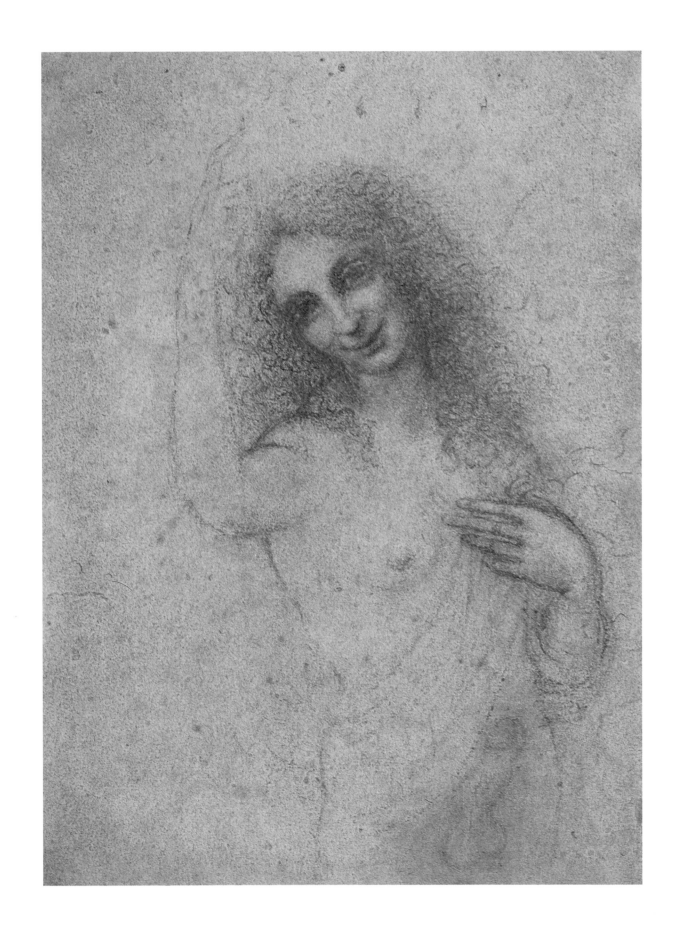

Leonardo da Vinci and workshop
The Dressed-up Angel (Portrait of Salai)

ca. 1495
Oil on panel
37x29 cm
Provenance: Grimani Collection, Venice
The Alos Foundation, Liechtenstein
(formerly Prince Roben Khan Paat-Zades Collection,
Berlin)

This is a three-quarter portrait of a young man, viewed from the left. His eyes gaze directly at the beholder, with the shadow of a smile across the sensuous lips. The light brown hair is parted in the middle and frames the face in a cascade of intricate curls and spirals reminiscent of the turbulent wind and water in Leonardo's representation of the "Deluge" in Windsor as well as of several school drawings and pictures with androgynous figures. An almost identical web of curled hair is to be found in a black chalk drawing in the Codex Atlanticus, fol. 349 v-g. The young man is wearing a laurel wreath and is fully clothed with a fur cape or cloak which, nonetheless, opens sufficiently to reveal a section of the breast more that of a woman than of a man.

A related drawing in the Uffizi, No. 566 E, which was originally attributed to Leonardo, later to Sodoma and is now thought to be by Boltraffio, appears at first glance to be a preliminary sketch for this painting but might, on the other hand, have been inspired by it, as there are considerable differences in the position of the head and particularly in the smile. Pietro C. Marani has shown how the picture relates to Solario's portrait of Charles d'Amboise in the Louvre which may in turn be regarded as a reflection on Leonardo's composition of the "Mona Lisa" (see page 61).

A full evaluation of the significance of this picture on the basis of these associations, independent of a possible connection with Leonardo and his workshop, has still to be made. It is Leonardo's subject matter which is currently most worthy of admiration, as the type of young man portrayed is without doubt the androgyne so favored by him: the devilish Salai who could be unclothed to reveal the shocking picture of the "Angel in the Flesh" (see page 179). There could be no more fitting commentary, in this connection, than that made by Sigmund Freud in his famous 1910 essay on Leonardo: "They are young, with beautiful looks, femininely fine features and female forms. They do not lower their eyes, but look straight ahead with an almost mysteriously triumphal gaze as if they were aware of a mighty victory, full of the promise of delight, about which not a word may be said."

This is how Tadzio looks at Gustav von Aschenbach in Luchino Visconti's film "Death in Venice" in which the ephebic young man from Thomas Mann's story is played by the Swedish actor Björn Andersen.

According to a document published by Jaynie Anderson (in: ALV Journal, VIII, 1995, pp. 226 to 227), a painting by Leonardo of the same subject, "una testa con ghirlanda di man de lunardo vinci", is listed as early as 1528 in an inventory of the famous Grimani Collection in Venice.

Carlo Pedretti

Bibliography
J. Anderson, ALV Journal, VIII, 1995, p. 227, fig. 3.

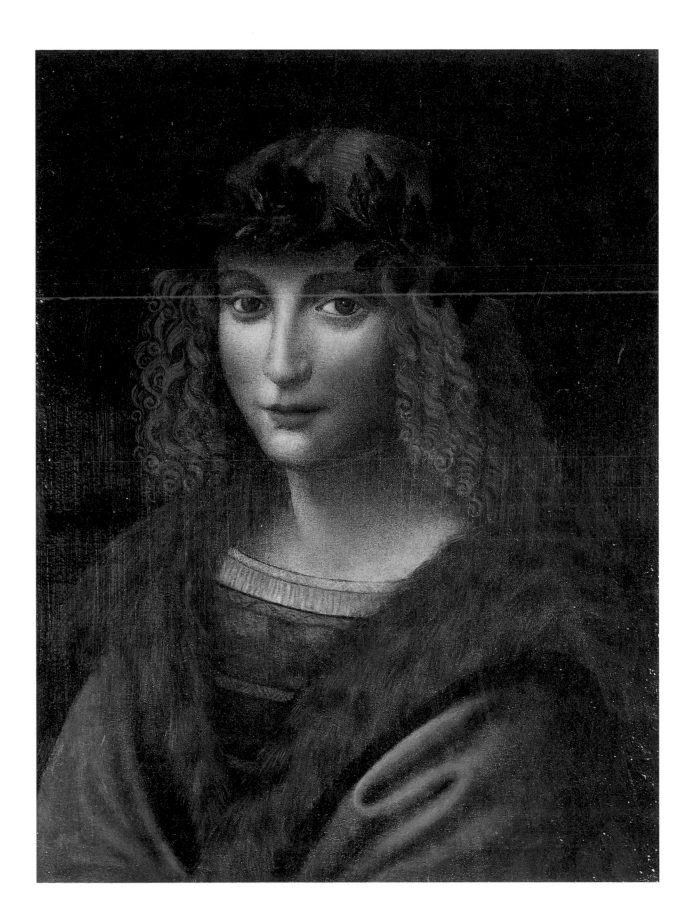

Giovan Pietro Rizzoli known as Giampietrino (active between 1508 and 1549)
Mary Magdalene

ca. 1515—20
Oil and tempera on panel
44.5x38.4 cm
Joseph M.B. Guttmann Galleries, Los Angeles

A typical work by this Leonardo pupil, whose identity has been ascertained only recently through documents newly discovered in the State Archives in Milan. Giampietrino is mentioned by Leonardo himself on a manuscript page from around 1505, but his earliest known works date from about 1515 and are based on Leonardo's drawings, e.g. his "Kneeling Leda" at Kassel, the subject of a drawing in the Chatsworth Collection, and the "Madonna di Castel Vitoni" (ALV Journal, VII, 1994, pp. 57—67). The theme of the Magdalene may also go back to Leonardo, particularly for the detail of the long hair resembling a cascade of flowing water. There are at least two more known versions of the subject, one in the Pavia Gallery and the other at the Hermitage. The figure is shown in a different stance in the versions at the Sforza Castle in Milan and at the Brera Gallery in the same city. A comparable treatment of the subject is shown by a later painting by Titian at the Pitti Gallery in Florence.

Carlo Pedretti

Giovan Pietro Rizzoli known as
Giampietrino

In a manuscript, Leonardo da Vinci mentions a pupil called Gian Pietro who probably is Giampietrino. Nothing is known about the dates of his birth or death. Neither does a document or a signature on a painting provide evidence of his creative activity. The tradition to relate a certain number of works with Giampietrino goes back to the 17th century. The oeuvre attributed to this pupil of Leonardo includes Madonnas, female saints like St Magdalene and St Catherine as well as mythological women. The influence of Leonardo da Vinci's art, especially his later work, is clearly discernible in Giampietrino's paintings.

Bibliography
Thieme-Becker, XXVI, 343f.

Bibliography
ALV Journal VII, 1994, pp. 57—67

Provenance
Christian IV, Duke of Pfalz-Zweibrücken, 1775
Maximilian-Joseph, Duke of Leuchtenberg, St Petersburg, ca. 1915
Private Swiss collection, 1990
Joseph M. B. Guttmann Galleries, Los Angeles

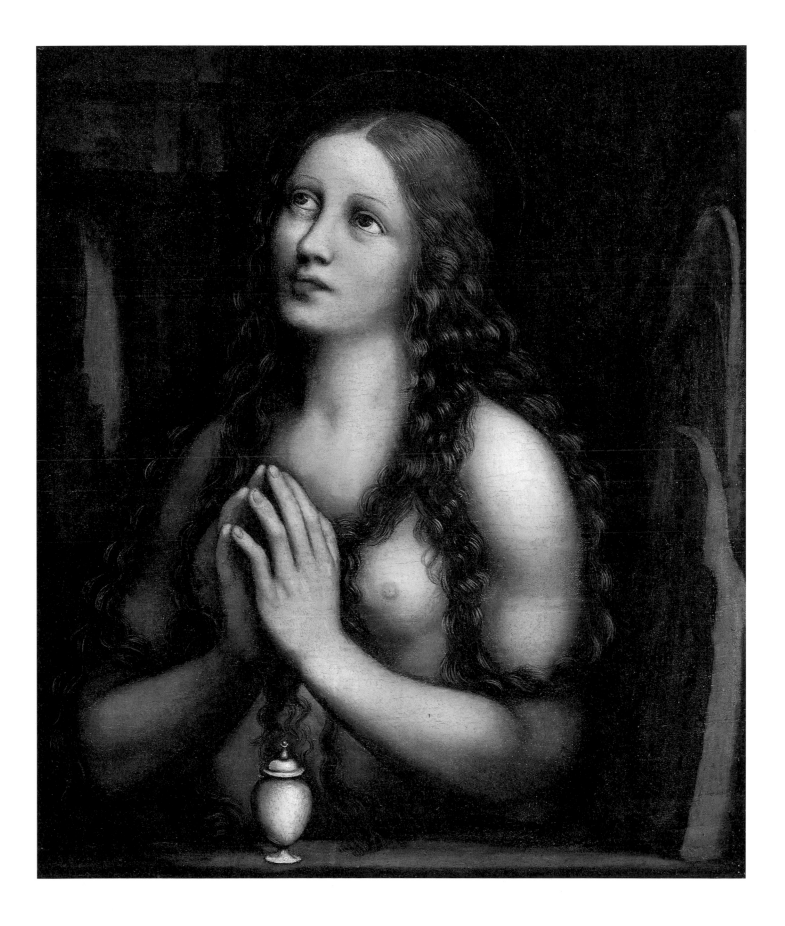

Giovan Pietro Rizzoli known as Giampietrino (active between 1508 and 1549)

St Catherine of Alexandria

ca. 1540
Oil on panel
58.5x45.5 cm
M. Steinberger Collection, Brussels

Recent scholarship taking advantage of newly discovered documents has finally defined the artistic personality of Giampietrino as a Leonardo pupil. According to Cristina Geddo (ALV Journal, VII, 1994, pp. 57–67), he had direct access to Leonardo's models and drawings and is mentioned by Leonardo himself (CA, fol. 264 r-b, ca. 1497–1500). His "Madonna di Castel Vitoni" is in fact based on Leonardo's figure study for the "Madonna of the Yarnwinder" (Royal Library, Windsor, RL 12514).

A comparable Leonardo model, no longer existing, must have inspired this most original interpretation of the theme of St Catherine of Alexandria. This painting was first attributed to Giampietrino by Heinrich Zimmermann in 1947, and then by Hermann Woss in 1960, but apparently it has never been published nor exhibited. Its iconography is truly unusual, if not unique, in that the Saint, with the symbol of her martyrdom – the toothed wheel – is shown in the lovely and enticing attitude of a courtesan with bare breasts, a splendid cascade of wavy hair framing a luminous, smiling face that adds emphasis to a peremptory gesture of the left arm, lifted to point upwards with a long, straight index finger – the gesture of the "Angel in the Flesh"!

The body of Raphael's "St Catherine of Alexandria" in the London National Gallery, ca. 1508, is abundantly draped, and yet it can be shown to belong to a comparable sphere of Leonardesque influence in that it repeats the same sinous, serpent-like movement of Leonardo's "Leda". In Luini's fresco of the "Martyrdom of St Catherine" in the Besozzi Chapel at the church of S. Maurizio in Milan, the kneeling Saint has bare breasts, and a preliminary study at the Ambrosiana (fol. 273 inf. no. 47) portrays a beautiful, adolescent, female model devoid of erotic connotations.

In the last century, much credit was given to some traditional belief that Leonardo had portrayed a Milanese courtesan named Caterina di San Celso, who was much admired by Louis XII, King of France, and was the lover of Antonio Pallavicino – a Leonardo patron. It was common practice to have the figure of a saint as a portrait in disguise.

The belief might have originated from a school painting such as this. On the other hand, Leonardo himself records having painted a religious subject – a female figure – from which the man who bought it wanted to have the symbol of its divinity removed in order to be able to kiss the beloved image without scruples (Leonardo, Treatise on Painting, no. 33, fol. 14 v, p. 22).

Carlo Pedretti

Bibliography
Cristina Geddo, ALV Journal VII, 1994. A. F. Rio, Leonardo da Vinci e la sua scuola, Milan, 1856, p. 47.

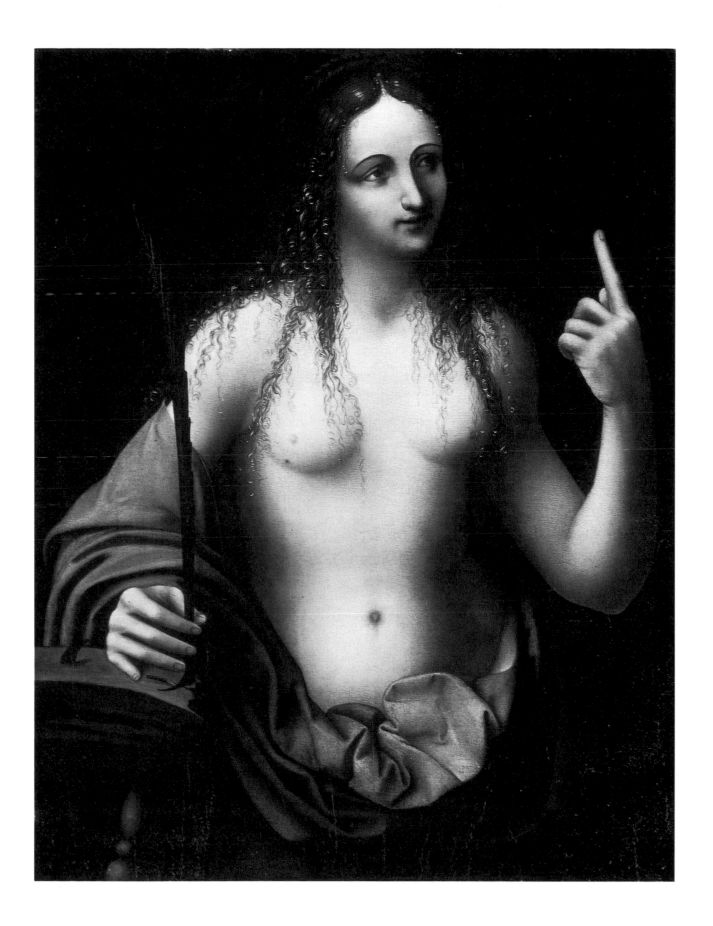

Raphael (1483–1520)

The Betrothal of St Catherine to the Infant Jesus

ca. 1497–1500
Oil on panel
50 x 37.5 cm
Private collection, Switzerland

Apart from Mary who sits enthroned, the Infant Jesus, Catherine of Alexandria, St Jerome and a donor are present. Gentle and serene in the splendor of a miniature-like architectural setting, which opens scenographically into the clear sky of a distant landscape, the foreground figures stand out in their lively attitudes – their character enhanced by the eloquence of their gestures and the intensity of their countenances. These are the qualities that Raphael was to develop into the academic magniloquence of his Vatican frescoes of some ten years later.

No painting of this subject is known from documents or early sources to have ever been commissioned from Raphael, but the first phase of Raphael's career as a pupil of Timoteo Viti and Perugino is still much of an open question in spite of Luisa Becherucci's fundamental contribution of 1968. Dr. Brachert's assessment of the style of the painting intimates the kind of subtle link between the various North Italian schools, such as Bologna, Ferrara and Venice, with those of Central Italy, notably the Umbrian one, at the time of Raphael's training in Perugino's studio – the inherent migration of ideas involving Timoteo Viti first, and then Ercole Roberti and Amico Aspertini, and finally Francesco Francia. It is in this context that Leonardo's idea of a comparable enthroned Madonna takes shape for an altarpiece at Brescia known only through a diagram in a notebook of his of 1497, but possibly reflected in later altarpieces by Giorgione and Bellini. Raphael's relation to Leonardo can be shown to start with his training under Perugino, who, like Leonardo, was a pupil of Verrocchio in Florence in the early 1470s.

The present painting could well be taken as evidence of the kind of training that an apprentice like Raphael was to receive as a sixteen-year-old boy just before his first commission, the "Tolentino Altarpiece" for Città di Castello of 1500–01, known in three fragments, at one time attributed to Timoteo Viti, Evangelista di Pian di Meleto and Perugino. To the same formative years belong a few predella-like panels, for example those at the Staedel Museum in Frankfurt and at Fano. As for the type of impasto in general, the treatment of the hands, and the character of the landscape in particular, the closest affinity is with Raphael's early "Portrait of a Youth" in the J. Paul Getty Museum at Malibu, California.

Nathalie Guttmann

Bibliography
Carlo Pedretti, Raphael – His Life and Work in the Splendors of the Italian Renaissance, Florence 1989. Id.,
"Giorgione e Leonardo", in: Giorgione e l'Umanesimo Veneziano, Florence 1981, vol. II, pp. 485–513.

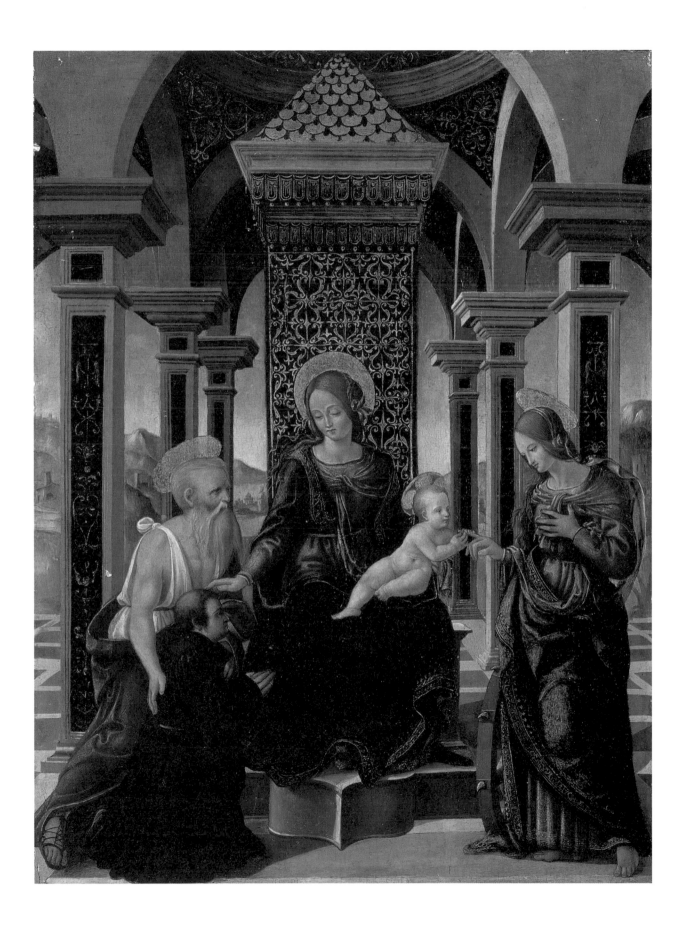

Raphael (1483–1520) and workshop

San Giovannino (the young John the Baptist)

ca. 1518–20
Oil on panel
174.3x154.5 cm
Galerie Hans, Hamburg

Raphael (1483–1520)

Raphael (Raffaello Santi) was born in Urbino in 1483. He initially undertook an apprenticeship with his father, the painter Giovanni Santi. After his father's death in 1494, he entered the workshop of Pietro Perugino in Perugia. In 1504, Raphael traveled to Florence. He rapidly assumed a position next to the city's two leading artists, Leonardo da Vinci and Michelangelo. In 1508, he responded to the call of Pope Julius II and went to Rome where he was active as a painter and master builder. He completed a fresco in the private chambers of the Pope, the Stanzas, and was a leading architect working on the reconstruction of St Peter's. He continually progressed, becoming one of the primary artists working on papal commissions. Raphael died in Rome in 1520.

Bibliography
Thieme-Becker, XXIX, 433ff.

The young John as the herald of Christ points to a cross bound together from branches which is issuing beams of light upon the saint. In his left hand he is holding a ribbon upon which the last letters of the familiar inscription "ECCE AGNUS DEI" may be discerned. He is sitting in a stony wilderness landscape and is clothed only by a panther skin.

Contrary to the usual representation of John as a bearded, ascetic hermit in a rough sheepskin, John is depicted here as a boy of radiant beauty like an antique Bacchus. This depiction is in keeping with the ideal Florentine image of the young boy John who was honoured as the patron saint of Florence.

The unusual appearance here of John in the wilderness may be the result of a certain amount of competition with the picture of the young John by Leonardo which has probably only been handed down in a workshop version in the Louvre. The picture, conceived of by Leonardo, was renamed "Bacchus in a Landscape" in 1695. The garland of vine leaves around the head and the panther skin, which could well be thought of as attributes of Bacchus, are said to have been added at this time. Both the youthful portrayal of the young John and the panther skin suggest that Leonardo's picture must have been known in one form or another in Raphael's workshop. It is probable that Leonardo was fully aware of the ambivalence of this figure and that of a "Bacchus", which according to a letter to his agent dated 1 April 1505 the Duke of Ferrara wished to acquire, but which was not preserved, a John was executed either in the workshop or by Leonardo himself, as was also unmistakably expressed in the case of the John by Cesare da Sesto by adding a cross with a ribbon and a halo and by obscuring the panther skin.

Giorgio Vasari names a "San Giovanni" for Cardinal Colonna in his index of the works of Raphael at the end of his list and after the drafts for the tapestries for the Sistine Chapel, together with the "Transfiguration" which Giulio Romano is supposed to have finished after Raphael's death, after the "Archangel Michael" the execution of which at least is wholly attributed to Giulio Romano, and with "St Margaret" which he recognizes as the exclusive work of Giulio Romano, in other words in connection with the works of 1518–20.

Surprisingly, Vasari says that the picture for Cardinal Colonna was painted on canvas – "in tela". He typically recounts, as was his wont, that the Cardinal presented the picture to his personal physician as a gift from whom it passed further into the possession of a Florentine family. As Raphael painted almost exclusively on wood we may assume that Vasari saw the picture himself in Francesco Benintendi's Florentine collection and gathered his information from this source. As there is evidence that the picture was still in this collection in 1584 and that, from 1589 onwards, a "Giovannino" on canvas by Raphael was registered in the inventory of the Uffizi it would seem reasonable to consider this to be the picture that was in the Benintendi collection and to consider it to be the original by Raphael or at least the picture that Cardinal Colonna purchased from him.

There is, however, a whole series of John the Baptist versions of roughly the same size and of especially good quality. Two further versions have become known since the "Raffaello a Firenze" exhibition in Florence in 1984, one from a Florentine collection and the version exhibited here, which have increased the number of versions to at least 12, although more detailed examination is likely to show some of these to be later copies. It has been clear

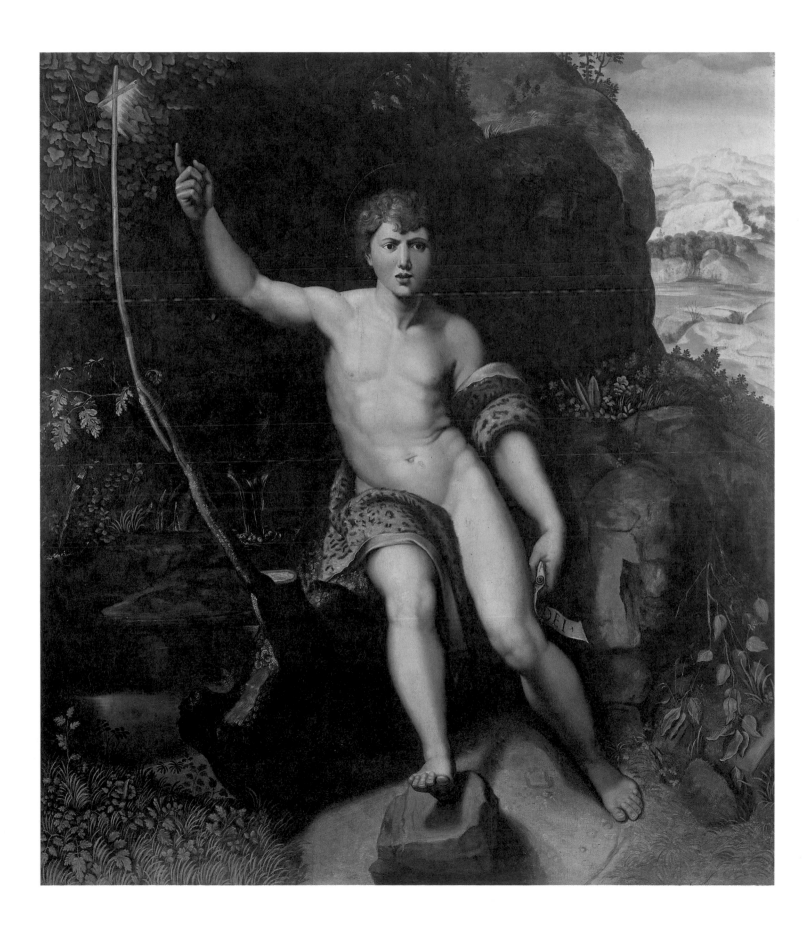

Raphael (1483–1520)
The young John the Baptist

ca. 1517
Oil on panel
103.3x82.5 cm
Private collection, Switzerland

since the close of the 18th century that the Florentine version could not have been by Raphael himself and its authenticity was also denied as a result, although the original conception of the late works from Raphael's workshop which has been handed down has, in contrast with the ideas of the 19th century, subsequently been revised. Ever since the "Stanza della Segnatura", Raphael was entrusted with such an enormous variety of work — as curator of the Roman antiquities, head of the reconstruction of St Peter's and other architectonic and urban development commissions, and as designer of the series of tapestries for the Sistine Chapel — that he had to leave the execution of the work to his obviously excellently organized workshop. This was not just the consequence of practical considerations, but also resulted from the absolute priority given to pictorial innovation, to "invenzione" and the "idea" as represented by Renaissance Neoplatonism, as well as resulting from the relationship of the designing architect to the Mason's Guild and of the drawer of cartoons to the weaving mill which corresponded here to the relationship between the master draftsman and the painter's workshop which actually executed the works. It is, nonetheless, difficult to define this relationship and the actual contribution of the master draftsman especially since, in the mature period of the "third style", so many new stylistic elements are developed which are only very reluctantly linked with Raphael by art history and for which Giulio Romano would appear to be responsible. It was he who pursued those elements which tended towards Mannerism, the distortion of the figures, the emphasis on the geometrical elements of the picture and particularly the diagonals and flat surface modeling of the cool, incarnate coloring. These are, however, features characterizing all the later pictures after the "Fire in the Borgo" Stanza, including those bearing the signature of Raphael. It is precisely these features which can be even more clearly discerned in the exhibited version than in all other versions of the picture of John. This suggests a close relationship with the work of Giulio Romano, even if the difference between it and the best amongst the other versions can only be expressed in nuances.

Albert Schug

Bibliography
Raffaello a Firenze, Florence, exhibition catalog, Palazzo Pitti, 11 January — 29 April 1984, pp. 222–228. Carlo Pedretti, Raphael — His Life and Work in the Splendors of the Italian Renaissance. With new documents, Florence 1989, p. 152, with a previously unknown version which is also attributed to Raphael's workshop.

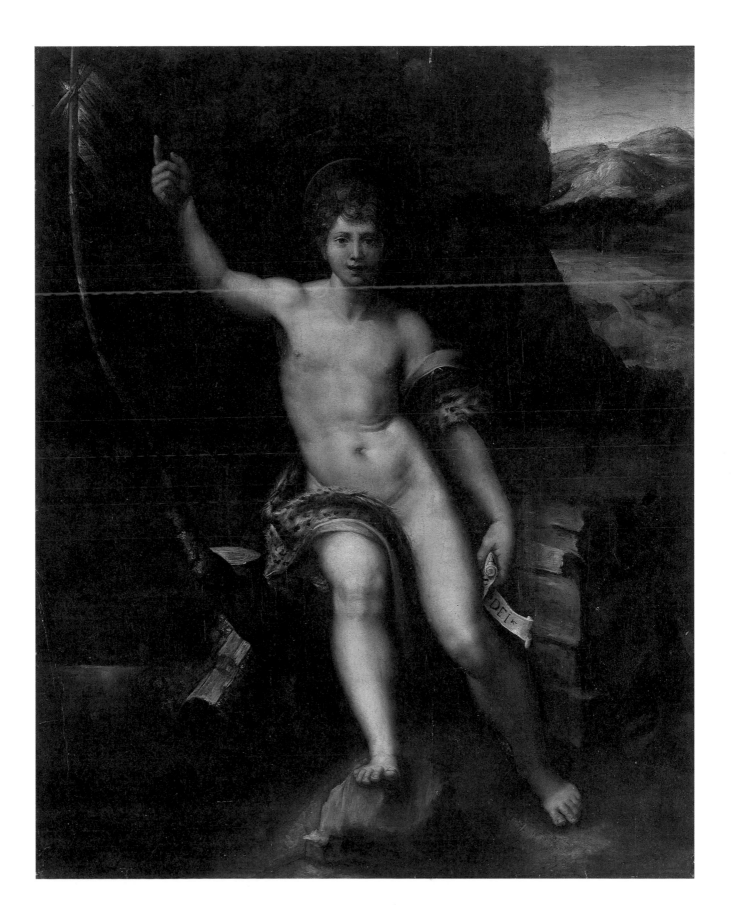

Leonardo da Vinci (school)
The kissing infants

ca. 1510—15
Oil on oak
97.2x59.2 cm
Private collection, Switzerland

The representation of children was always an object of particular interest for Leonardo. In his "Treatise on Painting" he described how children should be represented. In the group of pictures "Virgin of the Rocks", Leonardo fashioned the Infant Christ and the boy John. Both these motifs are used by the painter from the school of Leonardo for his painting "The kissing infants". He places the two closely embracing and kissing children in a landscape which in its turn is framed by a richly decorated window arch upon which is perched a bird. The landscape subject of the playing children thus becomes a picture within a picture.

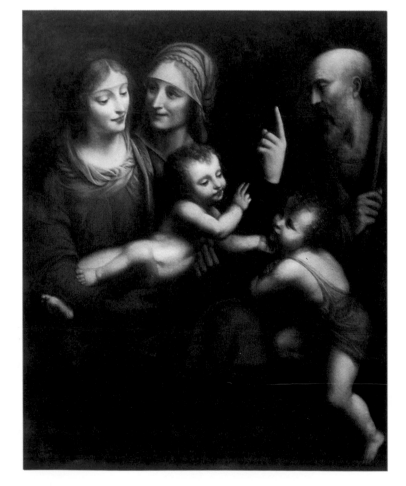

Anonymous follower of Leonardo da Vinci
The Holy Family (The Russian Madonna)

after 1530
Oil on canvas
115x90 cm
Private collection

Leonardo da Vinci
Profile of a man with laurel wreath
ca. 1506–08
Red chalk and touching up with pen
and ink by Francesco Melzi (ca. 1493–1570)
168×125 mm
Biblioteca Reale, Turin (15575 r)

Francesco Melzi or Andrea Solario
(attribution)
View of Amboise Castle
ca. 1508–18
Red chalk
133×263 mm
Pedretti 35 r
Royal Library, Windsor (RL 12727)

Francesco Melzi (attribution)
Study for a water wheel
ca. 1510
Pen and ink
175×475 mm
Codex Atlanticus fol. 706 r (ex 263 r-a)
Biblioteca Ambrosiana, Milan

Francesco Melzi
A dragon attacking a lion
Copy after Leonardo da Vinci
176×218 mm
Red chalk. At bottom left
a later collector's note in pen and ink:
"Ma de Rafael" (Hand of Raphael)
Graphische Sammlung, Städelsches Kunstinstitut,
Frankfurt (no. 426)

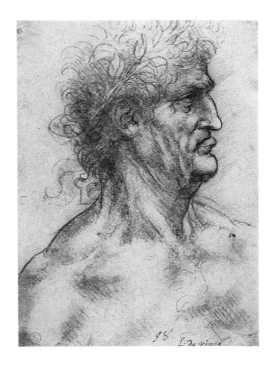

Francesco Melzi (ca. 1493–1570)

Francesco Melzi was born in Milan in around 1493. There is documentary evidence of his relationship with Leonardo da Vinci as early as 1508. He soon became the master's favorite student, accompanying him to Rome in 1513 and France in 1516. In 1517, the Cardinal of Aragon's secretary reported from Cloux that Leonardo was no longer working but that he had a Milanese student who painted extremely well. This can only have been Melzi, who remained the artist's faithful friend and companion until the latter's death in 1519. He was the executor of Leonardo's will and his principal heir. He inherited the manuscripts, tools and "works of the painter" and brought them to Vaprio d'Adda where he was visited in 1566 by the famous artist and biographer Vasari who expressed his excitement about the artifices left by Leonardo in his "Vita". Francesco Melzi died in Vaprio in 1570. Francesco Melzi's own oeuvre is not all that large. His works are characterized by careful execution of detail: Lomazzo called him a "grandissimo miniatore". He approached the style of his master like no other student of Leonardo. Some of his pictures are so similar to those of Leonardo as to be hardly distinguishable.

Bibliography
Thieme-Becker, XXIV, 374 ff.; Suida 1929, 230 ff.; Venturi 1941, 40 ff.

Bernardino Luini (ca. 1485–1532)
Two studies of a blessing
Infant Jesus
ca. 1500
Pen and ink
115x142 mm
Provenance: d'Este Collection.
Galerie Hans, Hamburg

Bernardino Luini (ca. 1485–1532)

Bernardino was born in Milan around 1480–85. His name on the other hand suggests he may have come from Luino. However, Luini's place of birth remains as unclear as the rest of his journey through life. Luini's work first became apparent in 1507. The fresco "Madonna, Saint and Founder of the Crivelli Family" in the Cappella della Cascina del Soccorso, as well as the panel "Madonna with the Saint" in the Musée Jacquemart-André in Paris, are signed and dated 1507. In his early work, the Lombardian artist emulated the work of his teacher Bramantino only to be drawn subsequently more and more under the influ-ence of Leonardo da Vinci's art. Leonardo's approach to painting and figures is clearly discernible in Luini's work. He, nonetheless, achieved wholly personal, occasionally folkloristic, apparently quattrocentist solutions. Bernardino Luini died in 1532 in Milan. He is one of the most important artists to have arisen in the circle of Lombardian artists to have succeeded Leonardo.

Bibliography
Venturi 1941; Suida 1929; G. A. Dell'Acqua, M.T. Binaghi, G. Mulazzani, Sacro e profano nella pittura di Bernardino Luini, exhibition catalog, Luino/Milan, 1975; Marani 1987.

Cesare da Sesto (1477–1523)
Study of a praying abbot
ca. 1507–14
Red chalk on red-prepared paper
180x158 mm
Provenance: G. Pacini Collection, Florence
Galerie Hans, Hamburg

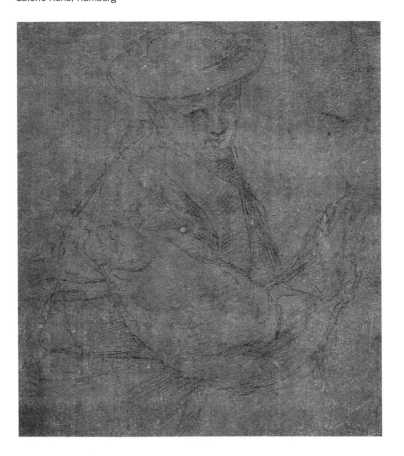

Cesare da Sesto (1477–1523)

Cesare da Sesto was born in 1477. He was active in Rome around 1506. He resided in Milan in about 1507 during which time he fell under the influence of Leo-nardo's art. Cesare da Sesto worked together with the landscape painter Bernazzano until 1510. During the period he spent in Milan he took up subjects to be found in Leonardo's work. They served as the basis for his own artistic creativity. Cesare da Sesto and Bernaz-zano probably parted after 1510. He traveled to Mes-sina in 1514 and again spent some time in Rome where he deliberated on the work of Raphael before returning to northern Italy in 1520. Cesare da Sesto died in Milan in 1523.

Bibliography
Thieme-Becker, XXX, 534 ff.; Suida 1929, 215 ff.; Venturi 1941, 37 ff.

Bartolommeo Suardi known as Bramantino (ca. 1465–1530)

Pietà (Lamentation over the Dead Christ)

ca. 1515
Oil on canvas
196.5x155.3 cm
Private collection

Before a 1958 restoration as fully documented by photographs, the painting was hardly visible on account of extensive color oxidation. It now shows occasional thinning down of the pigment due to earlier damages.

The painting, a typical late work of Bramantino, is still unpublished. Although so far not treated in specialist literature, it is a most important addition to the artist's œuvre.

The more dramatic expression of Christ's face and the enhanced chiaroscuro point to a more emotive and sentimental phase in the unfolding of Bramantino's style, when in about 1515 he seems to respond to the lesson of Leonardo's bold use of light and shade. Bramantino, in fact, must have come to specialize in this kind of composition with strong funerary connotations as shown not only by the number of such commissions, but also by a testament of March 19, 1509, with which Giovanni Antonio Castiglioni arranges for the erection of his own sepulchre in a chapel of San Pietro in Gessate, Milan, requiring that the altarpiece for it be painted by Bramantino, and though the subject is not specified, it could well have been a "Deposition" or "Pietà", such as the present painting.

Although Bramantino is an artist traditionally considered unaffected by Leonardo's art, recent scholarship and archival research have ascertained his keen interest in it. In fact, it is now known that in 1503 he made a copy of Leonardo's "Last Supper" for Antoine Turpin, treasurer of the King of France in Milan, while in such late works as the "Virgin and Child with two Angels", formerly in the Palazzo della Ragione, Milan, and now at the Brera, he appears to take into account Leonardo's studies of about 1508–10. Furthermore, a document just published, shows that on May 31, 1503, he was to receive money from Louis of Luxembourg, the famous Count of Ligny with whom Leonardo was in relation at the moment of leaving Milan following the fall of the Sforza dynasty in 1499–1500. This is an extraordinary fact which comes to link Bramantino with Leonardo's first French patrons, indeed a most significant one in that it was to lead to Leonardo's later association with him on the project for the funerary chapel of Gian Giacomo Trivulzio at San Nazaro, ca. 1508–10. As Leonardo planned the equestrian monument of the Trivulzio sepulchre, Bramantino was eventually to expand the architectural project into a grandiose mausoleum for the whole Trivulzio family, a work undertaken in 1511–21 and completed only after 1546.

Pietro C. Marani

Bartholommeo Suardi known as Bramantino (ca. 1465–1530)

Bartolommeo Suardi, called Bramantino, was born the son of Alberto Suardi in about 1465. Documentary evidence exists of him as a painter and architect in Milan from 1490. Before joining the famous Milanese architect Bramante – from whom his name is derived – he probably undertook an apprenticeship with Bernardino Butinone. After Bramante and Leonardo da Vinci had left Milan, Bramantino became the city's primary artist. Bernardino Luini was one of his students. Suardi lived almost exclusively in Milan. Documents show that he was employed as a painter in the Vatican in Rome in 1508. Bramantino was in Milan again in 1513 at the latest where he cintinued to enjoy a considerable reputation as a painter and architect. In 1525, Duke Francis II Sforza appointed him as court painter and architect. Bartolommeo Suardi died in 1530.

Bibliography
Thieme-Becker, IV, 519ff.; Kindlers Malerei Lexikon, p. 109ff.

Bibliography
P. C. Marani, in: Pinacoteca di Brera. Scuole lombarda, ligure e piemontese, ed. by F. Zeri, Milan 1988, pp. 140–142. Id., "Disegno e prospettiva in alcuni dipinti di Bramantino", in: Arte Lombarda, 100/1, 1992, pp. 75–88. G. Mulazzani, L'opera completa di Bramantino e Bramante pittore, Milan 1978, catalog nos. 29, 31, 35. A. Falchetti, La Pinacoteca Ambrosiana, Vicenza 1971, p. 156. M. Garberi & M. T. Fiorio, Pinacoteca del Castello Sforzesco, Milan, 1987, p. 136. J. Shell, Pittori in bottega. Rinascimento a Milano, Turin 1995, document nos. 65/110/240/265. Baroni, "Leonardo, il Bramantino e il Mausoleo di Gian Giacomo Trivulzio", in: Raccolta Vinciana XV–XVI, 1935–1939, pp. 201–270. J. Shell & G. Sironi, 'Documents for copies of the "Cenacolo" and the "Virgin of the Rocks" by Bramantino, Marco d'Oggiono, Bernardino de' Conti and Cesare Magni', in: Raccolta Vinciana XXIII, 1989, pp. 109–111.

Bartolommeo Suardi known as Bramantino (ca. 1465—1530) (attribution)

The Virgin of the Rocks

First half of the 16th century
Oil on panel
55.9x89.5 cm
Joseph M. B. Guttmann Galleries, Los Angeles

This painting derives from Leonardo's treatments of the same theme (see pages 45 and 47). Bramantino includes a new figure, however, in the person of a nobleman kneeling on the left of the picture. He is presumably the member of the Lazzari family who commissioned the picture. He is addressing his prayers to the Virgin Mary, the painting's compositional and substantive focal point. The Madonna's clothing, as well as the postures of the angel and the Infant Jesus on the right, show Bramantino seeking to blend the disparate details borrowed from Leonardo into a homogeneous entity. At the same time, the nobleman is integrated in the scene by the angel, Jesus and the infant John, whose looks, gestures and bodily postures present him to Mary and hold out the promise of her protection.

The golden flesh tint of the figures and the brightly lit landscape in the background have been taken as evidence for attributing this picture to the young Boltraffio or to his workshop. Interesting aspects are the palpable influence not only of the two Leonardo treatments of the theme but also of contemporary Lombard painting. The present picture's composition conforms with the prevailing iconographic conventions, while the lateral placement of the nobleman can be traced back to Bramantino's "Madonna Trivulzio" (around 1512, Brera, Milan).

One noteworthy detail is the manner in which the two children's genitals are portrayed. This suggests that the painter was familiar with the "Apocalypsis Nova" and was following in Leonardo's footsteps. In both versions of Leonardo's "Madonna of the Rocks", however, Saint John's genitals are concealed by a veil. Bramantino's picture emphasizes the two boys' human attributes and portrays them in all their youthful innocence.

It is not easy to assign the present picture to its correct chronological position. This has to be done step by step with reference to the various copies. Chronologically speaking, it must be placed after the Geneva version (see page 46) and the Copenhagen version (see page 47) of the same theme.

Gabriella Ferri Piccaluga

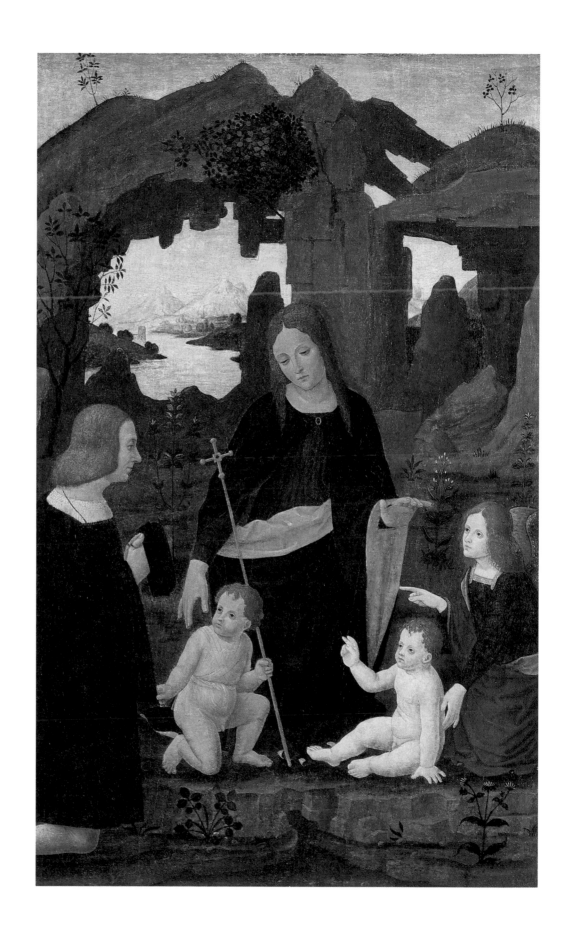

Michelangelo (1475—1564)

The Virgin with Child and the Infant St John

ca. 1500
Oil on panel
80.5x63.5 cm
Private collection, Switzerland

The Virgin is seated sideways so as to lean against a plinth on which she has placed a book touched by the Christ Child who stands in front of her, his arms spread open in the attitude of a Crucifix, while gazing at the page to which the Virgin is pointing and which reproduces the XXXIVth psalm:

"Benedicamus Dominum in omni tempore
Semper laus eius in ore meo..."
("Let the Lord be blessed all the time
Let He always be praised by my lips...")

Behind, on the left, stands the Infant St John the Baptist who holds a reed cross and points at his playmate. The Virgin, which prefigures the majesty of a Sybil in the Sistine Chapel, looks out in the opposite direction towards an imaginary viewer who is being invited by the Infant St John to look at his cousin Jesus. The composition is therefore meant to be read as a narrative in which St John, the Precursor of Christ, plays the role of a commentator. The Christ Child is introduced by him as the Savior whose predestined sacrifice on the cross is suggested by his open arms, a symbolism which is projected to an emphatic focal point in the foreground as if proceeding from the reed cross held by St John against the dim light of the background. The Virgin has the unperturbed and pensive expression of one whose mind is still with the words just read in the book, but her lively attitude in relation to that of her child is endowed with intense spirituality as in the Bruge "Madonna" of about the same time. This is the visual equivalent of Petrarch's "Hymn to the Virgin", and as such it has nothing to do with the ambiguities inherent in Leonardo's portrayal of the Divine through a domestic disguise involving human sentiments. Noble and aloof, Michelangelo's "Madonna" has the imposing monumentality of classical statuary, hence the posture reminiscent of that of a Sybil.

The motif of the "Virgin with the Two Holy Children" appears in Michelangelo's drawings from the time of Leonardo's studies for the "St Anne" cartoon, about 1503—05. According to Professor Parronchi, it was with a drawing such as the one in the Louvre (Berenson 1938, 1599) that Michelangelo conceived this painting of the "Virgin with the Two Holy Children" — a theme that was to be fully exploited in his best-known bas reliefs dating from the same time, namely the Taddei and Pitti tondos.

Nathalie Guttmann

Bibliography
A. Parronchi, Opere giovanili di Michelangelo, vol. III: Miscellanea michelangiolesca, Florence, 1981, pp. 205—211, pl. 139; M. Seracini, Technical Report on a Panel Painting Ascribed to Michelangelo, Florence, 1991—1992.

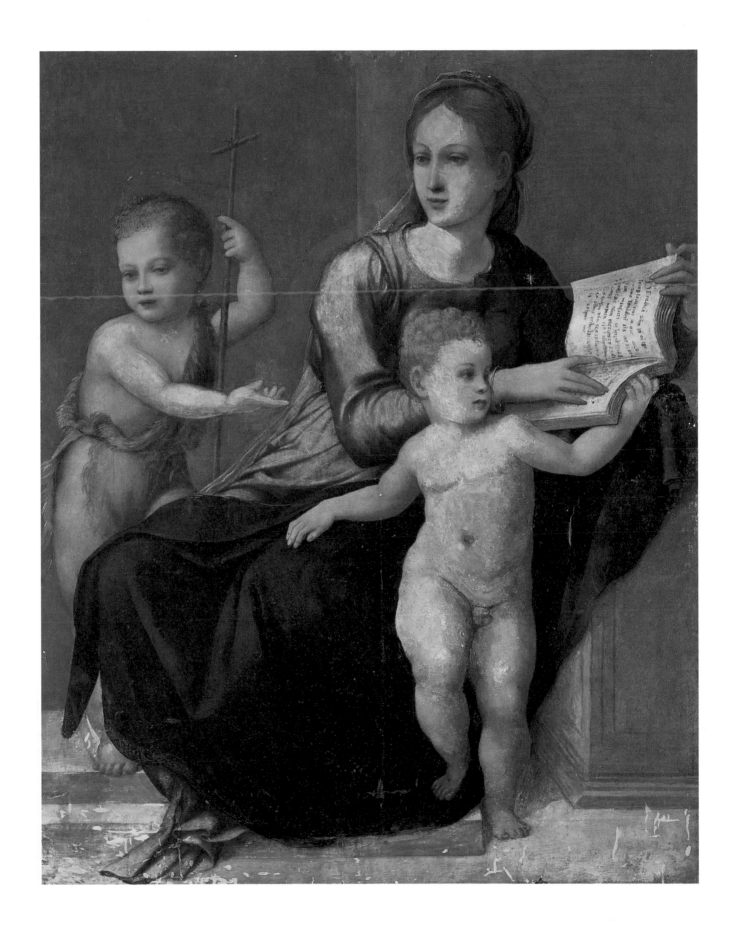

After Correggio

Madonna del Latte (Nursing Madonna with the Infant St John)

Early 16th century
Oil on canvas
67 x 56 cm
Private collection

This is an early copy of Correggio's famous "Madonna del Latte". The original is in the Szépmüvészeti Museum in Budapest: formerly in the Aldobrandini collection in Rome, it was brought to Hungary by Prince Esterhàzy in 1795. There are about twenty copies of it in existence, but only two — this and the one in the Hermitage at St Petersburg — are unquestionably the best. While the Hermitage copy was for a long time considered the original, the present one is known from family records to have been attributed to Lodovico Carracci (1555–1619) in the past. A late sixteenth-century inscription on the back of it seems to suggest a different origin: "Exechia dal / Pozzo / B.V.M.CVM.PVERO.IESV. / LACTENTE.EX.ARCHET[IPO]. / ANT.DECORIGIO." In translation: "Ezechiele Dal Pozzo. The Blessed Virgin Mary with the Infant Jesus being nourished, from the original [i.e. prototype] by Antonio Correggio". Since the name of Ezechiele Dal Pozzo is nowhere recorded as that of a painter, it is possible that it did not indicate the copyist but the owner, as in the case of an estate inventory. If so, he could have been a relative of Cassiano Dal Pozzo (1588–1657), secretary to Cardinal Francesco Barberini and a well known scholar and collector.

A Correggio painting of this subject was first described by Domenico Ottonelli in his "Trattato della pittura" (1652, p. 155), where he points out that the Christ Child turns around to reach for some fruit offered to him by an angel, and in fact what appears to be the Infant St John, Jesus' cousin, is shown with little wings. Sebastiano Resta, in his "Parnasso de' pittori" (1787, p. 63), mentions the same painting and says that in the preliminary drawings, which are today regarded as missing, the little angel is clearly a child, and therefore the Infant St John.

The theme of the Virgin and Child with the Infant St John is of course recurrent in the works of Leonardo and Raphael, and Correggio treated it several times in earlier paintings where Leonardo's influence is paramount, for example, in the Madonnas at the Sforza Castle in Milan and at the Chicago Art Institute, both dating from about 1517. The Budapest original of the present painting is somewhat later, ca. 1524–26, the time of the best-known "Madonna of the Basket" in the London National Gallery, where the Leonardo influence is combined with that of Tuscan Mannerism as best shown by the "Holy Family" (including the Infant St John) by Maso da San Friano in the Ashmolean Museum at Oxford. This accounts for the bold, un-Leonardesque "open" stance of the Christ Child with which to emphasize his sex — a feature which Correggio insisted on in his profane subjects as well, notably in the figure of Eros in the Borghese "Danae" and in the London "Allegory of Vice", both dating from 1531.

Carlo Pedretti

Bibliography
For background information, see K. Garas, in: Arte Antica e Moderna, 1960, and David Alan Brown, The Young Correggio and His Leonardesque Sources, New York & London, 1981.

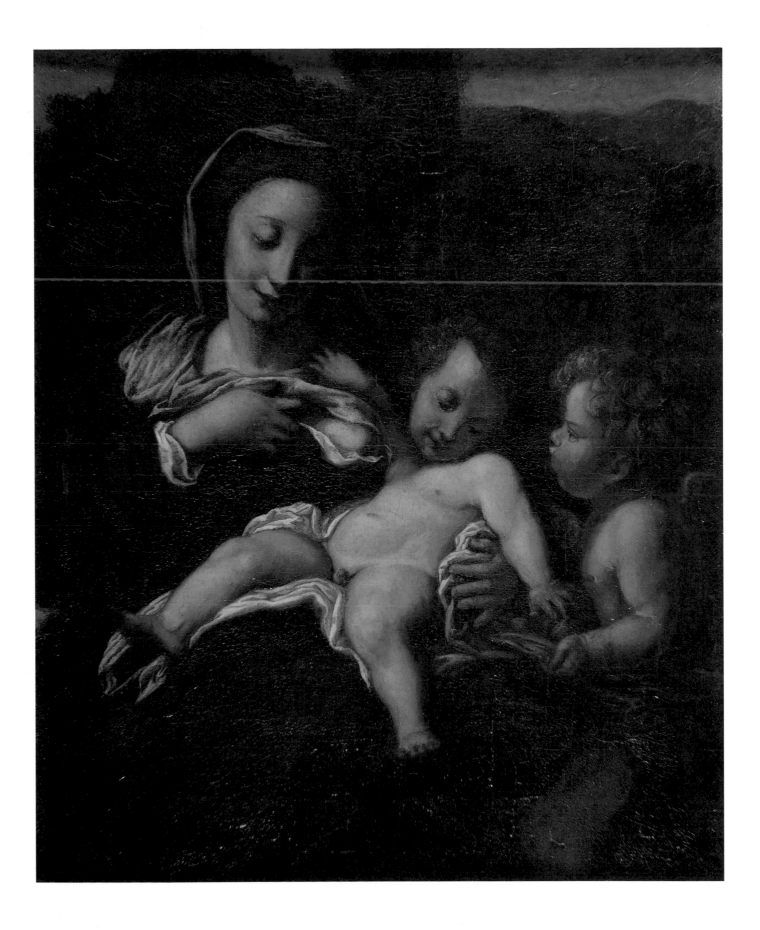

Lombard Follower of Leonardo
Madonna of the Yarnwinder

Mid 16th century
Oil on panel
43.5 x 34.7 cm
Private collection

This privately owned painting has a family provenance traceable back to about 1870. Of some thirty or so copies known of the subject, this is unquestionably the best after the two versions that have come to be recognized as products of Leonardo's studio under the direct supervision and even participation of Leonardo himself, namely the Buccleuch and ex-Reford versions. As such, it incorporates elements of both, for example, the emphatically flattened-out face of the Virgin, just as in Leonardo's well-known preparatory study at Windsor, the highly convincing detail of the stratified rock formation at the bottom right, and the atmospheric rendering of a chain of Alpine mountains in the far background, far more reminiscent of Leonardo than those in the ex-Reford version.

Different elements of the landscape are introduced in the mid-distance — the upstream view of a river flanked by a town with a bridge and by a long, winding road that leads up to a smaller town, on the left, and a hillside of dense vegetation on the right. The type of buildings may at first suggest a northern artist, but this is precisely the type of landscape that Bernazzano contributed to the paintings of Cesare da Sesto. A comparable detail appears even in a small sketch on a French folio of Leonardo's geometrical studies (CA, fol. 90v-b, ca. 1517–18).

Leonardo's lost original, as explained by Leonardo himself to a visitor to his studio in Florence in 1501, was highly innovative both in iconography and style. The scene is that of the Child who has just snatched the distaff (or yarnwinder) from his mother's hands and holds it up in earnest, as a symbol of the cross of his future sacrifice. The mother could not prevent his sudden action and looks at him in trepidation. It is precisely the unfolding of this action that is caught in Leonardo's painting in a way never seen before, thus suggesting the freezing of a motion picture sequence.

Nathalie Guttmann

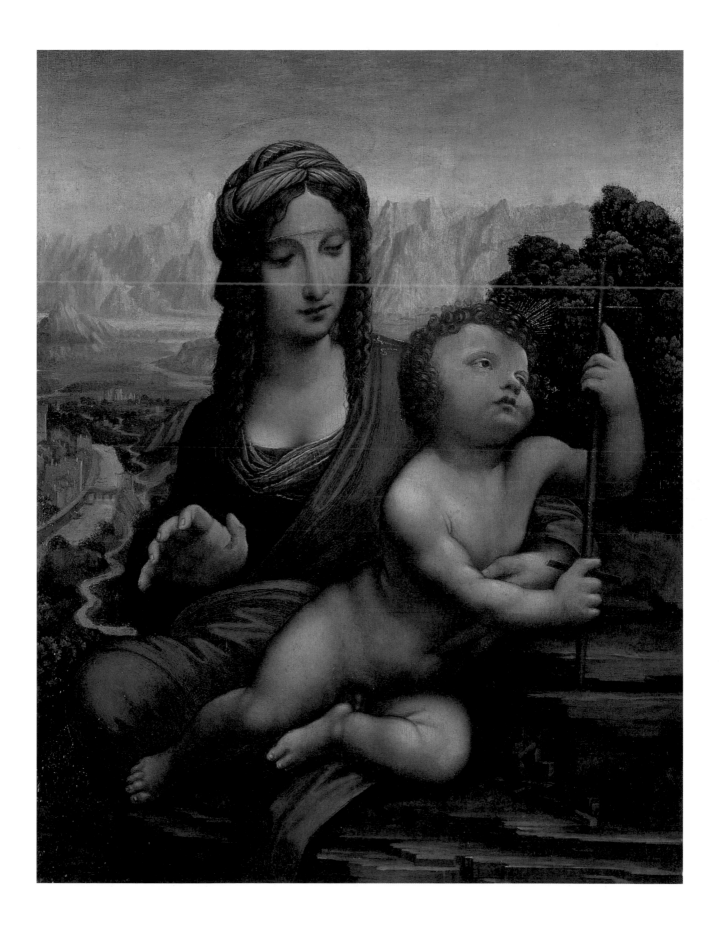

Gian Giacomo Caprotti known as Salai (1480–1523) under Leonardo's direction
Monna Vanna (The "Mackenzie Joconde Nue")

ca. 1510–15
Oil on panel
89x65.5 cm
Private collection, Switzerland

A naked "Mona Lisa" once attributed to Leonardo himself but executed by one of his best pupils under his direct supervision, is one of the highlights of the Leonardo exhibition. It is a famous painting with a prestigious provenance.

The picture occupies the first place in the official catalog that the Louvre issued in 1952 listing 61 copies or versions of the "Mona Lisa" (see page 61). It was published for the first time by Herbert Cook in 1909 with an attribution to Salai and Leonardo, and was included by Emil Möller in his 1928 study on Salai and Leonardo as an example of the collaboration between pupil and teacher. Its last appearance in a publication was in 1931 with the Leonardo monograph by Heinrich Bodmer in the prestigious series "Klassiker der Kunst".

Following its owner's death in 1930, the picture went to his daughter who sold it shortly afterwards to a Swiss collector. For the next fifty years or so it was no longer to be seen, and it was virtually forgotten.

In 1978 a publication on the origin of erotic portraiture, "Monna Vanna and Formarina: Leonardo and Raphael in Rome", the joint work of David A. Brown, curator of Italian Painting at the National Gallery of Art in Washington, D.C., and Konrad Oberhuber, Director of the Albertina in Vienna, focused on the "Joconde Nue" as the prototype for Raphael's celebrated portrait of "La Formarina" in the Borghese Gallery in Rome.

According to Brown, the "Joconde Nue" was Leonardo's "last great pictorial invention" carried out by his favorite pupil Salai, who followed him to Rome in 1513. There the painting was conceived by Leonardo shortly afterwards, possibly around 1515. Later, in 1550, Vasari was to record Salai's pictures as having been painted with the help of Leonardo. In addition, a recently discovered inventory of paintings in the possession of Salai at his death in 1523, includes a "Gioconda".

Brown characterizes this painting as "something strangely cool as well as provocative. The response Raphael made to Leonardo's portrait concept is a primary factor in the development of the type". The dense vegetation against which the statuesque female nude is set in the posture of "Mona Lisa", only allows a few glimpses of blue sky behind. It is made up of the branches of a plum tree which enhances with its fruit the erotic connotations of the picture.

The "Joconde Nue" is seen for the first time in a Leonardo exhibition, and it is appropriately joined by the mysterious "Angel in the Flesh", the newly discovered Leonardo drawing of a hermaphrodite, possibliy an idealized portrait of Salai, a bold and disturbing image out of the same hedonistic atmosphere that produced the "Joconde Nue".

Carlo Pedretti

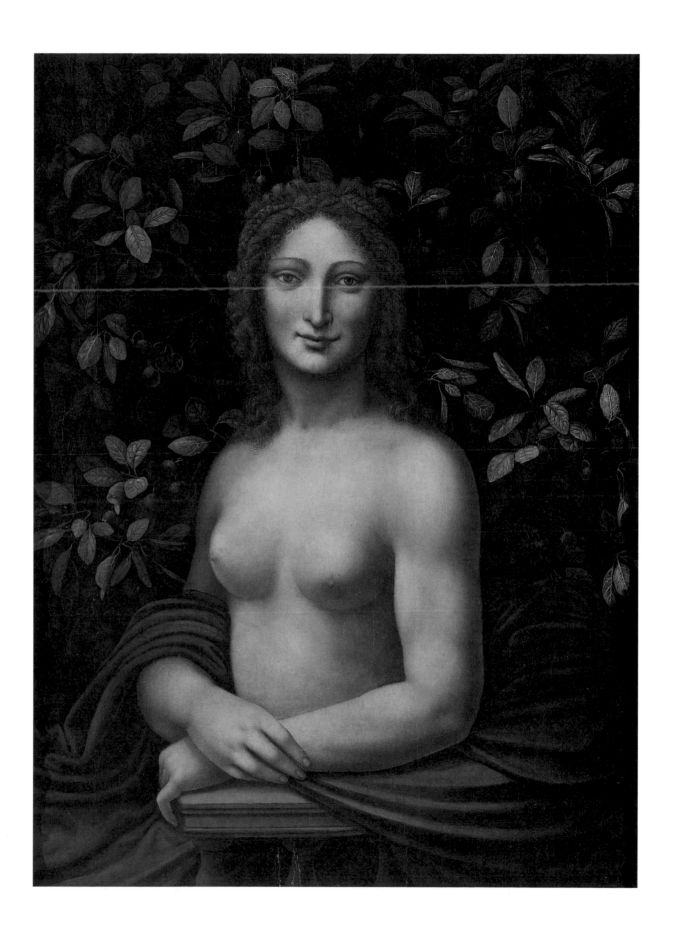

Daniele da Volterra (ca. 1509–66)
The horse of the so-called "Opus Praxitelis" at Monte Cavallo in Rome

ca. 1550
Lead point on yellowish paper, watermark
of a crown with a star,
similar to Briquet 4832–4836
317x320 mm
Joseph M.B.Guttmann Galleries, Los Angeles

The identical subject is shown in a drawing at the Ambrosiana Library in Milan published as Leonardo's by Gerli in 1784. Leonardo is known to have studied antique statues in Rome in about 1515, and to have invented a special tool to measure them, one sketch in CA, fol. 259 r-a, showing the instrument about to be set on the hind-quarters of the statue of a horse. It was probably with such an instrument that Raphael measured at that time this very same horse for a comparable drawing recently acquired by the National Gallery of Art at Washington, D.C. (Woodner Collection, formerly Duke of Devonshire Collection). The present drawing was first attributed to Daniele da Volterra, a Michelangelo follower, by Cecil Gould, former Keeper of Italian Painting at the National Gallery in London. The watermark confirms the proposed date.

Carlo Pedretti

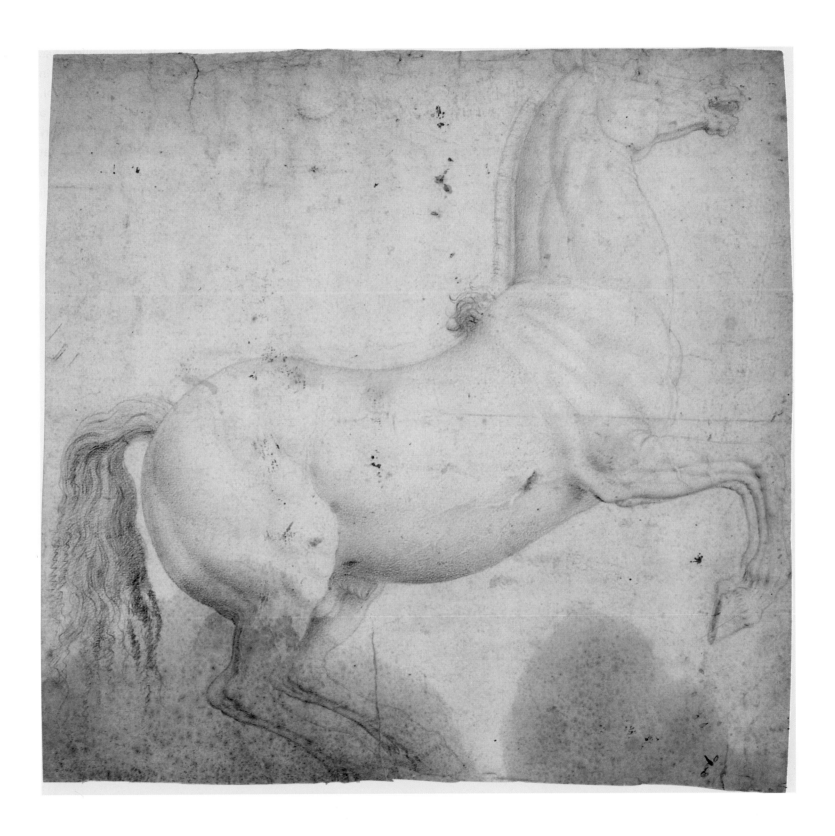

Leonardo da Vinci (attribution)

The Wax Horse (Fragmentary model for an equestrian statue of Charles d'Amboise)

Early 16th century
Wax
Height 25.4 cm
Private collection

This unique piece from a prestigious European collection, a now famous wax model of a horseman, has been recently published as a work by the great Renaissance master in the corpus of Leonardo's horse studies in the collection of the Queen of England. It was never seen until this official edition of the newly restored Leonardo papers in the Queen's Collection at Windsor Castle, a special project entrusted to Carlo Pedretti. The provenance of this small, fragmentary work could well be traced back to the estate of Leonardo's pupil Francesco Melzi, the inheritor of all Leonardo's manuscripts and drawings, as well as cartoons and sculptural models.

Scholars and general public alike are now given the opportunity to view the extraordinary piece which shows a bucking horse in a typical fifteenth-century harness and leather armor, the kind of ceremonial attire represented in the decoration of a Renaissance "cassone" at the Sforza Castle in Milan.

Charles d'Amboise was very fond of tournaments, and this equestrian statuette could well portray him in the sort of ceremonial attire that is more appropriate to a statesman than to a military leader. The liveliness of expression and dignity of posture, enhanced as they are by the elegance and nobility of a fluttering cape, taken in conjunction with the spirited action of the horse, are precisely as expected of Leonardo, whose horse studies from the first decade of the sixteenth century may offer remarkable occasions for comparison with this wax model.

It is well known that Leonardo used wax models to study the compositions of his own paintings. Furthermore, Leonardo was first trained as a sculptor in the workshop of Andrea del Verrocchio in Florence in the early 1470s. But the most convincing piece of evidence in favor of an attribution to Leonardo comes from Leonardo himself. On a sheet of horse studies at Windsor showing figures of horsemen in action for the composition of the "Battle of Anghiari", there is a note in his own hand: "Fanne uno piccolo di cera lungo un dito" ("Have one made of wax a finger long"). And one of the horses sketched on this folio shows the same bucking position as in the wax statuette.

Sources tell us that Leonardo designed a suburban villa and garden for Charles d'Amboise, and that he organized festivals in Milan. It is therefore reasonable to assume that he also entertained the idea of an equestrian portrait of his patron. The king himself, Louis XII., writing to the Florentine authorities from Milan in 1507 expressed the desire to be portrayed by Leonardo.

Carlo Pedretti

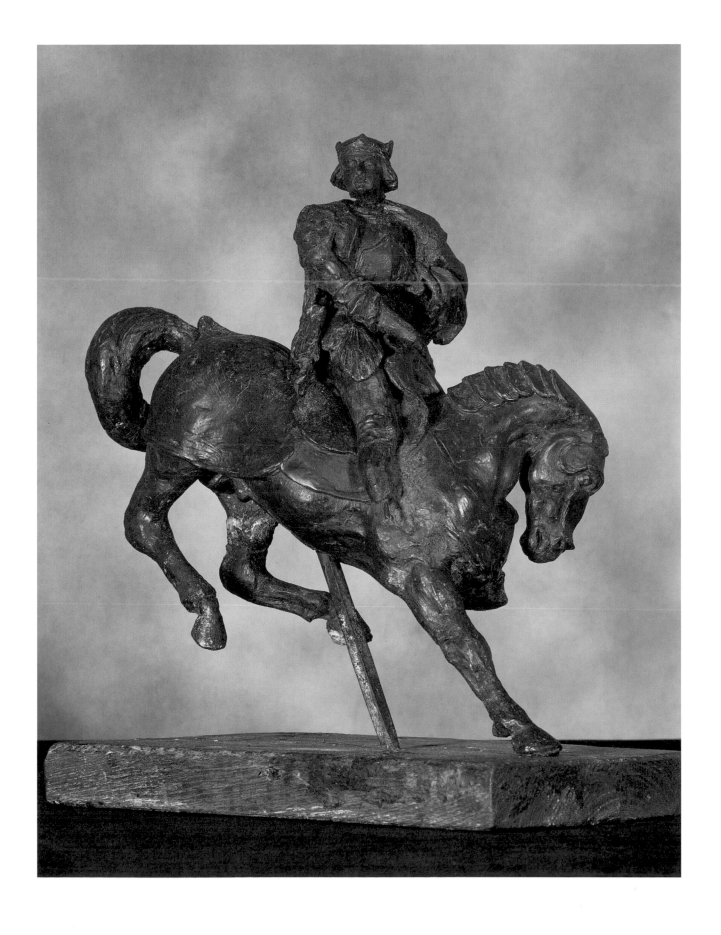

Selected Bibliography

G. D'Adda, Leonardo da Vinci e la sua libreria, Milan 1873.

F. Albertini, Memoriale di molte statue et picture sono nella inclyta cipta di Florentia..., Florence 1510.

M. Alpatov, D. Arasse et al.: Leonardo. La pittura, intr. by P. C. Marani, enlarged ed., Florence 1985 (1977).

ALV (Achademia Leonardi Vinci. Journal of Leonardo Studies & Bibliography of Vinciana).

Anonimo Gaddiano, Vita di Leonardo da Vinci, ed. by Carl Frey, Berlin 1892.

M. Bacci, Leonardo, Milan 1965.

C. Baroni, Tutta la pittura di Leonardo, Milan 1954.

S. Béguin, Léonard de Vinci au Louvre, Paris 1983.

L. Beltrami, Documenti e memorie riguardanti la vita e le opere di Leonardo da Vinci, Milan 1919.

B. Berenson, The Drawings of the Florentine Painters, classified, criticized and studied as Documents in the History and Appreciation of Tuscan Art, 2 vols., London 1903.

B. Berenson, The Drawings of the Florentine Painters, enlarged ed., Chicago 1938.

B. Berenson, I disegni dei pittori fiorentini, Milan 1961.

B. Berenson, Italian Pictures of the Renaissance. Central Italian and North Italian Schools, London 1968 (Oxford 1932).

W. Bode, Studien über Leonardo da Vinci, Berlin 1921.

H. Bodmer (ed.), Leonardo. Des Meisters Gemälde und Zeichnungen, Stuttgart 1931.

G. Boehm, Bildnis und Individuum. Über den Ursprung der Portraitmalerei in der italienischen Renaissance, Munich 1985.

G. Bora, P. C. Marani et al., Disegni e dipinti leonardeschi dalle collezioni milanesi, Milan 1987.

S. Bottari, Leonardo, Bergamo 1942.

S. Braunfels-Esche, Leonardo da Vinci. Das anatomische Werk, Stuttgart 1961.

A. M. Brizio, Scritti scelti di Leonardo da Vinci, 2nd ed., Turin 1966.

A. M. Brizio, M. V. Brugnoli & A. Chastel, Leonardo the Artist, Maidenhead 1979.

G. Calvi, I manoscritti di Leonardo da Vinci dal punto di vista cronologico, storico e biografico, Bologna 1925 (new ed. 1982).

G. Castelfranco, La pittura di Leonardo, Rome 1956.

A. Chastel, The Genius of Leonardo da Vinci, New Haven 1961.

A. Chastel, Leonardo da Vinci. Gemälde und Schriften, Munich 1990.

A. Chastel, P. Galluzzi & C. Pedretti, Leonardo, Art e Dossier 12, Florence 1987.

A. Chastel, C. Pedretti & F. Viatte, Leonardo da Vinci. Die Gewandstudien, Munich, Paris & London 1989.

A. Ottino della Chiesa, L'opera pittorica completa di Leonardo, Milan 1967.

K. Clark, A Catalogue of Drawings of Leonardo da Vinci in the Collection of His Majesty the King at Windsor Castle, Cambridge 1935.

K. Clark, Leonardo da Vinci. An Account of His Development as an Artist, Cambridge 1939.

K. Clark, Leonardo da Vinci, intr. by M. Kemp, Harmondsworth & New York 1988 (London 1952).

K. Clark & C. Pedretti (eds.), The Drawings of Leonardo da Vinci in the Collection of Her Majesty the Queen at Windsor Castle, 3 vols., London 1968–69.

K. Clark & C. Pedretti, Leonardo da Vinci. Natur und Landschaft. Naturstudien aus der Königlichen Bibliothek in Windsor Castle, exhibition catalog, Hamburg 1983.

M. Clayton, Leonardo da Vinci. One hundred drawings from the Collection of Her Majesty The Queen, London 1996.

M. Clayton & R. Philo, Leonardo da Vinci, The Anatomy of Man, exhibition catalog, Houston 1992.

H. F. Cook, Illustrated Catalogue of Pictures by Masters of the Milanese and Allied Schools of Lombardy, Burlington Fine Arts Club, London 1899.

J. Fletcher, "Bernardo Bembo and Leonardos Portrait of Ginevra de' Benci", in: Burlington Magazine, CXXXI, 1989, pp. 811–816.

M. T. Florio, Leonardeschi in Lombardia, Milan 1982.

J.-C. Frère, Leonardo da Vinci. Maler, Erfinder, Visionär, Mathematiker, Philosoph, Ingenieur, Paris 1995.

S. Freud, Eine Kindheitserinnerung des Leonardo da Vinci, Vienna 1910.

L. Fusco & G. Corti, "Lorenzo de' Medici on the Sforza Monument", in: ALV Journal, V, 1992, pp. 11–32.

P. Galluzzi (ed.), Leonardo da Vinci, Engineer and Architect, Montreal 1987.

J. Gantner, Leonardos Visionen von der Sintflut und vom Untergang der Welt: Geschichte einer künstlerischen Idee, Bern 1958.

R. Giacomelli, Gli studi di Leonardo da Vinci sul volo, Rome 1935.

G. Gibbs-Smith, The Inventions of Leonardo da Vinci, Oxford 1978.

P. Giovo, "Leonardo da Vinci Vita", in: G. Tiraboschi, Storia della letteratura italiana, vol. VII, Venice 1796.

L. Goldscheider, Leonardo da Vinci. Landschaften und Pflanzen, London 1952.

L. Goldscheider, Leonardo da Vinci. Life and Work. Paintings and Drawings, London 1952 (1948).

E. H. Gombrich, M. Kemp & J. Roberts, Leonardo da Vinci, exhibition catalog, London 1989.

C. Gould, Leonardo: The Artist and the Non-Artist, London 1975.

M. M. Grewenig & O. Letze (eds.), Leonardo da Vinci. Künstler, Erfinder, Wissenschaftler. Exhibition catalog Speyer, Ostfildern 1995.

I. B. Hart, The World of Leonardo da Vinci. Man of Science, Engineer and Dreamer of Flight, London 1961.

M. Herzfeld, Leonardo da Vinci. Der Denker, Forscher und Poet, Leipzig 1904.

L. H. Heydenreich, Leonardo, Basel 1953 (Berlin 1943).

E. Hildebrandt, Leonardo da Vinci, Berlin 1927.

K. Keele, Leonardo da Vinci on the Movements of the Heart and Blood, London 1952.

K. Keele, Leonardo da Vinci's Elements of the Science of Man, London & New York 1983.

K. Keele & C. Pedretti, Leonardo da Vinci. Corpus of Anatomical Drawings in the Collection of Her Majesty the Queen at Windsor Castle, 2 vols. and facsimiles, London & New York 1979/80.

M. Kemp, Leonardo da Vinci. The Marvellous Works of Nature and Man, London & Toronto 1981.

M. Kemp, Leonardo e lo spazio dello scultore, Lettura Vinciana XXVII, Florence 1988.

M. Kemp, Leonardo da Vinci: The Mystery of the Madonna of the Yarnwinder, exhibition catalog, Edinburgh 1992.

M. Kemp & J. Roberts (eds.), Leonardo da Vinci, exhibition catalog, London 1989.

M. Kemp & M. Walker (eds.): Leonardo on Painting, New Haven & London 1989.

M. Kwakkelstein, Leonardo da Vinci as a Physiognomist, Leiden 1995.

Leonardo da Vinci, Treatise on Painting (Codex Urbinas Latinus 1270), translated and annotated by A. Philip McMahon, with an introduction by Ludwig H. Heydenreich, 2 vols., Princeton/N.J. 1956.

Leonardo da Vinci, Il Codice Atlantico, 12 vols., Florence 1973—75.

Leonardo da Vinci, Codices Madrid, transcribed by L. Reti, translated by G. Ineichen et al., 2 vols., Frankfurt/Main 1974.

G. P. Lomazzo, Trattato dell'arte della pittura, Milan 1584.

E. Mac Curdy, Leonardo da Vinci, London 1929.

P. C. Marani, Leonardo e i leonardeschi a Brera, Florence 1987.

P. C. Marani, Leonardo. Catalogo completo, Florence 1989.

P. C. Marani, Leonardo e i leonardeschi nei musei della Lombardia, Milan 1990.

P. C. Marani, Leonardo da Vinci, Milan 1994.

A. Marinoni, I rebus di Leonardo da Vinci, Florence 1954.

A. Marinoni, La Matematica di Leonardo da Vinci, Milan 1982.

P. Müller-Walde, Leonardo da Vinci, Munich 1889.

G. Nicodemi, Leonardo da Vinci. Gemälde, Zeichnungen, Studien, Zürich 1939.

C. D. O'Malley & James Saunders, Leonardo da Vinci on the Human Body, New York 1952.

C. D. O'Malley (ed.): Leonardo's Legacy: A Symposium, Los Angeles 1969.

H. Ost, Leonardo-Studien, Berlin & New York 1975.

L. Pacioli, De Divina Proportione, Venice 1509.

C. Pedretti, Documenti e memorie riguardanti Leonardo da Vinci a Bologna e in Emilia, Bologna 1953.

C. Pedretti, Leonardo da Vinci. Fragments at Windsor Castle, London 1957.

C. Pedretti, Studi Vinciani. Documenti, analisi e inediti leonardeschi, Geneva 1957.

C. Pedretti, Leonardo inedito. Tre saggi, Florence 1968.

C. Pedretti, Leonardo da Vinci, The Royal Palace at Romorantin, Cambridge/Mass. 1972.

C. Pedretti, Leonardo. A Study in Chronology and Style, London 1973.

C. Pedretti, Disegni di Leonardo e della sua scuola alla Biblioteca Reale di Torino, Florence 1975.

C. Pedretti, The Literary Works of Leonardo da Vinci: A Commentary to Jean Paul Richter's Edition, Oxford 1977.

C. Pedretti, Leonardo, Bologna 1979.

C. Pedretti, Leonardo: Architect, London 1986.

C. Pedretti, "The Angel in the Flesh", in: ALV Journal, IV, 1991, pp. 34—48.

C. Pedretti (ed.), La Madonna dei fusi (1501), Florence 1982.

C. Pedretti (ed.), Leonardo's Broar, exhibition catalog, Malmö 1993.

A. Perrig, "Leonardo: Die Anatomie der Erde", in: Jahrbuch der Hamburger Kunstsammlungen, vol. 25, 1980, pp. 51et seq.

F. Piel, Tavola Doria. Leonardo da Vincis Modello zu seinem Wandgemälde der Anghiarischlacht, Salzburg 1995.

J. Pope-Hennessy, The Portrait in the Renaissance, London & New York 1966.

A. E. Popham, The Drawings of Leonardo da Vinci, London 1946.

A. E. Popp (ed.): Leonardo da Vinci. Zeichnungen, Munich 1928.

L. Reti (ed.): The Manuscripts of Leonardo da Vinci . . . at the Biblioteca Nacional of Madrid, 5 vols., New York 1974.

J. P. Richter, The Literary Works of Leonardo da Vinci, 2 vols., 3rd ed., London & New York 1970.

A. De Rinaldis, Storia dell'opera pittorica de Leonardo da Vinci, Bologna 1926.

A. F. Rio, Leonardo da Vinci e la sua scuola, Milan 1856.

M. Rosci, The Hidden Leonardo, Oxford 1978.

A. Schiapparelli, Leonardo ritrattista, Milan 1921.

J. Schumacher, Leonardo da Vinci. Maler und Forscher in anarchischer Gesellschaft. Berlin 1981.

G. Séailles, Léonard de Vinci. L'artiste et le savant, Paris 1928.

W. von Seidlitz, Der Wendepunkt der Renaissance, Berlin 1909.

J. Shell & G. Sironi, "Salai and Leonardo's Legacy", in: Burlington Magazine, CXXXIII, 1991, pp. 95—108.

O. Sirén, Leonardo da Vinci, Stockholm 1911.

W. Suida, Leonardo und sein Kreis, Munich 1929.

U. Thieme & F. Becker (eds.): Allgemeines Lexikon der bildenden Künstler von der Antike bis zur Gegenwart, 37 vols., Leipzig 1907—50.

E. M. Todd, The Neuroanatomy of Leonardo da Vinci, New York 1978.

G. B. De Toni, Le piante e gli animali in Leonardo da Vinci, Bologna 1922.

A. R. Turner, Inventing Leonardo, New York 1993.

G. Vallardi, Disegni di Leonardo da Vinci, Milan 1855.

G. Vasari, Le vite de' più eccelenti architetti, pittori et scultori italiani, Florence 1550.

A. Venturi, Storia dell'arte italiana, vol. VII, Milan 1915.

A. Venturi, La critica e l'arte di Leonardo da Vinci, Bologna 1919.

A. Venturi, Leonardo da Vinci e la sua scuola, Novara 1941.

A. Vezzosi, La Toscana di Leonardo, Florence 1984.

A. Vezzosi, Il sigillo del Vinci, Vinci 1989.

A. Vezzosi, Le trame del genio, Prato 1995.

A. Vezzosi (ed.), Leonardo e il leonardismo a Napoli e a Roma, intr. by C. Pedretti, Florence 1983.

A. Vezzosi (ed.), Leonardo. Art, Utopia and Science, exhibition catalog, Florence 1987.

A. Vezzosi (ed.), Leonardo scomparso e ritrovato, exhibition catalog, Florence 1988.

A. Vezzosi (ed.), Leonardo da Vinci & Il Codice Hammer, multimedia edition with disk for Windows, Florence 1994 & Milan 1995.

J. Wasserman, "The Dating and Patronage of Leonardo's Burlington House Cartoon", in: Art Bulletin, LIII, 1971, pp. 312—325.

J. Wasserman, Leonardo da Vinci, New York 1975, German translation 1977.

E. Winternitz, Leonardo as a Musician, New Haven 1982.

F. Zöllner, Leonardo da Vinci. Mona Lisa. Das Porträt der Lisa Gioconda. Legende und Geschichte, Frankfurt/Main 1994.

Paintings

Leonardo da Vinci and pupils: The Virgin of the Rocks (p. 47)

Leonardo da Vinci and pupils: The Dressed-up Angel (p. 181)

Giampietrino: Mary Magdalene (p. 183)

Giampietrino: St Catherine of Alexandria (p. 185)

Raphael: Betrothal of St Catherine to the Infant Jesus (p. 187)

Raphael and workshop: San Giovannino (p. 189)

Raphael: The young John the Baptist (p. 191)

Anonymous follower of Leonardo: The Holy Family (p. 192)

Leonardo da Vinci (school): The Kissing Infants (p. 193)

Bramantino: Pietà (p. 199)

Bramantino: Virgin of the Rocks (p. 201)

Michelangelo: The Virgin with Child and the Infant St John (p. 203)

After Correggio: Madonna del Latte (p. 205)

Lombard Follower of Leonardo: Madonna of the Yarnwinder (p. 207)

Salai: Monna Vanna (p. 209)

Sculptures

Leonardo da Vinci: Bust of Christ as a Youth (p. 25)

Leonardo da Vinci (attribution): The Wax Horse (p. 213)

Works on Paper

Perugino: Head of an old, bearded man (p. 22)

Leonardo da Vinci: Anatomical Study (p. 88)

Leonardo da Vinci: Anatomical Study (p. 89)

Leonardo da Vinci: The Angel in the Flesh (p. 179)

Cesare da Sesto: Study of a Praying Abbot (p. 196)

Luini: Two studies of a blessing Infant Jesus (p. 197)

Volterra: The horse of the "Opus Praxitelis" (p. 211)

Printed Work

Vitruvius: De Architectura (p. 218)

Facsimiles

All the other represented works on paper are shown as facsimiles, except the ones on pp. 50, 108, 109, 112, 113, 119, 129, 138, 168, 195.

Models

On pp. 114, 118, 128, 132, 134, 138, 142, 146, 148 and other models, which are not represented in the catalog.

The exhibition includes further works which are not illustrated in the catalog:

Works on paper
(except where otherwise stated,
The Elmer Belt Library of Vinciana,
University of California, Los Angeles)

Francesco Melzi
Caricatures
ca. 1550
Pen and ink
47 x 103 mm; 57 x 103 cm

Francesco Melzi
Head of a horse
ca. 1550
Red chalk
125 x 127 mm

Gerolamo Figino
Study for The Last Supper
ca. 1540
Red and black chalk
129 x 203 mm

Wenzel Hollar
Studies of heads
ca. 1645
Etching
54 x 105 mm; 86 x 115 mm;
33 x 100 mm

Wenzel Hollar
Grotesque figures
ca. 1645
Etching
95 x 136 mm

Wenzel Hollar
Grotesque heads
ca. 1645
Etching
71 x 115 mm; 80 x 119 mm;
93 x 130 mm

Wenzel Hollar
Five grotesque heads
1646
Etching
245 x 189 mm

Wenzel Hollar
Study of a head
1648
Etching
71 x 52 mm

Printed works
(except where otherwise stated,
The Elmer Belt Library of Vinciana,
University of California, Los Angeles)

Bernardo Bellincioni
Rime del arguta dt faceto
(Sonnet to Leonardo da Vinci's
portrait of Cecilia Gallerani)
ca. 1493
210 x 150 mm
Private collection, Los Angeles

Luca Pacioli
Divina Proportione
Venice, Pagani 1509
282 x 202 mm
Nationalbibliothek, Vienna

After Marcus Vitruvius
De Architectura
Como, 1512
372 x 265 mm

Joachim von Sandrat
Teutsche Academie der edlen Bau-,
Bild- und Mahlerey-Künste
Nuremberg, 1675
395 x 265 mm

Hartmann Schedel
Weltchronik
Nuremberg, A. Koberger, 1493
440 x 280 mm

Leonardo da Vinci
Traktat über die Malerei
Nuremberg, 1747
233 x 165 mm

Leonardo da Vinci
Trattato della Pittura
Florence, 1792
296 x 226 mm

Leonardo da Vinci
Trattato della Pittura
Paris, 1651 (Italian edition)
385 x 275 mm

Leonardo da Vinci
Traité de la Peinture
Paris, 1651 (French edition)
385 x 275 mm

Models after Leonardo da Vinci's sketches
Twentieth century

Model of a two-story bridge

Model of a pontoon bridge

Model of the bridge over the Golden Horn

Model of propeller

Model of an airplane

Model of an odometer

Model of ball-bearings

Model of a printing press

Model of a hydraulic screw

Model of a coin stamping machine

Model of a double-hulled ship

Model of an astronomical clock
after Giovanni de' Dondi
Chronometrie Beyer, Zürich

Model of a lunar clock
Museo Ideale, Vinci

Model of a clock
after Francesco di Giorgio
Museo Ideale, Vinci

Model of a clock
after Francesco di Galileo Galilei
Museo Ideale, Vinci

Model of a clock-work mechanism
Museo Ideale, Vinci

Sculptures:

Bronze model of a lyre in the shape of
a horse's head with horns of a ram
Museo Ideale, Vinci

Putto with a dolphin
copy after Verrocchio
Museo Ideale, Vinci

The little Budapest horse and rider
Bronze (copy)
Museo Ideale, Vinci

Facsimiles:

In addition, a further twenty-nine fac-
similes which are not reproduced in this
catalog are on display at the exhibition.

A basic exhibition "Leonardo's Bridges" was enlarged and redesigned by the Institut für Kulturaustausch, under the scientific guidance of Prof. Carlo Pedretti, to its actual status.

The Museo Ideale in Vinci, Italy — Leonardo's birthplace — with its Director Prof. Alessandro Vezzosi, has provided substantial support for this exhibition project.

The Institut für Kulturaustausch retains all rights to present this exhibition on an international tour.

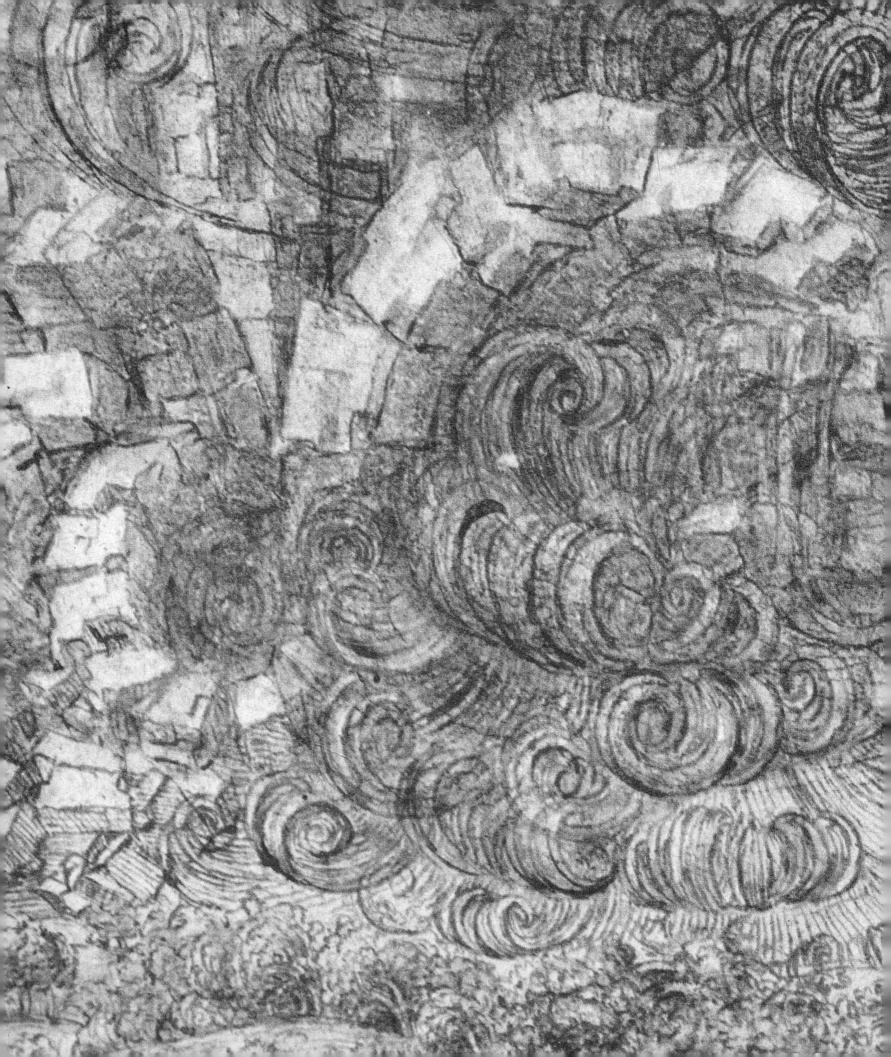